RAISING
HELL

RAISING HELL

A Concise History of the Black Arts—
and Those Who Dared to Practice Them

ROBERT MASELLO

A Perigee Book

A Perigee Book
Published by The Berkley Publishing Group
200 Madison Avenue
New York, NY 10016

First edition: October 1996

Published simultaneously in Canada.

The Putnam Berkley World Wide Web site address is
http://www.berkley.com/berkley

Library of Congress Cataloging-in-Publication Data:

Masello, Robert.
 Raising hell : a concise history of the black arts—and those who
dared to practice them / Robert Masello.
 p. cm.
 Includes bibliographical references.
 ISBN 0-399-52238-7
 1. Occultism—History. 2. Magic—History. 3. Witchcraft—
History. 4. Satanism—History. I. Title.
BF1411.M32 1996
133.4'09—dc20 96-11323
 CIP

Printed in the United States of America

10 9 8 7 6 5 4 3 2

For Bill Bleich,
who opened the door,
and the producers at Trilogy,
who welcomed me in.

FAUST: Did not my conjuring raise thee? Speak.

MEPHOSTOPHILIS: That was the case, but yet *per accidens*:
For when we hear one rack the name of God,
Abjure the Scriptures and his savior Christ,
We fly in hope to get his glorious soul.
Nor will we come unless he use such means
Whereby he is in danger to be damn'd.
Therefore the shortest cut for conjuring
Is stoutly to abjure all godliness
And pray devoutly to the Prince of Hell.

Christopher Marlowe,
*The Tragical History of the Life and Death
of Doctor Faustus* (c.1594)

Contents

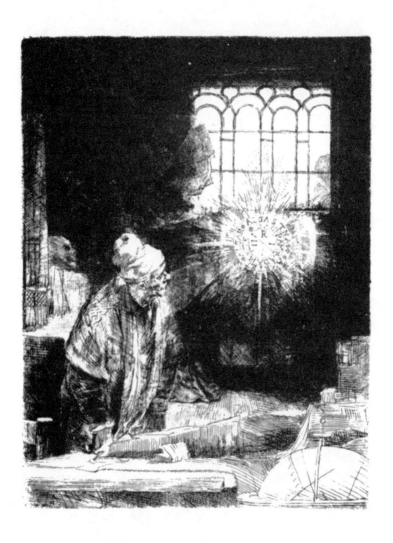

PREFACE

When anyone invokes the Devil
with intentional ceremonies,
the Devil comes, and is seen.

Eliphas Lévi,
French occultist
(c.1810–75)

*W*ho in full possession of his faculties would ever deliber-
ately invoke the Devil?

Who would call up infernal powers and then hope, once the
demons were conjured, to be able to control them?

If the history of black magic and the occult reveals anything
at all, it reveals that the drive to marshal the unseen powers of
the dark and bend them to a mortal will is as old as mankind
itself. Men and women have believed, in virtually every age and
in every land, that there is another world—this one invisible,
eternal, and essentially unknowable—coexistent with the one
we inhabit every day. It is the world of spirits and souls, angels
and demons, gods and monsters, and in it can be found the
answers to all the great questions: What is life all about? Does
man decide his own fate? Is death truly an end? Is there a
Heaven? And is there, perhaps more important, a Hell?

Magic, the mystical precursor of religion, professed to have
the answers. But where "white magic" looked for these answers
from a divine, or holy, source, black magic looked in the other
direction; by enlisting the aid of Satan or his spawn, sorcerers
and magicians claimed to be able to probe the great mysteries.
They made pacts with demons, promising their immortal souls
in exchange for a lifetime of riches or a godlike glimpse of the
cosmic order. They raised the souls of the dead, to ask them

where they'd gone and how they'd gotten there. They pored over ancient and sacred texts, the Holy Scriptures, the Cabbala, the Egyptian Book of the Dead, searching through the cryptic words for clues and advice.

Along the way, these occult pioneers often stumbled upon real and verifiable truths: the astrologers mapped the heavens and paved the way for the astronomers who followed; the alchemists, in their futile quest to make gold from lead, performed thousands of experiments which led to the discovery of everything from phosphorus, sodium sulfate, and benzoic acid to the manufacturing of steel. Even the seers, who read palms and interpreted dreams, contributed to the vast catalog of human thought and deed, and anticipated in their own way such later practices as psychology and hypnosis.

What made their efforts all the more surprising—in some cases, dare it be said, even inspiring—were the dangers, both real and imagined, that these explorers of the dark side faced. First, there was the ever-present threat of ecclesiastical or royal condemnation. Dabbling in the occult could get you interrogated, excommunicated, tortured, mangled, hanged, burned at the stake. (Or, as in the case of Father Grandier, who was accused of bewitching the nuns of Loudun, all of the above.)

Then, there was the imagined danger implicit in the act of conjuration—if you summoned a demon straight from Hell, there was a very good chance he'd try to take you back home with him. In all the *grimoires* (grammars) of black magic, there were repeated warnings and explicit instructions about what to watch out for. Demons were wily sorts, the books declared, who weren't too happy about taking orders from any witch or magician; given the slightest opportunity, they'd do their best to kill the conjurer's mortal body and make off with his immortal soul. When at long last it came time for Faust to make good on his deal with the devil, for instance, his body was found torn to pieces in an open field, and his soul—well, that was assumed, according to most accounts, to have been carried off to perdition.

Even so, the occult arts have never disappeared and have frequently flourished. Though many of them had their origins in

the ancient nations of the Middle East (where they formed the very basis of the faiths of Babylon and Egypt), during the Middle Ages and Renaissance they reached their zenith in western Europe. There, the antique practices were revived, revered, and refined; there, they were combined with the latest discoveries in medicine, metallurgy, astronomy, anatomy, botany, and zoology and subjected to the spirit of inquiry that increasingly distinguished the era. What started as magic occasionally became fact. Occult arts over time turned into rudimentary science.

And though the Devil and his minions were gradually ushered from the scene, they were never altogether banished. They were always waiting in the wings . . . listening patiently for their cue to return . . . ready to offer, to anyone foolhardy enough to accept it, their unholy bargain.

RAISING
HELL

BLACK MAGIC
AND
SORCERY

\mathcal{I} hereby promise the Great Spirit Lucifuge, Prince of Demons, that each year I will bring unto him a human soul to do with as it may please him, and in return Lucifuge promises to bestow upon me the treasures of the earth and fulfill my every desire for the length of my natural life. If I fail to bring him each year the offering specified above, then my own soul shall be forfeit to him.

Signed_____[Invocant signs pact with his own blood.]

"The Complete Book of Magic Science," unpublished manuscript in the British Museum

THE MAGUS

*I*n the West, he has gone by many names. Magus, sorcerer, wizard, magician. We know him best as a figure in a long robe, bespangled with stars, wearing a pointed hat and a long white beard, wielding a magic wand. He is the master of the occult world and its invisible forces, able to call up storms, cast spells, defy nature, and make all things do his bidding.

But the true origins of the magus lie in the East, in the ancient empire of Persia.

There, the magi, or wise men, were the high priests, the interpreters of the wisdom of Zoroaster. Our word "magic" is derived from their name. They were revered for their profound learning and for their gift of prophecy; rulers consulted them on everything from matters of personal health to great affairs of state. In their own temples, built on the highest mountaintops, the magi made the search for truth their chief aim; to that end, they studied the sky and the stars and made sacrifices to the elements. Because they believed in the transmigration of souls, they generally abstained from eating any kind of meat.

The wise men who brought their gifts to the infant Jesus were magi from the Orient: named Caspar, Melchior, and Balthasar, they were, according to some theologians, master astrologers who, after following the star to Bethlehem, abandoned their pagan beliefs. (And, if legend is to be believed, their bones are now interred in Cologne Cathedral.)

Over the centuries, and with the gradual decline of the Persian empire, the wisdom of the magi made its way westward. Soldiers who survived the Crusades brought back with them news, and bits of arcane lore, from the eastern lands; trade routes were forged and frequently traveled among the Mediterranean nations. What the magi had begun, European magicians quickly adopted and developed. But they added to it their own mystical precepts and philosophy, culled from the Jewish Cabbala and early Christian theology. It was a curious but potent

brew, a mix of alchemy and chemistry, metallurgy and medicine, astrology, anatomy, divination, metaphysics. It was all things thrown together, an amalgam out of which the magicians hoped to extract answers to all things mysterious. "Magic," Paracelsus wrote, "has power to experience and fathom things which are inaccessible to human reason. For magic is a great secret wisdom, just as reason is a great public folly."

Each man, it was believed, was a miniature cosmos, replicating in his own constitution the natural order and affected, at the same time, by the larger universe he inhabited—the motions of the planets and stars, the winds that blew and the rain that fell, the changing of the seasons. The magus, it was thought, could work his wonders in two ways. First, by controlling and directing his own inner forces, he could project his will and desires outward, influencing the actions of others. At the same time, he could call down, or invoke from the outside, powers and intelligences that he could then use to effect his own aims. Agrippa von Nettesheim, one of the greatest magicians of the sixteenth century, described the magus as one "who has cohabited with the elements, vanquished Nature, mounted higher than the heavens, elevating himself to the archetype itself with whom he then becomes co-operator and can do all things."

Eliphas Lévi, sometimes called the last of the magi, wrote in 1855 *The Doctrine and Ritual of Magic*. In it, he offered anyone wishing to pursue the occult some critical advice: "To attain the sanctum regnum, in other words, the knowledge and power of the magi, there are four indispensable conditions—an intelligence illuminated by study, an intrepidity which nothing can check, a will which nothing can break, and a discretion which nothing can corrupt and nothing intoxicate. TO KNOW, TO DARE, TO WILL, TO KEEP SILENCE—such are the four words of the magus."

But success could prove dangerous. Even if the magus met all the requirements, both personal and professional, he could still find himself in deep trouble. If, for instance, he summoned up infernal forces that he was not able to control, either through the strength of his imagination or through his magical tech-

niques, he ran the risk of being overpowered by them. The spirits of the dark were never noted for their charity. In the batting of an eye, the magus could lose his life and, if he really wasn't careful, his immortal soul to boot.

THE SACRED CIRCLE

𝒯he circle has always held great meaning for magicians and mystics, philosophers and priests, alchemists and astrologers. The simple act of drawing a circle around something or someone was often considered a means of protecting it from outside forces of evil. If someone fell ill in ancient Babylon, a circle was drawn around the sickbed to defend the patient from the demons who were presumably preying upon him; in medieval Germany, Jews did the same when a woman was giving birth, just to make sure no mischievous spirits got into the act. When Roman emissaries were sent to deliver news (or ultimatums) to foreign rulers, they drew a circle around themselves with the base of their staff to symbolize that they should be immune from retribution. Even prehistoric societies revered the circle, as the circular stone monuments of Stonehenge and Avebury attest.

Why? What gives the circle such a powerful reputation? In part, it is the figure's simplicity; the circle is, at once, capable of circumscribing anything and everything, and at the same time it contains nothing. At its center it is a hole. Over time, and in many disparate cultures, the circle has become a symbol of the unity, the oneness, of all things, a single line that seemingly has no beginning and no end, a figure that can suggest everything from the eternal to the idea of perfection.

Alchemists used a symbol they called the *ourobouros*. A circle formed by the image of a dragon or a serpent swallowing its own tail, this mystical symbol sometimes carried the Greek phrase *En to Pan,* or "All is One." Using the kind of numerology at which alchemists were so skilled, they counted the three words in the Greek phrase, the seven letters of which the words were comprised, and then added them together to get 10—a

number that itself was thought to mean "all things." Not only does 10 mark the completion of the primary numbers, it is also made up of a 1 and a 0; add a 1 and a 0 and what you get, again, is a 1. Many a learned treatise was written to elaborate on all this.

Magicians used the circle for a couple of different reasons. On the one hand, by drawing a circle and remaining inside it, the magician thought it would be easier to marshal and concentrate his powers. The circle would keep the unseen energies from running off every which way. But more important, the circle would also provide a protective barrier against the infernal forces his incantations might summon up. The demons outside could gibber and rail, but as long as the magician—and in some cases his assistant—stayed inside the magic circle, all dangers could be kept at bay.

If, that is, the circle had been done right.

Though the recipe differed in many details, the general instruction remained fairly consistent. The circle was drawn on the floor or in the dirt (a wooded glen was often a good choice of locale) with the tip of a sword, a knife, a staff. Sometimes charcoal or chalk was used. A French grimoire from the 1700s suggested the circle should be fashioned from strips of skin, cut from a young goat, and secured to the floor with four nails pulled from the coffin of a dead infant.

It was also important when drawing the circle to do so in the appropriate direction. If it was drawn in a clockwise manner, or deasil, it was designed to perform feats of white, or good, magic. If it was drawn counterclockwise, its purpose was malign. Going to the left in this way was called widdershins, a word derived from an Anglo-Saxon phrase that meant "to walk against." The sun went from east to west, from right to left, and anything that went in the opposite direction was thought to be moving against nature and, consequently, against the powers of good.

As to size, nine feet was generally considered the proper diameter of the outer circle, with another, smaller circle—eight feet in diameter—drawn inside it. In that narrow space between

the rims of the two circles, the magician placed various holy objects and talismans that were thought to ward off evil forces. He might put crosses there, a bowl of pure sanctified water, and plants like vervain (which demons supposedly hated). But most important of all, he had to make sure the circle was completely closed. Any little gap, and an enterprising creature could weasel its way in, possess his immortal soul, and cart it off to the infernal regions.

The magician himself had so much to do it's a miracle he could ever remember it all. Among other things, there was a host of sartorial requirements. The standard garb, or pontificalibus as it was called, included a long robe made of black bombazine, to which two drawings on virgin parchment were attached, depicting the two seals of the earth. Under this outer robe, a ceremonial apronlike vestment known as an ephod was worn; the ephod, which was held up by two shoulder straps, was made of fine, white linen. Around his waist the magician wore a wide, consecrated girdle inscribed with magical words; on his feet, shoes decorated with crosses; on his head, a sable silk hat with a high crown. In his hands, the sorcerer held a wand and a Bible, either written or printed in the original Hebrew. So accoutred and equipped, he was ready to start his incantations.

Standing safely inside the inner of the two magic circles, and within the smaller triangle that was often demarcated inside of that, the magus was as protected as he could be from the demonic forces he was about to unleash. Which was just as well, since their return was heralded by the most dreadful and harrowing sounds—shrieks and growls, anguished cries, and angry barking. Long before they could be seen, the spirits and demons ranted and raved at the perimeter of the circle, trying to scare the daylights out of the magician and persuade him to abandon his nefarious scheme.

If that didn't work, they took on visible shapes, also designed to intimidate and terrify. They appeared as lions and tigers, belching flame, snarling and snapping and clawing. If the magician faltered in his resolve, if—God forbid—he picked up his robes and tried to make a run for it, he'd be ripped to pieces

the moment he left the confines of the circle. But if he was stalwart, if he held on to his Bible and his wits, and continued uninterrupted to repeat the necessary conjurations, the demons would eventually be drawn close to both the outer circle and the innermost triangle and settle down; they would shed their beastly shapes and reconfigure themselves as naked men of a peaceful demeanor.

At this point, the magician could relax a little, but not a lot. For although the spirits had taken on a gentle appearance and were for the moment behaving themselves, they were still an antagonistic force, lying in wait for their first opportunity to sow doubt or fear in the mind of the sorcerer or trick him into doing something stupid. His best bet was to make his demands of them, or ask for the information he sought, as quickly as possible, while his strength and senses were intact.

As soon as that was done, as soon as he'd gotten what he was after, he could begin the rituals prescribed for dismissing the spirits. As these rites were performed, the spirits would regress, going backward through all the same stages and transformations that had announced their coming, until they vanished in a sulfurous cloud.

Then, and only then, could the magician safely poke his toe outside the confines of the sacred circle.

According to a celebrated account from eighteenth-century England, an Egyptian fortune-teller named Chiancungi made a fatal mistake. On a bet, he accepted the challenge of summoning up a spirit named Bokim. He drew the magic circle and installed himself and his sister Napula inside it. Then he went through all the necessary steps and recitations—to no apparent avail. Nothing showed up. He tried to conjure the spirit, over and over again, until he gave up in disgust and stepped outside the magic bounds. The moment he did, he and his sister were set upon and crushed to death by the invisible spirit, which had been silently lying in wait for them the whole time.

PENTAGRAM AND HEXAGRAM

*I*n addition to the magic circle, there was another sacred shape that provided the magician with a powerful measure of protection—and that was the pentagram. A five-pointed star, the pentagram was to be drawn around the rim of the larger circle and again just inside it. Demons, it was thought, had an inborn fear and loathing of the pentagram.

Why? With demons, it's never easy to say why they felt or behaved the way they did. But according to some early theologians, the five points of the pentagram stood for many things that demons, unnatural creatures that they were, felt a quite natural aversion to—the living, breathing world of nature, for one. The five points could be thought to represent the four elements of which the world was believed to be composed—earth, air, water, and fire—plus the quintessence of them all. Or the four points of the compass and its center. Or the five wounds inflicted on the body of Christ. Or—and this was considered very significant—man himself. With arms and legs extended, a human being could be viewed as a five-pointed star (the head being the fifth point), and man was often said to be the embodiment, the microcosm, of all of nature. And what could be more repulsive than that to a creature of the dark, bent on destroying order and goodness at every opportunity?

If, however, a magician wished to issue a clarion call to the forces of evil, the pentagram was good for that, too. All that he had to do was turn it upside down, so that its two lower points were now on top, symbolizing the reversal of the natural order and pointing upward like the Devil's horns: "It is the goat of lust," the magician Eliphas Lévi wrote, "attacking the heavens with its horns." This particular configuration was also known as the Goat of Mendes, because the inverted star roughly resembled the shape of a goat's head. When used for such black and nefarious purposes, the pentagram was sometimes called the footprint of the Devil or the sign of the cloven hoof.

In the manuals of the Order of the Golden Dawn, a nine-teenth-century mystical order, the overturned pentagram was recommended whenever "there may arise an absolute necessity for working or conversing with a Spirit of an evil nature." Even so, it was a good idea to write inside the pentagrams the names of power—the ancient Hebrew Tetragrammaton, for example, and other such names as Hallya, Ballater, Soluzen, Bellony, and Hally—so that once the devils did appear, they didn't get out of hand.

In *The Tree of Life*, Dr. Israel Regardie, who wrote four volumes on magic and the Golden Dawn between 1937 and 1940, went so far as to suggest that the actual physical laying out of the pentagram was a waste of time and chalk. If the sorcerer had sufficient powers of imagination (and if he didn't, why was he mucking around with sorcery at all?), he could simply imagine his protective pentagram "on the Astral Plane in glowing figures of fire, so that through the streaming lines of light and power, representative of the spiritual being, no lesser entity of any kind dare make its way. . . . The blazing five-pointed star is like the flaming sword which debarred Adam from the Edenic paradise."

To go that extra mile, a magician might also construct—on this plane or the astral one—a hexagram. Created by laying one triangle upside down on top of another, this six-pointed star was also known as the Seal of Solomon. Solomon himself, the king of Israel, was said to have worn a ring with the seal on it, and engraved with the real name of God, which gave him the power to control and corral the spirit world. Using the ring, he was able to get the demons to help build his temple for him. Furthermore, the ring allowed him to travel, each day at noon, up into the Firmament, where he could listen in on the secrets of the universe. (Legend has it that the Devil was able one day to persuade Solomon to take the ring off his finger; the moment he did, the Devil assumed his shape, and Solomon had to wander in distant lands for three years until he could get his throne back.) For alchemists, the two triangles of the hexagram symbolized fire (an upward-pointing triangle) and water (a downward-pointing triangle), making the figure as a whole the ideal sign for the

elusive philosophers' stone, thought to be an amalgam of the two elements.

THE GREAT GRIMOIRES

*A*ny sorcerer worth his salt had a grimoire, or book of black magic, on which he relied for all the necessary instruction and advice. Raising spirits was a devilishly difficult and dangerous task: first, you had to conjure them up, then you had to keep control of them long enough to get them to do your bidding, and finally you had to make sure you got rid of them safely and soundly and that you managed to hang on to your own soul throughout the whole process.

None of this was easy.

The great grimoires (which meant, literally, "grammars") were weighty and seemingly impenetrable books, often written in ancient tongues, filled with confusing and arcane lore, meant by their very obscurity to fend off dilettantes and amateurs and reward the wizard willing to put in the required time and effort. If you could get through the grimoire itself, you were halfway to meeting a demon.

Two of the most venerable of these books were known as the *Key of Solomon,* or *Greater Key,* and the *Lesser Key of Solomon* (also called *The Lemegeton*). Some believed that these Keys were written by King Solomon himself; others believed they were written by devils and entrusted to the king. They came to be called Keys after the lines in Matthew 16:19, in which Jesus says to Peter, "And I will give unto thee the keys of the kingdom of heaven: and whatsoever thou shalt bind on earth shall be bound in heaven: and whatsoever thou shalt loose on earth shall be loosed in heaven." These books, it was thought, held the power to unlock occult powers and wisdom.

The ruler of Israel in the tenth century B.C., Solomon was widely regarded as a master magician, one who could control the spirits and get them to do whatever he desired. It was even said that he had marshaled their forces to help in the building

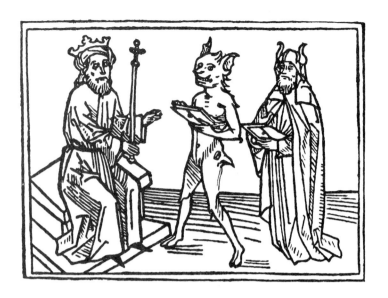

of the Temple in Jerusalem. In the *Greater Key,* he set out all the necessary steps for summoning a spirit and keeping hold of the reins, as it were, once you had. The book also included the fasting and purification rituals to which the magician must submit himself before trying any such conjuration, along with practical advice on what to wear, what equipment to use, how to go about drawing the magic circle, etc.

In the *Lesser Key,* which was often thought even more useful, Solomon left off with the general advice and really got down to brass tacks. In the first section, entitled "Goetia" ("magical arts"), he described just how to conjure up seventy-two chief demons and their respective ministers. In the second, "Theurgia Goetia," he discussed spirits and their main characteristics. In the third, the "Pauline Art," he ran through the angels of the hours and the days, and the signs of the zodiac; and in the fourth, the "Almadel," he described the angels who presided over the altitudes, as the compass directions, north, south, east, and west, were then called.

According to legend, both of these Keys were buried under

Solomon's throne, where they would have stayed forever if it hadn't been for the intervention of some troublemaking demons. After Solomon died, the demons whispered where the books were hidden to a few of the king's courtiers, who promptly dug them up and unleashed all kinds of trouble on the world.

In addition to the two Keys of Solomon, there were other grimoires, which were also considered hallmarks of the occult trade. They shared a great deal of common advice on the proper ways to invoke the infernal powers (for the space of an entire quarter of the moon, the sorcerer was advised to keep his thoughts centered on the task before him, to eat no more than two meals a day, to sleep little, change his clothes as infrequently as possible, etc.), along with words of wisdom on how to thwart the demons' own evil intentions.

In one such book, the *Grimoire of Honorius*, a veritable catalog of the fallen angels was offered, along with advice on how to raise them. Credited to Pope Honorius III, who succeeded Innocent III in 1216, it pretended to carry the imprimatur of the papacy and was first published in Rome in 1629. Heavily freighted with Christian formulas and benedictions, it not only instructed priests in the arts of demonology but virtually ordered them to learn how to conjure and control demons, as part of their job. The brief introduction reads surprisingly like a modern-day sales pitch: "But until the time of this Constitution," it says in part, "only the Ruling Pontificate has possessed the virtue and the power to command the spirits and invoking them. Now his Holiness, Honorius III, having become mellowed by his pastoral duties, has kindly decided to transmit the methods and ability of invoking and controlling spirits, to his brothers in Jesus Christ, the revered ones."

What followed the introduction claimed to be a papal bull, or edict, from Honorius himself, addressed to all the brethren of the Holy Roman Church. "In the times when Jesus, the Son of God, the Saviour, of the tribe of David, lived on this earth: we see what power he exercised over Demons. This power he

passed on and communicated to Saint Peter with these words: 'Upon this Rock I shall build my Church, and the Gates of Hell shall not succeed against it.' "

The bull goes on to explain that although this power over infernal spirits had indeed resided only in the pope until that time, Honorius now felt every priest and deacon, abbott and archbishop, ought to know how to perform such feats: "We feel that while exorcising those who are possessed, they [the clergy] might become overcome at the frightful appearances of the rebellious Angels who were thrown into the Pit for their sins, for they may not be well enough versed in the things which they should know and use; and we desire that those who have been redeemed by the Blood of Jesus Christ should not be tortured by sorcery or possessed by a demon, and so we have added to this Bull the unchangeable manner whereby they may be invoked." That said, the book conferred upon its readers not only the powers of demonic invocation but a sort of papal permit for doing so.

The *Grimorium Verum,* or *True Grimoire*, which was printed in 1517, claimed to be a translation from the Hebrew and borrowed heavily from both of the Keys of Solomon. Its publisher was listed as "Alibeck the Egyptian" and its place of origin was given as Memphis (as in Egypt, of course). It was divided up into three sections, but the organization wasn't very strict. Overall, the book was a nuts-and-bolts outline for the invocation of demons: "In the first part," states the grimoire itself, "is contained various dispositions of characters, by which powers the spirits or—rather—the devils are invoked, to make them come when you will, each according to his power, and to bring whatever is asked: and that without any discomfort, providing also that they are on their part content; for this sort of creature does not give anything for nothing."

There were two kinds of pacts, the grimoire explained, "the tacit and the apparent," and only by reading the book would you know one from the other. "It is when you make a pact with a spirit, and have to give the spirit something which belongs to you, that you have to be on your guard."

As for the spirits themselves, there were many you could call upon, but three who were referred to as the superiors. They were Lucifer, who directly lorded it over Europe and Asia, Beelzebub, who resided in Africa, and Astaroth, who lived in the New World of America.

In appearance, these spirits were quite malleable. Because, as this grimoire contended, they didn't really exist in a corporeal form of their own, they had to find a body to inhabit, "and one suited to their (intended) manifestation and appearance." Lucifer, the great deceiver, often chose to appear as a handsome young boy, with "nothing monstrous about him." But if he got angry—not an uncommon occurrence—he turned bright red.

Beelzebub, on the other hand, opted for a more conventionally frightening look, appearing sometimes as a gargantuan cow or as a male goat with a long tail. When he got angry, he had a tendency to vomit flames.

Astaroth appeared as a human being, cloaked in black. Once a seraph in Heaven, Astaroth had fallen with Lucifer and been made a great duke of the infernal regions.

Each of these three had a couple of lieutenants they could dispatch to do their dirty work; in addition there were dozens of freelance demons that the well-versed sorcerer could call upon for specific tasks. Although their names and powers differed according to the particular manual being used, in the *Grimorium Verum* eighteen of these demons were listed, along with their specialities:

Clauneck can bestow riches upon you and uncover buried treasure.

Muisin can sway the minds of great lords and offer strategic and political advice.

Bechaud has power over many natural forces, including rain and hail, thunder and lightning.

Frimost can control the bodies and minds of women and girls.

Klepoth can provide you with insightful visions and dreams.

Khil can create earthquakes on demand.

Mersilde can magically transport you anywhere, instantaneously.

Clisthert can turn the day into night, or the night into day, whenever you feel the need for a sudden change.

Sirchade can introduce you to any one of a huge assortment of animals, both real and supernatural.

Hicpacth can deliver to you anyone you want to see, from whatever distance, in the batting of an eye.

Humots can provide you with any book you want.

Segal can make all kinds of prodigies appear.

Frucissiere can bring the dead back to life.

Guland can inflict any kind of disease.

Surgat can unlock anything.

Morail can bestow invisibility on anyone or any object.

Frutimiere can serve up any feast you desire.

Huictiigaras can put you to sleep or create insomnia.

In the third part of the *Grimorium Verum,* all of the invocations and rituals that the magician had to go through, step by

step, were described. If he actually expected to raise a spirit and get it to do his bidding, he had to follow the instructions to the letter—which wasn't at all easy. The instructions were convoluted, time-consuming, and often nearly imcomprehensible. But even so, the *Grimorium Verum* was considered far more precise and authoritative than most of the other manuals of black magic.

To begin with, the sorcerer had to purify himself. The "Ablution of the Sorcerer," as it was called in the *Grimorium Verum,* began with these words: "Lord God Adonay, who hast made man in Thine own image and resemblance out of nothing! I, poor sinner that I am, beg Thee to deign to bless and sanctify this water, so that it may be healthy for my body and my soul, and that all foolishness should depart from it." With the blessed water, the sorcerer was to wash his face and hands, and only then could he go about preparing the instruments he'd need to perform his magic.

There were lots of instruments.

First, there was the knife or lancet, which had to be made "on the day and hour of Jupiter with the Moon crescent" (or, in other words, it had to be new); the magician then had to recite a lengthy conjuration over it, followed by the Seven Psalms.

Then there was what was known as the sacrificial knife, "strong enough to cut the neck of a kid with one blow," which also had to be new, and had to have a wooden handle made at the same time as the steel. Four magical characters were to be engraved on the handle.

Once you had the knife, it was necessary to cleanse it in the blessed water and fumigate it over a coal fire. Aromatic branches and perfumes—aloe and incense and mace—were to be added to the blaze so that the knife was made fragrant, too. Again, there were prayers to be recited over the blade.

A virgin parchment was also indispensable; most of the time it was made from the skin of a goat, lamb, or other unfortunate virgin animal. The creature was laid on a flat surface before having its throat cut "with a single stroke . . . do not take two strokes, but see that he dies at the first." After the animal was skinned, "take well-ground salt, and strew this upon the skin,

which has been stretched, and let the salt cover the skin well." Needless to say, the salt, too, had to have an extensive benediction performed over it first.

When the skin was dried, blessed, and fumigated, it was ready for use—provided none of these preparations had been observed "by any women, and more especially during certain times of theirs, otherwise it will lose its powers." The parchment was used for the writing of spells and for the holy names of power that would keep the sorcerer safe from the demons he'd summoned.

The quill pen, the inkhorn, and the ink itself all had to be newly made, too, then "asperged" (cleansed) and fumigated.

As for the baton, or magic wand, it had to be cut from a hazel tree, on a Wednesday, during a crescent moon, and engraved with the seal of the demon Frimost. Then a second wand had to be made, also of hazel wood, only this one was to be engraved with the seal of Klepoth. The wand was presumably so important, it was essential to have a spare on hand.

"All this [and much more] having been done correctly," advised the *Grimorium Verum,* "all that remains is to follow your invocations and draw your characters. . . ." It was time to pick your demon and tell him what to do.

CONJURATIONS FROM THE *TRUE GRIMOIRE*

𝒯he *Grimorium Verum,* or *True Grimoire,* was filled with spells and incantations, all designed to accomplish a specific aim.

For instance, there was the formula for making yourself invisible. First, you had to collect seven black beans—and the head of a dead man. You put one of the beans in the dead man's mouth, two in his eyes, two in his nostrils, and two in his ears. Then you made upon his head the figure of the demon known as Morail. (Each demon had a figure, an ideogram, as it were, and all of these were provided in the grimoire.)

Next, you buried the head faceup and for eight days watered it every morning, before the sun rose, with a very good brandy.

On the eighth day, the spirit would appear and ask, "What wilt thou?"

"I am watering my plant," you were supposed to reply. To which the spirit would answer, "Give me the bottle, I desire to water it myself."

At this juncture it was important not to hand over the brandy bottle, but to say no to the demon—even after he'd repeated his request. The next time he reached out his hand, he'd show you the same figure you'd drawn on the head—that's when you'd know you had the right demon. (There was always a danger that another demon might show up and try some mischief.) Once you'd determined that you had the one you wanted—Morail—you could give him the bottle, which he'd use to water the head, before taking his leave.

On the ninth day, you'd find that the beans were germinating. To see if they were now able to confer invisibility, all you had to do was put one in your mouth and look in the mirror—if you saw nothing there, you'd succeeded. You could try out each bean in the same way, using your own mouth or that of a child, and the ones that didn't work you were advised to bury again with the head.

If it wasn't invisibility, but riches, you were after, there was another formula to follow. To acquire gold or silver, you were instructed to find a mare in heat, then pull out a handful of its hair by the roots. (Then run for it.) Next, you were to tie the hairs into a knot and place them in a brand-new earthenware pot, filled almost to the brim with spring water. After putting the lid back on the pot, "place it where neither you nor anyone else can see it, for there is danger in this."

Nine days later, when you lift the lid, you will find a small, snakelike creature inside, which will leap up. Say to it, "I accept the pact." Without actually touching the creature, transfer it to a new box bought expressly for this purpose and feed it with wheat husks every day.

To get the gold and silver you require, you must put an equivalent amount into the box first. Put the box by the side of

your bed, sleep a few hours, and when you open the box again, you'll find double what you put in. Take out the newly minted stuff, but leave the original gold or silver inside.

Even so, according to the *True Grimoire,* there were limits you should observe. If the snake was fairly ordinary, you shouldn't ask for more than one hundred francs at a throw. If, however, the snake had a human face, it would be able to produce one thousand francs each time.

If you ever wanted to kill the creature off (though it's hard to imagine why you would), you had only to change its diet. Stop feeding it the wheat husks and feed it, instead, "some of the flour which has been used for the consecration in the first mass said by a priest." This will prove fatal every time.

Suppose it was love you sought. The *True Grimoire* included a spell "To Make a Girl come to You, however Modest she may Be." Whether it worked in reverse, on boys, is uncertain.

In any event, the first thing to do was to wait for the crescent moon and make sure you'd spotted a star between the hours of eleven and midnight. Taking a piece of virgin parchment, cut in a roughly circular shape, you were to write on one side of it the name of the person you wanted to come to you, and on the other side the words *Melchiael, Bareschas.* Place the parchment on the ground, with the name of the love object facing down, and put your right foot on it. Bend your left knee to the ground, and while looking up at the highest star in the sky and holding a candle of white wax (big enough to burn for a full hour), recite the spell written in the grimoire.

Although, like most spells, this one began with a fairly lengthy invocation to angels and planets and stars, it got down to business soon enough:

> I conjure you again, by all the Holy Names of God, so that you may send down power to oppress, torture and harass the body and soul and the five senses of [girl's name], she whose name is written here, so that she shall come unto me, and agree to my de-

sires, liking nobody in the world . . . for so long as she shall remain unmoved by me. Let her then be tortured, made to suffer. Go, then, at once! Go, Melchidael, Bareschas, Zazel, Firiel, Malcha, and all those who are with thee! I conjure you by the great Living God to obey my will, and I [your name here] promise to satisfy you.

After this tender and loving plea had been recited three times in its entirety, the candle was to be used to set fire to the parchment. The ashes were to be put in the conjurer's left shoe and kept there "until the person whom you have called comes to seek you out. In the Conjuration, you must say the date that she is to come, and she will not be absent."

The long-term prospects for such a relationship remain unclear.

If revenge against an enemy was your goal, your first stop was a cemetery, where you were instructed to remove the nails from an old coffin. As you did so, you were to say, "Nails, I take you, so that you may serve to turn aside and cause evil to all persons whom I will."

Nails in hand, your next stop was the road or street where your intended victim was known to walk. Once you'd seen him leave a footprint, you were ready to go: drawing in the dirt the figures of the three spirits Guland, Surgat, and Morail, you were to place the nail smack-dab in the center of the footprint, saying, *"Pater noster upto in terra."* Then, while driving the nail into the ground with a stone, utter the words "Cause evil to [X], until I remove thee."

After making a careful notation of where you'd hammered in the nail (because the only way to undo the spell, should you wish to, was to find and remove it), you were to conceal the spot with some dirt and dust. If all went as planned, you'd see your enemy start to suffer from one thing or another in short order.

If, after a while, you felt he'd been punished enough, you

could always cancel the curse by plucking the nail out, saying, "I remove thee, so that the evil which thou hast caused to [X] shall cease." Using whichever hand had not drawn them in the first place, you were then to rub away the characters of the three spirits you'd made in the dust. That done, the spell would be at an end.

After conducting many of these rituals, all that remained was to dismiss the infernal spirits who might still be hanging around, wondering what to do next. As they were known to be of a prickly nature, it was wise to dismiss them with care and solicitude. The *True Grimoire* advised the sorcerer to disperse them with the following formula: "Go in peace to your own place, and peace be with you, until I shall invoke you again. In the name of the Father and of the Son and of the Holy Spirit. Amen."

THE *LIBER SPIRITUUM*

*B*esides his grimoire, the sorcerer had another, handmade volume in his occult library, and this was called the *liber spirituum* (the book of spirits).

As would be expected, it was to be made only of virgin parchment, and the sorcerer was instructed to fashion it himself. On each left-hand page, he inscribed the name and seal of one of the spirits he was planning to conjure. On the right-hand page, he wrote the words of the incantation that would summon, and control, that same spirit. This information included the spirit's full name, its ranking in the spirit world, the particular areas over which the spirit held sway, and the times and places at which it could be most successfully invoked.

The object was to get each spirit first to manifest itself and then to autograph the book, as it were. Once a spirit had done that, it could be recalled whenever the magician wanted it. In *The Magus,* Francis Barrett included a specimen from a book of spirits, showing the demon Cassiel Macoton riding a dragon on

the left-hand page and the magician's invocation on the right: "I conjure thee, Cassiel, by all the names of the Most High Creator . . . that thou shalt hearken instantly unto my words and shalt obey them inviolably as the Judgments of the Last Day. . . ."

Once the magician had compiled his personal book of spirits, he had to consecrate it with a powerful, all-inclusive conjuration. In the *Grimoire of Honorius,* this conjuration was followed by a command, which began, "I conjure and I command you, O Spirits, however many of you may be, to agree to this Book with alacrity, in order that when we may read it, since it is acknowledged to be in order and potentised, you will be compelled to appear when you are commanded, in a proper and human shape, as the reader of the Book shall desire."

It went on to warn the spirits not to interfere with the body or soul of the magician, or to stir up any unnecessary storms or trouble. And if the spirits weren't able to fulfill their obligations for some reason—a prior commitment, possibly—then they were required to "send other spirits, who have been empowered to act for you, and they, too, shall swear equally to perform everything that the reader of the Book may command: you are all thus now compelled by the Holiest Names of the All-Puissant and Living God: Eloym, Jah, El, Eloy, Tetragrammaton!" There was even a final clause that threatened the spirits with "torture for a millennium" for any recalcitrance or unwillingnesss to perform the magician's will.

When all of this was done, the signs written, the conjurations made, the book was sealed, and only opened again when the magician was standing inside a pentagram or magic circle and protected from the demons the book would invoke. It was then that he recited the Conjuration of the Spirits, in which he called upon "all the Spirits of the Hells" to appear before him, place their marks upon the book, and do his bidding forever more.

THE UNHOLY PACT

\mathcal{W}ithout a doubt, the sorcerer's trade was a dangerous one; dealing with demons was like juggling hand grenades that could explode any moment. But the most dangerous element of all was the black, or unholy, pact that many demons insisted the sorcerer sign before they would do his bidding. Although the terms and wording varied, the general agreement was that the demon would deliver the goods—riches, women, forbidden knowledge—for a period of time (usually twenty years) but that at the end of that period the demon would claim, in return, the soul of the sorcerer for all eternity. Hard as that bargain seems, many a wizard apparently agreed to it.

In a grimoire known as *Le Dragon rouge* (which was largely based on the two Keys of Solomon), the contract was offered in the following form:

> Emperor Lucifer, master of all the rebellious spirits, I beseech thee be favorable to me in the calling which I make upon thy great minister Lucifuge Rofocale, having desire to make a pact with him. I pray thee also, Prince Beelzebub, to protect me in my undertaking. O Count Ashtoreth! be propitious to me, and cause that this night the great Lucifuge appear unto me in human form and without any evil smell, and that he grant me, by means of the pact which I shall deliver to him, all the riches of which I have need. O great Lucifuge, I beseech thee leave thy dwelling, in whatever part of the world it may be, to come and speak with me; if not, I will thereto compel thee by the power of the mighty words of the great Clavicule of Solomon, whereof he made use to force the rebellious spirits to accept his pact. Appear, then,

instantly, or I will continually torment thee by the mighty words of the Clavicule.

Done right, this will bring the demon calling. But he will assent to the sorcerer's demands only "on condition thou give me thyself at the end of twenty years, so that I do with thee, body and soul, what shall please me."

Now, you'd think that this would be the moment the sorcerer would rethink the whole deal. Twenty years of great living in exchange for an eternity of pain? But many sorcerers believed they could have their cake and eat it, too—that they could sign the bargain, then wriggle out of it later. Assuming he was thinking this way, the sorcerer would scrawl on a piece of virgin parchment, in his own blood, the words "I promise great Lucifuge to repay him in twenty years for all he shall give me. In witness whereof I have signed," followed by the sorcerer's name.

The sorcerer, still enclosed in the magic circle or pentagram, would then toss the parchment to the waiting demon, who'd look it over for loopholes. If he was satisfied with it, he'd take it back with him to Hell and file it in the archives. It's for this reason that so few of these actual documents have ever been found—that, and the fact that if such a written pact had ever been discovered by the church authorities, the sorcerer who'd signed it would have been in for some very big trouble right here on earth. Making deals with the Devil was heresy at its worst, a renunciation of God, the Virgin Mary, the saints, the church, the whole shebang. This was not the kind of contract you ever left lying around the house.

One of the few such documents that do exist, now housed in the Bibliothèque Nationale of France, claims to be the pact that Urbain Grandier made with the Devil in 1634. Grandier, a powerful priest known for his oratory, arrogance, and vanity, was accused of having bewitched the Convent of the Ursulines in Loudun; the nuns showed harrowing signs of demonic possession, and in court twelve of them gave the names of the

demons by whom they claimed to be possessed. Their testimony was corroborated by a sheet of parchment on which Grandier had supposedly written his vow in a clear hand:

> My Lord and Master, I own you for my God; I promise to serve you while I live, and from this hour I renounce all other Gods and Jesus Christ and Mary and all the Saints of Heaven and the Catholic, Apostolic, and Roman Church, and all the good will thereof and the prayers which might be made for me. I promise to adore you and do you homage at least three times a day and to do the most evil that I can and to lead into evil as many persons as shall be possible to me, and heartily I renounce the Chrism, Baptism, and all the merits of Jesus Christ; and, in case I should desire to change, I give you my body and soul, and my life as holding it from you, having dedicated it for ever without any will to repent. Signed Urbain Grandier in his blood.

After a good deal of torture, Grandier was taken on a stretcher to the public square—his legs had been broken by his inquisitors—and burned at the stake. According to a monk who was present at the execution, a big black fly buzzed around and around Grandier's head. In the monk's opinion, this droning insect was in actuality the devil Beelzebub, Lord of the Flies, there to make sure the pact was observed and to carry Grandier's soul off to Hell.

From the moment a deal with the Devil was signed, both participants kept a close eye on each other—the Devil knew that the sorcerer would be trying to renege on the deal somehow, and the sorcerer knew that the Devil would be hovering nearby to make sure his prey didn't escape. By one account, the two black dogs who accompanied the magician Agrippa von Nettesheim everywhere he went were in fact demons, keeping track of his whereabouts. The French historian Palma Cayet

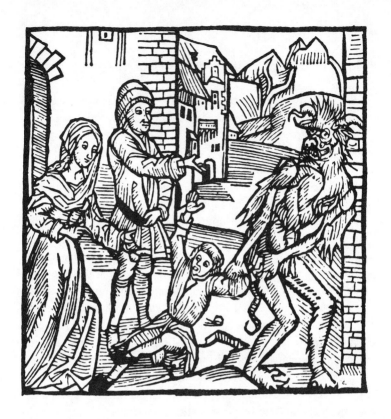

had purportedly signed a pact that guaranteed he would emerge victorious in all his disputes with Protestants; the contract was reportedly found after he died, and although there was a public funeral, rumor had it that the coffin had been filled with rocks. Demons, it was believed, had already made off with his body.

Le Dragon rouge even includes a prayer, which serves as a kind of insurance policy. Right after making his unholy pact, the sorcerer was advised to declare (out of the demon's earshot, of course), "Inspire me, O great god, with all the sentiments necessary for enabling me to escape the claws of the Demon and of all evil spirits!" How well this prayer worked, however, was up for debate.

THE OCCULT PHILOSOPHY

*O*f the many tomes published over the centuries purporting to explain the workings of the unseen world, the three-volume *De Occulta Philosophia,* or *The Occult Philosophy,* was one of the most important and, in its own way, authoritative. Written in 1510 by the sorcerer best known as Agrippa von Nettesheim, it wasn't published until 1531—and even then it brought the author far more trouble than praise.

Though Agrippa had only been in his early twenties when he wrote it, *The Occult Philosophy* was a mature compendium of magical practice and theory. A brilliant young scholar born in Cologne in 1486, Agrippa started out by studying the approved subjects, such as Greek philosophy and Latin, but his interests were far-ranging, and his natural inclination was toward the mysterious and undiscovered. Like many a young man, he wanted to make his mark in the world, and in the arena of the occult, where everything from theology to alchemy met and mingled, he thought he'd found it.

Despite its increasingly bad reputation, magic, Agrippa declared, had nothing to do with demons and devils; it wasn't a means to do evil or to invert the natural order. If anything, Agrippa argued in his book, magic was a way to understand the cosmos, as God had created it, and by extension to understand God himself. Man, he contended, "is the most express image of God, seeing man containeth in himself all things which are in God. . . . Whosoever therefore shall know himself, shall know all things in himself; especially, he shall know God, according to whose Image he was made."

The occult, in Agrippa's view, was a science all its own, using the more traditional branches of knowledge in a new and different fashion. It employed physics, as it was then understood, to study the nature of things; mathematics to plot the movements of the planets and stars; theology to cast a light on the human soul and on the spiritual world inhabited by angels and demons.

Furthermore, Agrippa believed that all things, animate or not, had a soul, or spiritual essence, and that all of these souls, such as they were, contributed to one vast oversoul. This, he believed, explained the miraculous properties he attributed to everything from garden herbs to precious stones; they contained powers that, however dormant, could be called forth and put to use by a sufficiently skilled magician. There were correspondences and harmonies between all sorts of things, which, if properly understood, could solve a whole host of problems and cure almost any illness.

For instance, a woman who did not wish to become pregnant could prevent it by drinking a dose of mule urine every month. (Mules are sterile.)

A man who wanted to become invisible could wear the stone known as heliotrope, as it reputedly conferred that power.

Anyone suffering from a loss of sight was advised to procure a frog's eye, as frogs have big eyes and can see even in the dark.

Everything from the constellations to the commonest lump of coal was bound up in Agrippa's great scheme: "The stars consist equally of the elements of the earthly bodies and therefore the ideas (powers and nature) attract each other. Influences only go forth through the help of the spirit but this spirit is diffused through the whole universe and is in full accord with the human spirit. Through the sympathy of similar and the antipathy of dissimilar things, all creation hangs together; the things of a particular world within itself, as well as the congenial things of another world."

It was up to the magus to comprehend, interpret, and manipulate this fantastically complicated web of life.

AGRIPPA THE MAGICIAN

For all his protestations to the contrary, Agrippa managed to cultivate a pretty fair reputation for black magic and sorcery. Although he claimed to be firmly on the side of the angels, throughout his lifetime he was dogged by reports that he had

consorted with demons and used his powers for nefarious purposes—reports he didn't go too far out of his way to quash. Some of these stories were later recycled by Goethe and attributed to his title character Faust.

At many inns where Agrippa stayed, for instance, there were stories that he had paid his bill in perfectly good coins, which, once he'd checked out, turned to worthless shells.

There was the magic mirror in which Agrippa could conjure up images and visions. The lonely Lord Surrey, it was said, had seen his lovely mistress, Geraldine, pining for him in this looking glass.

And then there were all the reports that Agrippa had had contact with the dead; to please a crowd gathered by the elector of Saxony, he summoned the shade of the great orator Cicero, whose eloquence moved the members of the rapt audience to tears.

He was also capable, it was said, of divination. By spinning a sieve on top of a pivot, he could ferret out guilt: Agrippa claimed to have used this method three times in his youth. "The first time," he wrote, "was on the occasion of a theft that had been committed; the second on account of certain nets or snares of mine used for catching birds, which had been destroyed by some envious one; and the third time in order to find a lost dog which belonged to me and by which I set great store." Although the system worked perfectly all three times, he claimed that he had given it up, anyway, "for fear lest the demon should entangle me in his snares."

This wouldn't be the only time Agrippa reputedly stepped back from the brink. Everywhere he went, for instance, he was accompanied by a big black dog (in some accounts, two), which many claimed was his familiar (unholy helper). As legend has it, one day Agrippa decided he had fallen too deeply into the clutches of the Devil, and he ordered the demon dog to leave his side then and there. The dog, obedient to the last, ran downhill to the river Saône, hurled itself in, and disappeared.

But the most famous story involved Agrippa's student lodger, who waited until Agrippa went out one day, then weedled the key to his workroom out of his unsuspecting wife. The

student couldn't wait to sit down at Agrippa's desk and pore over the books of magic lying open all around. He was in the middle of one, reading the passages under his breath, when there was a knock at the door. The student didn't answer, the knock came again—and the door was opened by a demon. "Why have you summoned me?" the demon asked, and when the terrified student couldn't come up with an answer, the demon, furious at being called up for no purpose, and by a rank amateur to boot, leapt on the student and choked him to death.

When Agrippa got back and found the body, he was immediately afraid that the murder would be pinned on him. But it didn't take him long to figure out who'd really done it. He summoned the same demon to return to the study—only this time, the demon was given explicit orders by a master magician; he was told, in short, to revive the student and walk him up and down the town market for a short while, long enough for everyone to see him hale and hearty. The demon did it, then allowed the boy to fall over dead of an apparent heart attack. It was only on closer inspection of the body that the strangulation signs were seen. The people, in an outrage, chased Agrippa out of town.

MAGIC CANDLES, MAGIC HANDS

Although sorcerers all had their own favorite magical devices, there were a couple of items that were something like staples of their art. If they couldn't manufacture these, they could hardly be expected to perform the more elaborate feats.

One such standard was the Magic Candle, which was used to uncover hidden treasure. A recipe for making the candle was included in a book called *Secrets merveilleux de la magie naturelle et cabalistique du Petit Albert*, published in Cologne in 1722. (The book, quite popular with the sorcery crowd, was usually referred to as simply *Le Petit Albert*.) The candle was to be made of human tallow and wedged upright in a curved piece of hazel wood. (A diagram was included in the book.) If you then took

the candle underground and lighted it there—presumably in a cave, burial vault, castle keep—it would sputter noisily and throw off a bright light whenever treasure happened to be buried nearby. The closer you got to the secret cache, the brighter the candle would burn; when you got right up to it, however, the candle would suddenly go out. That's when you knew it was time to start digging.

But there were some precautions to take. For one thing, it went without saying—though *Le Petit Albert* said it—you should keep several other candles or lanterns burning at all times so that you weren't suddenly pitched into the dark. More important, if you thought there might be a chance the treasure was being guarded by the souls of the dead, these extra candles had to be made of wax alone and blessed. If you did run into some guardian spirits, it was wise to ask them if there was anything you could do "to help them to a place of untroubled rest." Whatever they asked you to do, you were advised to do it, without fail.

The Magic Candle usually had a companion piece in something called the Hand of Glory; together, they often occupied pride of place on a sorcerer's mantel. But the Hand was used for far more nefarious purposes, as is evident from its preparation alone. The first thing you had to do was go to a gallows near a highway and cut off the hand—either one would do—of a hanged felon. Using a strip of the burial shroud to wring it dry of any remaining blood, you then put the hand into an earthenware pot, filled with a concoction of herbs and spices, and left it to marinate for two weeks. The next step was to take it out and expose it to bright sunlight until it was good and dry. If the weather wasn't cooperating, it was permissible to heat it up in an oven, along with fern and vervain.

What you had now was the perfect, if somewhat grisly, candlestick: if you stuck into it a candle made from the fat of a hanged man, mixed with virgin wax, sesame, and ponie (ponie is an obscure term, but it probably referred to horse dung), you could cast a spell over the inhabitants of any house you chose, rendering them motionless and insensible. The advantages to

this—burglary chief among them—are pretty clear. For as long as the candle burned outside their house, the residents would be powerless to protect themselves or their possessions.

According to one account, from the sixteenth-century demonologist Martin del Rio, a thief once lit the Hand of Glory outside a family's home, but he was observed by a servant girl. While he was busy ransacking the house, she was desperately trying to put out the candle. First she tried blowing it out, to no avail. Then she doused it with water, which didn't work; then she tried beer, which also didn't work. Milk, for unknown reasons, did. The moment the candle was extinguished, the family awoke and caught the thief red-handed; the maid was, of course, rewarded for her bravery and quick thinking.

There was, however, a kind of home security system you could install to ward off anyone using the Hand of Glory. During the dog days of summer (generally reckoned from July 3 to August 11), you had only to prepare an unguent from three ingredients—the gall of a black cat, the blood of a screech owl, and the fat of a white hen—and then smear it over the thresholds, window frames, chimney stack, and any other place that someone might use to get into the house. Once the unguent was down, the house was impenetrable to anyone attempting to use the Hand of Glory.

CURSES AND INCANTATIONS

The resourceful sorcerer always had at hand a variety of spells, culled from his manuals and his own experiments, with which he could achieve his desired aims. Sometimes these aims were indeed diabolical—raising the dead, conjuring demons—but sometimes they were more mundane, such as predicting a needed change in the weather or helping a ''client'' to find a lost object. Selling their services, sorcerers could be called upon to inflict a curse or remove one, to do evil or ward it off. In a way, they were something like brokers, making money off the transaction whichever way it went. An unscrupulous sorcerer

(never very hard to find) could even cast a curse on someone, rendering him impotent or his fields barren or his prospects ruined, and then offer to put things right again—for a fee.

It might be thought of as an early form of the protection racket.

If someone was truly unlucky, he might find himself caught between two *competing* sorcerers, one laying a curse on him and the other trying to get it off. Setting things straight could cost the patient a pretty penny.

And then, on occasion, sorcerers found themselves in direct conflict with each other, testing their powers against a member of their own secret fraternity. In a celebrated case recounted by Olaus Magnus in his *Historia de Gentibus Septentrionalibus* (1555), a magician named Gilbert challenged his master, a powerful sorcerer named Catillum, who responded by imprisoning Gilbert in an underground cavern, where he was "shackled by two wooden bars inscribed with certain Gothic and runic characters in such manner that he could not move his limbs." According to the legend, Gilbert would remain a prisoner there until another sorcerer, one even more powerful than Catillum, could break the spell.

Sorcerers also tended to specialize, to some extent based on where they lived. Those who lived near the sea, for instance, were often called on to do something about things like winds and currents. They were asked to speed some ships on their way, and sink others, to stir up tempests or calm the turbulent waves. In seafaring nations, particularly the Scandinavian countries, sorcerers did a lively trade selling favorable winds; it was thought possible, for example, to tie up the winds in a knotted rope. A ship's captain could buy such a rope, and when he needed a gentle west-southwesterly breeze, he had only to undo the top knot; for a strong northerly wind, the second; for a terrible storm, the third. (That third knot, presumably, was seldom untied.) In Scotland, the wives of sailors thought they could conjure up favorable winds on their own; stealing into a chapel after the regular service had been performed, they blew the dust on

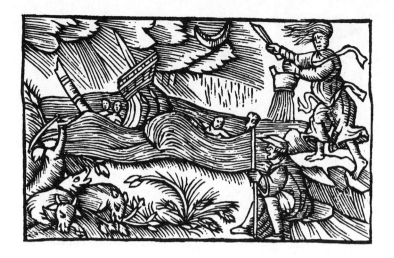

the floor in the direction that their husbands' ships were traveling.

Magicians who lived inland were called on to do everything from improving the crops to sweetening the milk of the herdsman's cows. In times of plague, they could be accused of having caused the epidemic—or they could be begged to eradicate it. In times of war, they could be asked to inflict curses on the enemy—or heal the wounds of their compatriots. Sorcerers were thought capable of stanching the flow of blood from a wound or magically removing a bullet or arrowhead. They could start a fire, and they could put one out. They could be, at once, the most dreaded foe or most prized ally. To stay on the safe side, it was always wise to give them a wide berth and a polite tip of the hat.

Especially as they often had unpleasant friends that they could call upon.

Thomas Aquinas, in his *Sententiae*, declared in no uncertain terms that "magicians perform miracles through personal contracts made with demons." If that wasn't clear enough, Ebenezer Sibly, author of *The New and Complete Illustration of the Occult Sciences* (1787), warned his own readers that while sor-

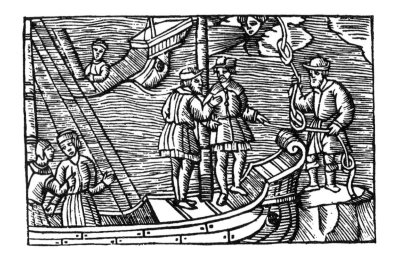

cerers and witches could call upon all sorts of spirits and apparitions, there were three types in particular that were most likely to do the magicians' bidding.

First, according to Sibly, there were the astral spirits, who haunted mountaintops and deep, dark forests, ancient ruins, and any spot where someone had been killed. Then there were the igneous spirits, of a "middle vegetative nature," but "obsequious to the kingdom of darkness." These monstrous creatures, with a naturally nasty turn of mind, were particularly receptive to skillful conjurers. Last, there were the terrine spirits, who seemed to have an innate hatred of mankind. Maybe it was because of where they lived. Confined to the "hiatus or chasms of the earth," caves and mines and tunnels, they were simply chafing at the bit to cut loose and create some real mayhem. Some of their attacks were recorded in a treatise entitled *De Animantibus Subterraneis* (On Subterranean Hauntings) in 1549 by a German metallurgist named Georgius Agricola.

According to Agricola, the workers in a mine called the Rosy Crown, in the district of Saxony, were suddenly surprised by a dreadful apparition, a "Spirit in the similitude and likeness of a horse, snorting and snuffling most fiendishly with a pestilent blast." Its breath was so noxious that a dozen miners died on

De lanijs et phitonicis mu=

licribus ad illuſtriſſimum principem dominũ Sigiſmũdum
archiducem auſtrie tractạtus pulcherrimus

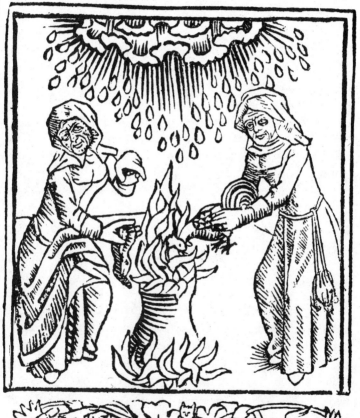

the spot, while the others scrambled up to safety, screaming in terror. And despite the fact that the mine was rich with ore, no one would ever go back down again to dig it. In Schneeberg, Saxony, the mine of St. George was also haunted by a terrine spirit, but this one took the shape of a man in a big, black cowl. When the miners encountered him, he grabbed hold of one of them and hurled him at the roof of the mine. By the time he came down, bruised and battered, the others had already taken their leave.

But all of these spirits, in the view of Sibly, existed in a state of "continual horror and despair" themselves. "That they are materially vexed and scorched in flames of fire," Sibly wrote, "is only a figurative idea, adapted to our external senses, for their substance is spiritual, and their essence too subtle for any external torment. The endless source of all their misery is in themselves, and stands continually before them, so that they can never enjoy any rest, being absent from the presence of God; which torment is greater to them than all the tortures of this world combined together."

The conjurers who called upon them, for whatever purpose, ran the risk of sharing their fate.

LOVE AND DEATH

*H*uman nature being what it is, there were two areas that the sorcerer was most often called on to explore—one was love, the other death. And he had at his disposal a whole raft of potions and philters, talismans and incantations.

When it came to winning a woman's love, there were easy methods—and there were hard. Among the easier ways of winning her heart, there was what might be called the horoscope ploy. As outlined in an eighteenth-century French manuscript now in the Bibliothèque de l'Arsenal, "To gain the love of a girl or a woman, you must pretend to cast her horoscope—that is to say, when she shall be married—and must make her look right into your eyes. When you are both in the same position

you are to repeat the words, 'Kafe, Kasita non Kafela et publia filii omnibus suis.' These words said, you may command the female and she will obey you in all you desire."

Want something even easier? Rub the juice of the vervain plant on your hands, then touch the one you love.

Or try touching her hand while saying, *"Bestarberto corrumpit viscera ejus mulieris"* ("Bestarberto entices the inward parts of the woman").

If the simpler methods aren't working, you can always resort to a philter, a love-inducing potion made from wine mixed with assorted herbs and drugs. In the tragedy of Tristan and Iseult, a philter that Iseult's mother had planned for King Mark to drink is actually consumed by Tristan and Iseult—who wind up paying for the mistake with their lives. In Richard Wagner's *Gotterdämmerung,* Siegfried's affections are diverted from Brünnhilde to Gutrune after he quaffs a magic philter. The recipe for such a philter is included in a seventeenth-century manuscript called the *Zekerboni,* written by a self-styled "Cabbalistic philosopher" named Pietro Mora: it requires "the heart of a dove, the liver of a sparrow, the womb of a swallow, the kidney of a hare," all reduced to an "impalpable powder," and added to an equal portion of the manufacturer's own blood. The blood, too, must be dried to a powder. If a dose of this concoction is then slipped into the intended's wine, "marvellous success will follow."

A simpler, though no less revolting, recipe is offered by Albertus Magnus in his "Of the Vertues of Hearbes." After taking some leaves of the periwinkle and mashing them into a powder with "wormes of the earth," add a dash of the succulent commonly known as houseleek. Use the result as a sort of condiment with the meat course and then just watch the sparks fly.

The plant kingdom actually yielded any number of aphrodisiacs, which included lettuce, jasmine, endive, purslane, coriander, pansy, cyclamen, and laurel. The ancient Greeks included carrots, perhaps because of their shape. The poppy and deadly nightshade plants were also thought helpful in the quest of love, but less because they inspired ardor than because they could render someone unconscious and therefore vulnerable.

In the Middle Ages, the mirror method was recommended to many a lovesick swain. The idea was to create in the looking glass itself a kind of link between yourself (the owner of the mirror), the woman you desired, and the act of making love. How did you do this? Simple.

First you bought a small mirror (without haggling over the price), and you wrote the woman's name on the back of the glass three times.

Then you went out looking for a pair of copulating dogs and held the mirror in such a way that it would capture their reflection.

Finally, you hid the mirror in some spot you were sure the woman would be passing frequently and left it there for nine days. After that, you could pick it up again and carry it in your pocket. Without knowing why, the woman would find herself irresistibly attracted to you.

Conversely, if a woman had her eye on an elusive male, she could win his love by serving him, as it were, a casserole of herself. First, she had to take a very hot bath and then, as soon as she got out, cover herself with flour. When the flour had soaked up all the moisture, she took a white linen cloth and wiped all the flour away; then she wrung out the cloth over a baking dish. She cut her fingernails and toenails, plucked a few stray hairs from all parts of her body, burned them all to a powder, then added them to the dish. Stirring in one egg, she baked the whole awful concoction in the oven, and served it to the object of her affections. Assuming he could get a mouthful down, he'd be hers forever.

Casting a death spell was, for obvious reasons, a more dangerous matter than magical matchmaking. If you tried it, and were found out, the penalty could be your own life. As a result, the death spells were often reserved for very high-stakes games—most notably, royal thrones and titles. If you were a king or queen, chances are there was some malcontent in your kingdom casting a death spell your way.

In 1574, Cosmo Ruggieri, a Florentine astrologer at the

French court of Charles IX, was accused of having created a waxen image of the king and then beating it on the head. He then made the mistake of asking around if the king was having any pains in his head of late—and was quickly placed under arrest. (It didn't help that the king died that same year.)

In 1333, Robert III of Artois was banished from France by Philippe VI for forging land deeds to support his claim to the title of count; in revenge, Robert tried to cast a death spell on the French king, but his plot was revealed to the king by Robert's priestly confessor.

And around 1560, the Privy Council of England was thrown into a panic when a waxen image of Queen Elizabeth, with a long needle stuck through its heart, was discovered in Lincoln's Inn Fields. Her advisers quickly called in Dr. John Dee for an immediate consultation with the young queen, who was dreadfully worried. Dee met with her in her private garden in Richmond, explained the mechanics of the death spell, and reassured her that it could be counteracted. As she reigned until 1603, he clearly did a good job of it.

Although there were plenty of methods for casting the death spell, the waxen image was one of the oldest and most popular. A little wax doll was made, representing the person on whom you wished to inflict the harm, which was then pierced with needles to inflict, by magical transmission, actual physical damage or death. If possible, it was a good idea to dress the figure up in the style of the intended victim; in a French engraving, Robert of Artois has dressed his figure of the king in the appropriate court costume.

An alternative to the waxen doll was an actual human heart. With the right incantations said over it, this inert heart could serve as an occult substitute for the one still beating in the victim's chest. Again, a needle or two in the right place, according to the lore, could dispatch your foe.

For skilled sorcerers who wanted to enlist a demon to do their dirty work, there was a specific ritual to perform, known as the Ceremony of Mars. Mars, it will be recalled, was the god of violence and war; the planet named after him is called the

red planet. To start the ceremony, the sorcerer draped the whole room in red and put on red robes to match; on his finger he wore a gleaming ruby. The instruments he used were made of iron, the wand he wielded was an unsheathed sword. Conjuring Asmodeus, "the arch-devil of the Fifth Infernal Habitation," the sorcerer offered himself as a conduit for the malignant force of the demon, which he would then direct on toward the intended victim.

To make sure of his aim, however, the magician needed some link with the victim—some of his nail parings, an article of his clothing, the pipe he smoked. If he couldn't lay his hands on any such item, he could resort to two alternatives. One method was to channel his lethal thoughts toward an object he'd left in the victim's house or buried in a spot where he knew the victim would be stepping over it; the other was to make his own artificial connection to the victim by formally identifying something with him, before inflicting harm on it. Usually, this sad duty fell to an animal, which would be baptized with the victim's name, then tortured or slain.

If a sorcerer had sufficient powers of imagination, he could even conjure up an elemental spirit of his own, to go forth and do his bidding. Elementals were minor spirits of fire, earth, air, and water, thought to exist invisibly all around us. By creating one of his own, which would hold only a temporary lease on life, the sorcerer got himself the perfect accomplice—one that ceased to exist once the job was done. Sometimes these creatures manifested themselves in animal form, as wolves or snakes or toads, and sometimes they appeared as half-human, half-animal. Either way, they could only be seen by those who were being attacked or by someone with great psychic gifts (such as the sorcerer).

Signs of such an attack included dread and anxiety, not to mention more visible tokens, such as a thick, foul-smelling slime, and bruises that took the shape of goat's hooves or the ace of clubs. Sometimes an "astral bell," which rang clearly, or almost inaudibly clicked, could be heard when the spirit was on the prowl. Francesco-Maria Guazzo, the Italian friar who wrote

the *Compendium Maleficarum* in 1608, listed other symptoms of such an attack as mental lassitude, pricking pains in the chest, convulsions, fever, inexplicable sweating, and sexual impotence. The skin, he stated, could take on a yellowish cast, and the victim could find himself unable to look a priest in the eye; confronted with his tormentor, "the patient is at once affected with great uneasiness and seized with terror and trembling," Guazzo wrote. "If it is a child, it cries."

In one such case of psychic malevolence, in the English town of York in 1538, the perpetrator, Mabel Brigge, was hauled into court under suspicion of having made an occult attempt on the life of King Henry VIII. She was accused of having performed a ritual known as the Black Fast; while concentrating all her mental powers on his demise, she herself had abstained from eating any meat, milk, or dairy foods. While in court, she admitted to having earlier "fasted upon" a thief, who had broken his neck while her spell was in effect. Convicted of witchcraft, she was summarily executed.

And lest anyone think such powers have been dismissed in our own century, British witches in 1940 reportedly focused their psychic powers on Adolf Hitler, in this case to convince him that he could not bring his armies across the English Channel. In view of the fact that he never did, maybe the witches were onto something.

THE EVIL EYE

In Italy, it's known as *malocchio,* in Germany the *böser Blick,* in France the *mauvais oeil.* In Scotland, it was thought that a glance from the evil eye could sicken cattle; in England, it was considered capable of killing a person. Among colonial Americans, the evil eye was sometimes thought to be at the bottom of everything from soured milk to butter that turned in the churn. No matter how far back in history we go—to the ancient Mesopotamians or the Greek Pliny, who described the basilisk whose gaze was so terrible that it could die if it saw its own

reflection—the eye has been considered much more than the mere organ of sight. Likened by the Egyptians to the sun itself, the eye has been considered a powerful source and repository of energy, will, and desire, capable of kindling love on the one hand and wreaking havoc on the other. But the evil eye has been something always to be feared.

Who had the evil eye? Who could, with a glance, project calamity or misfortune on another? There were many, some who came by the "talent" inadvertently, and some who practiced it with magical intent. Among those who were supposed to have been born with it were people whose eyebrows met over their nose or who were blind in one eye; those who were hunchbacks or dwarfs; those whose eyes were crossed or divergent, of different colors, or situated unevenly in their face. Gypsies were thought to be naturals at it. Among the ones who had to *learn* the malignant trick were witches, sorcerers, and magicians.

What could the evil eye do? Depending on the country and its particular customs, the evil eye could affect anything from childbirth to the crops in the field. It could cause such minor irritations as hiccups and headaches, along with major diseases that would lead a person to waste away and die. Sexual afflictions, such as impotence and frigidity, were routinely ascribed to having been "overlooked," another way of describing the evil eye, and during childbirth the woman's house would be sprinkled with urine as a preventive measure.

During the sixteenth and seventeenth centuries, when the witch craze was sweeping Europe, the evil eye was a charge often leveled at the unfortunates on trial. It was generally believed that when a witch made her compact with Satan, in return for doing his bidding on earth she received, along with other favors, the ability to cast spells with her eyes. According to the *Malleus Maleficarum,* the witchcraft manual compiled by two Dominican friars (and containing instructions on the torture, interrogation, and execution of the accused), "there are witches who can bewitch their judges by a mere look or glance from their eyes, and publicly boast that they cannot be punished." As a

result, many of the people charged with witchcraft were led into the courtroom backward.

Theoretically, the evil eye had its most devastating power when it first landed on the object of its intent. In other words, if you could avert a direct gaze for an instant, you could deflect its power; for that reason, people in some parts of Europe wore amulets, in the shape of a toad or a hunchback, which were thought to soak up some of the venom. In ancient Greece, they wore talismans of Medusa or the caduceus of the god Mercury; Romans wore beads made to look like a human eye or gold, silver, or bronze phalli (symbolic of the life force). Even such seemingly harmless customs as wearing a bridal veil and a boutonniere can be traced back to the belief in the evil eye: by wearing the veil, a bride is protected from the envious gaze of any ill-wisher, while the colorful flower in a man's lapel will surely draw any eye first to the blossom instead of the face of the man wearing it.

But there were other ways, too, to ward off the evil eye. Spitting three times was a good precaution, as was carrying salt, a symbol of life and purification, in the pocket. Touching iron or carrying iron keys was recommended, as iron was credited with supernatural powers. The color red was useful, too: in England, homeowners sometimes nailed a red ribbon over the door, and in Scotland, farmers tied a red ribbon to the tails of their cattle.

A couple of hand gestures were popular remedies, too: one, called the *mano fica* (roughly translated, the "poking hand"), was made by inserting the thumb between the first and second fingers while making a fist; the other, the *mano cornuta* ("making the Devil's horns") involved holding down the two middle fingers with the thumb while sticking up the index and little fingers. Parents could protect their children by making the sign of the cross with their tongues on the children's foreheads or by tying little bells around their necks; the jingling of the bells was a sign of good luck. By one account, a Yorkshireman who was burdened with the unwanted power to throw the evil eye was very careful, first thing every morning, to look out the window at a pear tree in the yard. That first look of the day is considered the

most lethal, and though the pear tree withered and died, his friends and family were spared the deadly rays.

THE BLACK MASS

𝒯he Mass, the sharing of the holy sacraments with the Christian faithful, is a ritual of such significance and power, its every element, from the words to the wine, so infused with meaning, that it would be surprising if it had not been altered or desecrated for occult and unworthy purposes.

And, of course, it has.

The Black Mass, the unholy parody of the Christian ritual, has been used for centuries by witches and sorcerers, to invoke not God, but Satan, to promote not good, but evil, and to achieve not sacred goals, but profane ones. Among these unholy aims, undoubtedly the worst has been the actual killing of another person. As early as the seventh century, there are records of the Mass being used to curse a living soul. *"Requiem aeternam dona ei, Domine"* ("Give him eternal rest, O Lord") was a chant meant to be recited only for the souls of the dead, but the Council of Toledo, meeting in 694, determined that priests had sometimes recited it for the living, too. Done this way, it amounted not to a prayer, but a death sentence. One particular priest, and the man who had paid him to perform the perverted Mass, were both banished for their sacrilege.

Nor was this the only such incident on record. On occasion, priests were said to fashion wax dolls of their intended victims, then lay them on the altar and curse them. In the thirteenth century, Giraldus Cambrensis asserted that there were corrupted priests who made a practice of reciting the Mass for the dead ten times, on the theory that their living victim would die on the tenth day or shortly thereafter. And in 1500, the bishop of Cambrai made an appeal to the University of Paris, arguing that his underlings were casting spells at him. According to the unhappy bishop, his dean and canons were inserting into the Mass condemnatory passages lifted from the Old Testament; furthermore,

these passages were recited by the priest with his back to the altar, the choir singing in response. The university judges sided with the bishop.

One unholy rite, which came to be known as the Mass of St. Sécaire, originated in Gascony. The priest who wished to perform it had first to find an abandoned church that had fallen into disrepair and disuse. With a female server, one with whom he had pointedly broken his vow of chastity, he recited the Christian Mass—replacing the usual host, however, with a black, triangular host, and the consecrated wine with water drawn from a well in which an unbaptized infant had been drowned. The person against whom this Black Mass was directed would, according to the lore, die a slow and lingering death.

But if there was any one time, and any one place, at which elements of the Mass were routinely diverted toward evil aims, it was at the communal festivities known as the witches' Sabbat. The Sabbats were held in forest glens and on mountaintops, in hidden valleys and at deserted crossroads. Witches gathered in these secret places to celebrate their victories, to swap trade secrets, to initiate new members, and to pledge their allegiance once more to their leader and Lord, Satan himself. It was Satan, or whatever emissary he sent, who presided over the unholy Mass.

With a devil behind the altar, everything was done, as might be expected, in an unnatural fashion. The wine in the chalice was replaced with water, urine, or the blood of a sacrificed child; the host was replaced by a blackened turnip. The words of the ceremony were purposely altered, so that "Our Father, which art in heaven" became, for instance, "Our Father, which *wert* in heaven." Where Christians prayed, "Lead us not into temptation," Satan's followers prayed that they *would* be led there. The Confiteor (confession of sins) was omitted from the ceremony, as it would be too much like bragging, and so was the Alleluia, a chorus of praise to the Christian God that the Satanists, of course, had renounced. Such prayers as were offered were invariably vile and offensive; one, which was made after the sacrifice of a lamb, went, "Lamb, which the priests of Adonai

have made a symbol of sterility raised to the rank of a virtue, I sacrifice you to Lucifer. May the peace of Satan always be with you."

The altar, too, was designed to be an abomination. Sometimes it was adorned with a naked woman; sometimes a naked woman, down on all fours, served as the altar itself. The demon or sorcerer officiating at the Mass wore a chasuble (the sleeveless outer robe) much like the one a priest wore, but this one might be bright red, with a green patch depicting a weasel and bear consuming the host, or on the back a picture of a black goat with shining silver horns.

In sum, at every step of the Sabbat Mass the most objectionable or sacrilegious substitutes for the Christian words or symbols were employed, with one purpose in mind: to refute the traditional Mass while at the same time converting its undeniable power to the glorification of the dark side.

BELL, BOOK, AND CANDLE

𝒜s much as possible, sorcery and witchcraft were conducted in the strictest secrecy—in part because they were unholy rites, in part because they unleashed such unpredictable forces, and in part because the civil and ecclesiastical penalties were so extreme. Torture was common, and a capital sentence almost a foregone conclusion.

The ingenuity of witch judges and Inquisition officials in inflicting pain was quite remarkable—they invented a whole array of instruments and techniques to cause unbearable agony and elicit the wanted information. When in 1611 Father Louis Gaufridi was accused of having bewitched and seduced a nun in Aix-en-Provence, he was subjected to several forms of torture, including two of the most horrible.

First, he suffered the strappado: his arms were tied behind his back and then hooked to a hoist which was used to lift him high off the floor; hanging in agony, he had weights tied to his feet to intensify the pain. Then the torturers proceeded to the

squassation, dropping him suddenly, then pulling up on the rope just before his feet touched the ground. Done right, squassation could wrench out of place every joint in the body.

The tortures worked so well on Gaufridi that, although he had repeatedly proclaimed his innocence, in the end he signed a confession that included not only the original charges—"More than a thousand persons have been poisoned by the irresistible attraction of my breath which filled them with passion"—but additional crimes, such as eating babies and celebrating the Black Mass. As a final mercy, and because he had begged the pardon of God, he was strangled before his body was burned over a slow fire.

The tortures had to be designed to do two things, really: to inflict great pain while at the same time preserving the life of the victim long enough to ensure there'd be time for both that highly desirable confession (customarily, witches could not be put to death until they'd actually admitted their guilt) and a public execution. The burning or hanging of the witch was considered more than entertainment for the crowd that would gather; it was considered an edifying experience, the culmination of the judicial process and a clear indication that dealing with demons would not be tolerated.

In Bamberg, Germany, the town fathers even had the foresight to construct what was, for 1627, a kind of maximum-security prison for witches, which they called the Hexenhaus ("House of Witches"). Several stories high, and built above a running stream, the Hexenhaus could hold up to twenty-six witches at a time, each one in a private cell with a small window up near the ceiling. There was a chapel, an interrogation room, and, of course, a state-of-the-art torture chamber (where the stream came in handy for drowning techniques). Though drawings and floor plans of the Hexenhaus still exist, the building itself has long since been torn down.

But awful as the physical agonies were for anyone convicted of practicing black magic, the spiritual penalty was almost as bad. In Catholic countries, to be excommunicated from the church was to be sentenced to an eternity of pain and loss. In

effect, the sorcerer or witch was cursed by the church itself, in a ritual that stemmed from the lines of Matthew 18:18: "Whatsoever ye shall bind on earth," Jesus tells his disciples, "shall be bound in heaven: and whatsoever ye shall loose on earth shall be loosed in heaven." In other words, judgments made here would be upheld there. If a soul was cast out of the Christian community on earth, and failed to offer sufficient repentance to gain readmission, it was doomed in the afterlife, too.

The ceremony of excommunication came to be known as bell, book, and candle, as these were the three elements needed to see it through. The curse of excommunication was first read from a book, which the cleric then closed. A bell was tolled, as if for a dead man, and then candles were blown out, to signify the extinguishing of the offender from the very sight of God. In a variation of the ceremony, devised by Pope Zachary in the eighth century, the pope wore his miter and violet robes, he was

assisted by twelve priests carrying the candles, and he deliber-
ately deprived the guilty party of the Mass and of any commin-
gling with uncorrupted Christians: "We exclude him from the
bosom of our Holy Mother the Church in heaven and on earth
. . . and we judge him condemned to eternal fire with Satan and
his angels and all the reprobate, so long as he will not burst the
fetters of the demon, do penance and satisfy the Church."

RAISING THE DEAD

The Church does not deny that, with a special permission of God, the souls of the departed may appear to the living, and even manifest things unknown to the latter. But, understood as the art or science of evoking the dead, necromancy is held by theologians to be due to the agency of evil spirits. . . .

The Catholic Encyclopedia

NECROMANCY

*O*f all the black arts, undoubtedly the most dangerous was necromancy—the summoning of the dead. In a way, it was the pinnacle of the magician's art, the most extreme and impressive feat he could add to his professional résumé. In part this was due to its difficulty—the ritual requirements were extraordinarily elaborate—and in part it was due to the great risks any magician was expected to encounter the moment he summoned ghosts and devils from the underworld. These spirits were often quite unhappy at having to make the trip.

So why bother them? Necromancers had all kinds of motives, some of which were more pure than others.

Spirits were sometimes conjured up out of affection—the magician missed a loved one who had departed this vale of tears.

Sometimes spirits were summoned up because the sorcerer wanted the arcane or secret knowledge that only spirits were reputed to possess.

And sometimes—perhaps quite often—spirits were called upon to divulge the whereabouts of hidden treasure hoards. It was generally understood that the dead may have lost their lives in the normal sense but that they had gained the ability in the afterlife to uncover all secrets and see into all things. According to the common folklore, these spirits could be found loitering around their burial place for one year after their interment. After that, however, getting in touch with them became increasingly difficult, if not impossible.

Not that it was ever easy. First, the proper location had to be found to perform the magical rites. Some of the preferred spots for necromancy were underground vaults, hung with black cloth and lighted with torches, or forest glens where no one was likely to intrude. Crossroads were popular, too—perhaps on the theory that many souls, both living and dead, were accustomed

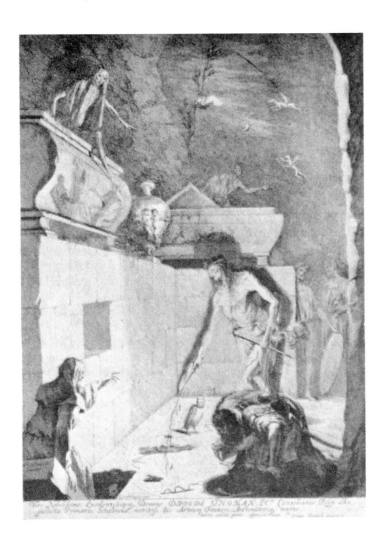

to passing by. Ruined castles, abbeys, monasteries, churches, were all considered good venues, as were, of course, graveyards.

The best time for necromancy was, as might be expected, midnight to 1:00 A.M. If a bright full moon hung in the sky, that was fine. But even better was a tempestuous night, one filled with wind and rain, thunder and lightning. And it wasn't just for effect. Spirits, it was thought, had trouble showing themselves

and remaining visible in the real world, but stormy weather for some reason helped them in their efforts.

The necromancer had many preparations to make. In the nine days preceding an attempt to raise the dead, he and his assistants were required to steep themselves in every way imaginable in the gloom of death. They took off their normal, everyday attire and put on faded, worn clothes that they had stolen from corpses; as they put them on for the first time, they were required to recite the funeral rites over themselves. And until the actual necromancy had been performed, they were forbidden to take these clothes off.

There were other restrictions, too. They were not allowed even to look at a woman. The food they ate had to be taken without salt, because salt was a preservative—and in the grave, the body, putrefied, did not remain intact. Their meat was the flesh of dogs, for dogs were the creatures of Hecate, goddess of ghosts and death, whose appearance was so terrible that anyone conjuring her was warned to avert his gaze; one look at her, and the mind would be destroyed. And, in a kind of necromantic version of the Holy Communion, the bread they ate was black and unleavened; their drink was the unfermented juice of the grape. These symbolized the emptiness and despair of the realm they were about to explore. In all these preparations, the aim was to create a kind of sympathetic bond between the necromancers and the souls of those they were hoping to summon.

Once everything was in order, the necromancer and his accomplices went to the churchyard and, by the light of their torches, drew a magic circle around the grave they were planning to disturb and set fire to a mixture of henbane, hemlock, saffron, aloes, wood, mandrake, and opium. After unsealing the coffin, the body was exhumed, then laid out with its head to the east (the direction of the rising sun) and its limbs arranged like those of the crucifed Christ.

Next to the body's right hand, the necromancer placed a small dish, burning with a mixture of wine, mastic, and sweet oil. Touching the corpse with his wand three times, the conjurer recited a conjuration from his grimoire. Though the wording of

these conjurations differed from book to book, one of them went: "By the Virtue of the Holy Resurrection and the agonies of the damned, I conjure and command thee, spirit of [the name of the person] deceased, to answer my demands and obey these sacred ceremonies, on pain of everlasting torment. Berald, Beroald, Balbin, Gab, Gabor, Agaba, arise, arise, I charge and command thee."

In a slight variation, if the soul being summoned had committed suicide, the sorcerer was required to touch the cadaver nine times and invoke it using other powers, including the mysteries of the deep and the rites of Hecate; he could also ask it why it had cut short its own life, where it resided now, and where it was likely to go hereafter. The spirit was enjoined to answer the sorcerer's queries "as thou hast hope for the rest of the blessed and the ease of all thy sorrow."

If all went well, the spirit reentered its old, cast-off body and caused it slowly to stand up. In a weary, sepulchral voice, the deceased would answer each question the necromancer put to it—what lay beyond this world of tears, which demons were causing us harm, where a buried treasure might lie. When the interrogation was over, the sorcerer rewarded the spirit for its cooperation by assuring it of undisturbed rest in the future; he burned the body or buried it in quicklime, which would dissolve it. Either way, the spirit knew the body would be gone, and it could never be forced to enter it again.

GRAVE ENCOUNTERS

Although with some adjustments necromancy could be performed in the comfort of one's own home, graveyard necromancy, or raising the dead right where they lay, was understandably the most popular form of the black art. There were many precedents, and several famous cases often cited in legend and lore, which no doubt provided much encouragement to would-be raisers of the dead.

Norse wizards were reputedly so skilled at the art that they

didn't even need to wait for the body to be plunked into the grave; they could enjoin hanged men, still swinging from the gallows, to speak to them.

In medieval Spain, necromancy was taught, like any other discipline, in Toledo, Seville, and Salamanca—except that the classrooms were deep, dark caverns, often lying beneath cemeteries and mausoleums. When Isabella, a Catholic, came to the throne, she sealed up these subterranean lecture halls.

One of the earliest stories of necromancy appears in the Bible's First Book of Samuel, chapter 28. Looking out over the enemy army of the Philistines, King Saul "was afraid, and his heart greatly trembled." Wondering what to do, and what the outcome of the battle would be, he turned to his seers, who could tell him nothing; he looked to his dreams, but they were unclear; he prayed to the Lord, but the Lord was silent. Finally, in desperation, he begged his servants to find him someone who could raise spirits, and they advised him to consult with the woman known as the Witch of Endor.

Disguising himself (which was especially important, in view of the fact that by his own decree all wizards and such had been banished from the land), Saul went to the witch and asked her to summon a spirit for him. At first, she was reluctant; she knew the law, and she was afraid she was being lured into a snare. But Saul swore to her that no punishment would befall her, and she finally agreed. She asked whom he wanted to see, and Saul told her the prophet Samuel.

Shaking and fearful, the witch performed the necessary rites, and the shade of Samuel, an old man in a long robe, soon appeared. At first, Saul could only bend low and press his face to the ground. "Why hast thou disquieted me, to bring me up?" the ghost asked, and when Saul summoned the courage to ask his questions, it wasn't good news that he received. "Tomorrow," Samuel intoned, "shalt thou and thy sons be with me: the Lord also shall deliver the host of Israel into the hand of the Philistines."

Saul, knowing now that both he and his army were doomed, threw himself on the ground in despair.

Sextus, the son of Pompey the Great, had a similar experience with a witch. He, too, was wondering what the outcome of a battle would be; his father was campaigning to become ruler of the Roman empire, but when Sextus tried to find out from the oracles whether the campaign would succeed or not, he got such confusing answers he threw up his hands in disgust. According to Lucan, who recounted the story in his *Pharsalia*, Sextus decided to consult with the celebrated witch Erichto.

This wasn't a step to be taken lightly.

Erichto was a frightening creature, who'd been mixing up her personal and professional life for many years. To facilitate her communications with the dead, she had taken up residence in a graveyard, sleeping in a tomb, surrounded by bones and funerary relics. When Sextus asked her to look into the future for him, she said they'd first have to get hold of a fresh corpse.

Luckily, there was a battlefield quite nearby, and after they'd combed over the casualties for a while, they found the body of a recently slain soldier that Erichto said would suit them just fine. The fact that his body was still warm indicated that the energy of life, which could quickly dissipate, was still there. Just as important, he hadn't been wounded in the mouth, lungs, or throat; if he had been, he might not be able to talk once they'd gone to all the trouble of reviving him.

Together, Sextus and the witch dragged the body into a cave, which was concealed by yew trees and consecrated to the gods of the underworld. There, Erichto went about fixing a ghastly stew, using the flesh of hyenas that had fed on the dead, the skin of snakes, the foam from the muzzles of mad dogs, and assorted, foul-smelling herbs. When the vile concoction was ready, she ordered Sextus to cut a hole in the corpse of the soldier, just above the heart, so she could pour in this new substitute blood.

Then she began to recite her incantations, calling upon Hermes, the guide of the dead, and Charon, who ferried dead souls across the inky waters of the river Styx. She appealed to Hecate and Proserpine, the queen of the underworld, and Chaos, the dark lord whose aim was to spread destruction and discord

among men. She reminded them all that she had always been their faithful disciple, that she had poured out human blood on their altars and sacrificed infants in their names. From the sky, thunder pealed, and all around the entrance to the cave Sextus could hear wolves howling and snakes hissing.

But Erichto kept up her chant, and gradually Sextus could make out the spirit of the dead soldier, hovering in the dark air above its own mangled corpse. Erichto ordered the spirit to reenter the body, but the spirit refused; she ordered it again, threatening to dispatch it straight to Hell. The spirit still wouldn't do it. Then she tried a different tack: if the spirit would do her bidding, she said, she promised to utterly destroy the corpse; that way, no other magician could ever use it to perform such an awful rite again.

This time the spirit acquiesced; it entered the corpse, and the blood began to circulate in its veins, the limbs twitched with life, and slowly, unsteadily, the body rose up on its feet. In halting speech, it described for Sextus the dismal outcome of his father's campaign—the imminent battle would be lost, and Sextus himself would die an early death. But when it had finished, and Sextus was satisfied that he had received the true, if unhappy, news, Sextus and the witch built a funeral pyre, and the dead soldier stretched himself out on it. True to her word, Erichto recited a spell that freed the spirit from any earthly bonds, and the pyre was set ablaze.

The dead could be more, however, than just the bearers of good or bad tidings—they could also be dispatched on errands of evil.

According to a Greco-Egyptian text, a clever necromancer could use the dead to seduce whatever woman he desired. First, the magician had to make a wax doll and pierce it with thirteen needles, through the eyes, ears, mouth, hands, feet, stomach, brain, anus, and genitals. At sunset, he was to go to the cemetery and place the doll on the grave of someone who had died by violence or early in life. To summon the corpse from the grave, he then called upon the spirits of everyone who had ever died a premature death, along with the powers still held by an

eclectic group of gods and spirits which included Persephone, Ereshkigal (a queen of the underworld in ancient Sumeria), Adonis, Hermes, Thoth, and Anubis (the Egyptian god of the dead, usually depicted with the head of a jackal).

The corpse, reanimated now, was ordered to march to the desired woman's door "and bring her hither and bind her. . . . Let her sleep with none other, let her have no pleasurable intercourse with any other man, save with me alone. Let [her] neither eat nor drink nor love, nor be strong or well, let her have no sleep except with me. . . ." And so on. It's hard to imagine any woman resisting such a lovely seduction.

When it wasn't love or hidden riches that the necromancer was after, it was sometimes just the cadavers themselves. In ancient Egypt, sorcerers bought dead bodies from the embalmers and kept the mummies on hand for any future rites. And in the Middle Ages, sorcerers haunted tombs and gravesites in search of pieces of the corpses themselves, which were thought to hold powerful occult properties. Most prized were the bodies of people who had died suddenly, by accident or violence or execution; it was generally conceded that sudden deaths left a goodly measure of the precious life force still unused.

"Some take a small piece of buried corpse," wrote Paolus Grillandus, a sixteenth-century witch judge, "especially the corpse of anyone who has been hanged or otherwise suffered a shameful death," and employ it for occult purposes. Very little of the corpse went to waste: "the nails or teeth . . . the hair, ears, or eyes . . . sinews, bones or flesh," all of these, according to Grillandus, were put to some use. In an even grimmer note, the flesh of unbaptized babies was much sought after; their graves were often desecrated as a result. Isabel Gowdie, the Scottish witch, once dug up the body of a freshly buried infant and buried it in a farmer's manure pile, as a way of putting a curse on him and his crop.

Not surprisingly, the Christian church took a very dim view of all this. The Bible inveighed against such practices—Saul and the Witch of Endor as a case in point—and the third-century theologian Tertullian roundly condemned anyone who would

disturb or desecrate a grave. In the sixteenth and seventeenth centuries, the church was even arguing that these spirits were nothing more than demons taking on a mortal disguise. William Perkins, in his 1608 *Discourse on the Damned Art of Witchcraft,* wrote that "the Devil being sought unto by witches appears to them in the likeness of a dead body."

DEMONS IN THE COLISEUM

*A*lthough Benvenuto Cellini was best known for his brilliance as a goldsmith and artisan to popes and princes, he was also a devoted fan of occult studies, and recounted in his autobiography several harrowing experiences with the denizens of the otherworld.

Once, having met a Sicilian priest who was reputedly skilled in the black arts, Cellini confessed to him his great interest. "A stout soul and a steadfast must the man have who sets himself to such an enterprise," the priest replied, and Cellini, never one to duck a challenge, a fight, or a romantic assignation, immediately said that he was ready for anything. "If you have the heart to dare it," said the priest, "then I will amply satisfy your curiosity."

The next night, the priest, his assistant, Cellini, and a friend entered the Coliseum. The priest gathered everyone around him, drew the magic circle, and assigned each one of them a task: the necromancer-in-training was told to hold the pentagram, while Cellini and his friend were instructed to keep the fire burning; they were also told to feed the flames with various perfumes, or noxious weeds. As for the priest, he recited the necessary incantations for the next hour and a half, until he declared that the Coliseum was now filled with legions of devils.

"Benvenuto," he said, "ask them something," and Cellini requested that the infernal horde reunite him with Angelica, his Sicilian mistress. But the devils wouldn't say yes or no. The priest dismissed them for the night and told Cellini they'd have to try again.

On their next pass, they brought with them, at the priest's request, "a little boy of pure virginity." Again, the priest drew the magic circle, and again he recited the prayers in Hebrew, Latin, Greek; he called upon the lords of the infernal world to bring their legions with them, and in no time "the whole Coliseum was full of a hundredfold as many as had appeared upon the first occasion." Cellini reiterated his earlier request, and this time the priest said, "Hear you what they have replied; that in the space of one month you will be where she is?"

Cellini would have been happier to hear it if he hadn't noticed that the priest himself was now quaking with fear. The demons he'd summoned were so numerous, and so fierce, that the priest was afraid he'd never be able to get them peaceably to go. The little boy, who claimed he could see four giants trying to force their way into the magic circle, stuck his head between his knees and cried, "This is how I will meet death, for we are certainly dead men!"

But Cellini plucked up his courage and rallied the others; he had them throw more foul-smelling weeds on the fire. And eventually, the devils departed. By the time the matin bells had begun to ring, it appeared to be safe to leave the circle and make their way home. The priest threw off his necromancer's robe, picked up the pile of books he'd brought, and they all left the Coliseum, "huddling as close as we could to one another," Cellini recalled, "especially the boy, who had got into the middle, and taken the necromancer by his gown and me by the cloak."

But what of the devils' promise? Cellini got into a terrible scrape a short time later—knocking a man out in a street fight— and had to get out of town fast. He wound up in Naples, staying at an inn where, lo and behold, a fellow guest was his Sicilian mistress, Angelica. "While drinking deep of this delight," he writes, "it occurred to my mind how exactly on that day the month expired, which had been prophesied within the necromantic circle by the devils. So then let every man who enters into relation with those spirits weigh well the inestimable perils I have passed through!"

FRIAR BACON

*W*hen it came to estimating the dangers of conjuring up demons, no one was more persuasive than Roger Bacon, the Franciscan friar.

In his *Discovery of the Miracles of Art, Nature and Magick,* written in the thirteenth century, Bacon argued that "there is a more damnable practice, when men despising the Rules of Philosophy, irrationally call up Wicked spirits, supposing them of Energy to satisfie their desires. In which there is a very vast errour, because such persons imagine they have some authority over Spirits, and that Spirits may be compelled by humane authority, which is altogether impossible, since humane energy or Authority is inferiour by much to that of Spirits." It was a lot easier to get what you wanted, Friar Bacon went on, by invoking "God, or good angels"—though he doesn't seem to have stuck to his own advice.

Throughout his life, Bacon wrote learned tracts and essays, extolling the virtues of art and nature, praising science over superstition, devout prayer over magic. But if there's any truth to the many legends that surround his name, he never quite gave up on magic. He studied alchemy, astrology, and necromancy; he believed strongly in the power that incantations might possess, admitting that "all the miracles since the world began, almost, have been wrought by words." And he warned often that the Antichrist would one day come, and use these powers—both natural and magical—to bring destruction on the world.

Born in 1214, near the town of Ilchester in Somerset, Bacon studied at Oxford, taught there, and later moved to Paris; it was while he was in France, and already a member of the Franciscan order, that he first ran into trouble; in a letter to the pope, he complained that "the Prelates and Friars have kept me starving in close Prison nor would they suffer anyone to come at me, fearing lest my Writings should come to any other than the Pope

and themselves." This at least piqued the interest of the papal office—what could this humble friar be writing that was so dangerous? Bacon was asked to forward a copy of his work so the pope could see what all the fuss was about, and Bacon did so, sending on his *Opus Majus, Opus Minus,* and *Opus Tertium.*

In these works, Bacon described a world of wonders, of instruments, experiments, and techniques that could be used to plumb the depths of the natural world. He outlined what could be a diving suit for the exploration of the ocean floor and recounted experiments with niter that foretold the discovery of gunpowder. In the *Opus Tertium,* a kind of overview of the first two books, he predicted the use of "burning glasses which operate at any distance we can choose, so that anything hostile to the commonwealth may be burnt—a castle, or army or city or anything; and the flying machine, and a navigating machine by which one man may guide a ship full of armed men with incredible speed; and scythe-bearing cars which full of armed men race along with wondrous machinery without animals to draw them, and break down or cut through all obstacles."

It's easy to see why such suppositions were considered so volatile; weapons like these, in the wrong hands, could indeed do the Devil's work. Although he was released from his confinement and returned to Oxford in 1268, his life remained one of trial and turmoil. Imprisoned again ten years later, once more for his writings, he spent fourteen years under arrest. Which makes it all the more amazing that by the time he died, most probably in 1294, he had left behind him such a legacy of stories and adventures. In sixteenth-century England, there was a Bacon revival of astounding proportions.

Among other things, he was credited with having invented, while at Oxford, two magical mirrors. One of them could be used day or night to light candles. The other was far more astonishing—it could reveal what someone else was doing, anywhere in the world, at that precise moment. Legend has it that two young noblemen asked to see their fathers in the mirror, and when they did, they saw them with drawn swords, fighting a deadly duel with each other. The two sons instantly drew their

own swords and engaged in a fatal duel of their own—much to Friar Bacon's dismay.

Bacon was also a great patriot, and he dreamed of one day defending the entire English coastline with an insurmountable wall of brass. But as present engineering techniques did not allow for anything so monumental (for that matter, neither do today's), he decided to start small, and build a talking brass head that would tell him how to do it. (Strangely enough, these talking brass heads were considered nothing very extraordinary to construct; Robert Grosseteste, bishop of Lincoln, was said to have made one, Albertus Magnus another, and even the ancient Roman philosopher Boethius reportedly had one on hand.) Bacon built his according to all the specifications, but for some reason it wouldn't talk.

Much frustrated, Bacon and his trusted assistant, Friar Bungay, went to the woods one night and raised a demon to ask it what the problem might be. After demurring at first, the demon finally told them what to do and said the head would talk in one month's time, though he couldn't say at exactly what day or hour. He warned the friars that if they didn't hear it before it had finished speaking, all would be lost.

Consequently, the two friars went on a round-the-clock vigil. But after several weeks of constant attendance on the head, they decided to get some rest one night and delegated the responsibility to Miles, their servant.

And of course, that night turned out to be the fateful one. The head opened its brass jaws and said two words, "Time is," but Miles didn't think this was important enough to wake his masters for.

Some time later, it said, "Time was," but again Miles figured this was pretty inconsequential stuff; in fact, since the head had so little to say, Miles started to jeer at it and sing bawdy songs.

Half an hour more passed, and the head, unhinging its jaws one last time, said, "Time is past," and exploded into a thousand pieces. Bacon and Bungay, awakened by the deafening roar, raced into the room, but too late to learn anything from the smoldering ruins.

On a separate occasion, however, Bacon did come to the aid of his country (or so legend has it). Using one of his burning glasses, the English army was able to set fire to a French town they were besieging. The French garrison surrendered, a treaty was signed, and a grand fête was held to celebrate the generous terms of the newfound peace.

As part of the festivities, a magical contest was held, with Bacon pitting his skills against a renowned German sorcerer named Vandermast. Vandermast led off by conjuring the spirit of Pompey, in full martial dress, ready to fight the battle of Pharsalia. Bacon, not impressed, summoned the spirit of Caesar, who engaged and, once again, defeated Pompey. The English king was pleased with his friar's work.

But Vandermast said he was ready for another round. Bacon said he'd let Friar Bungay handle this one. Bungay waved his wand in the air, uttered some incantations, and made the tree of the Hesperides appear before the celebrants, adorned with its golden apples, protected by its watchful dragon. Vandermast took one look and knew just what to do: he summoned up the shade of Hercules, who had slain the dragon and plucked the fruit. The famous warrior was ready to enact his victory all over again when Bacon stepped in to save the day; he waved his wand and Hercules stopped dead in his tracks.

Vandermast, furious, shouted at Hercules to carry on. But Hercules, trembling, said he couldn't do that—not with a superior power like Bacon's telling him not to.

Vandermast cursed the ancient shade, and Bacon laughed. Then, to seal the victory, Bacon said that since the spirit wouldn't be following Vandermast's instructions, it might as well follow his: he commanded Hercules to carry Vandermast home to Germany, which the spirit obligingly did, throwing the rival magician over his shoulder like a sack of potatoes. When the crowd cried out, sorry to lose one of the competitors so completely, Bacon relented, and said Vandermast would just be in Germany long enough to say hello to his wife, and then he'd be back at the celebration.

This contented the crowd—but not Vandermast. Angry and

humiliated, he later paid a Walloon soldier one hundred crowns to travel to England and kill the friar. But Bacon, who'd consulted his books of magic, knew that the assassin was coming and was ready for him when he sprang out with his sword drawn. Bacon knew that the man was an infidel, one for whom the fires of Hell were just a story. So Bacon, to convince him otherwise, conjured up on the spot the shade of Julian the Apostate; his body besmirched with gore, his skin crackling with flame, the ghost confessed that this was the torment that it had to endure for its apostasy. The Walloon fell to his knees in terror and instantly became a convert to Christianity. In fact, he went on to join the Crusades, where he died fighting for the return of the Holy Lands.

Despite Bacon's protestations of his own faith, he was commonly thought to have come by his magical powers by making a deal with the Devil. How else, people reasoned, could he perform all these feats? But even there, Bacon's genius was thought to have prevailed. In return for his skills, Bacon was said to have promised the Devil his eternal soul, on but one condition—that he died neither in nor out of a church. The Devil, thinking this was a pretty safe bet, agreed. And Bacon, during the last two years of his life, built and lived inside of a tiny cell in the outer wall of a church—neither in the church nor out of it.

There, he spent all his time, praying, meditating, having his meals delivered to him, talking to his visitors through a small window. When he died, his bones were interred in the grave he'd dug, inside the cell, with his own fingernails.

THE BELL OF GIRARDIUS

For those of a more squeamish disposition, who wished to avoid digging up coffins or cracking open tombs, there was a more delicate method of summoning the dead, and this was a magic handbell invented by the necromancer Girardius.

In a document dated 1730, and now housed in the Bibliothéque de l'Arsenal in Paris, the bell is described and dia-

grammed and its usage explained. Surprisingly, all of this is done in relatively clear and concise French (most such tracts were written in Latin, of purposeful obscurity). If the document is to be believed, the bell can summon the spirits of the dear departed with the same efficacy as a dinner bell brings family members to the kitchen table.

But first, as with any occult exercise, many careful steps had to be taken. The bell itself had to be cast of an alloy of lead, tin, iron, copper, gold, silver, and fixed mercury. These various metals must be melded "at the day and hour of the birth of the person who desires to be in confluence and harmony with the mysterious bell." Near the top of the bell, the necromancer must engrave the date of his birth and the names of the seven planetary spirits needed to make the incantation work; in order, these spirits were Aratron for Saturn, Bethor for Jupiter, Phaleg for Mars, Och for the sun, Hagith for Venus, Ophiel for Mercury, and Phuel for the moon. Below these names, and around the bottom rim of the bell, he was to write the ancient Hebrew formula Tetragrammaton. As for the wooden handle, on one side of this the necromancer was instructed to carve "Adonai" and on the other side "Jesus."

When the bell was ready, the magician was to wrap it up in a swatch of green taffeta, and under cover of darkness take it to the cemetery. There, he dug a hole in a gravesite and buried the bell in the dirt for one week. In theory, lying undisturbed in the grave this way, the bell absorbed from the neighboring corpse "emanations and confluent vibrations" which would give it "the perpetual quality and efficacy requisite when you shall ring it for your ends."

When it came time to dig up the bell and ring it, the necromancer had to don ceremonial clothes (much like a toga) and hold the bell in his left hand and a parchment with signs of the seven planets on it in his right. The deceased, whose grave the bell had been buried in, would hear this sympathetic ringing and be compelled to come forth and answer its summons.

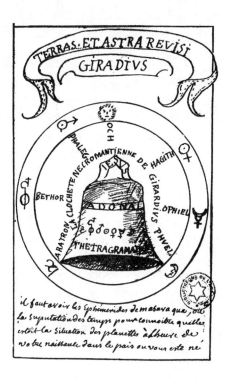

DR. DEE AND MR. KELLEY

*I*n all the annals of the occult, there is no more unusual pair than Dr. John Dee, unofficial astronomer to Queen Elizabeth I, and Edward Kelley, the unscrupulous scryer, or crystal gazer, with whom he formed a long, and tempestuous, alliance.

Dr. John Dee, by all accounts, was a serious and devoted scholar all of his life. Born in 1527 to a minor functionary at the court of Henry VIII, he soon distinguished himself at his studies, attending Cambridge University at the age of fifteen (where he records in his diary that he studied up to eighteen hours a day) and graduating with his bachelor of arts two years later. Already an avid student of astronomy, in subsequent years he traveled

the Continent, learning all that he could, meeting with other scholars, scientists, and astronomers and absorbing every new discovery they were willing to share with him.

Among his most valued prizes were two Mercator globes, which he acquired from the Flemish cartographer Gerardus Mercator himself and brought back to England, and a treatise on magic which he came across, quite by chance, while browsing through the bookstalls in Antwerp. Written by Trithemius, the Benedictine abbot of Sponheim-on-Rhine, this treatise on natural magic, entitled *Steganographia,* made the most powerful impression on Dee; indeed, he wrote an enthusiastic letter about it to the influential statesman Sir William Cecil, in which he claimed that the book's "use is greater than the fame thereof is spread." Inspired by what he found in its pages, he wrote in twelve feverish days his own work, *Monas Hieroglyphica*, on the correlation between numbers and various arcane magical practices. Though no one has ever been able to decipher with absolute assurance its true meaning, Sir William declared that Dee's book was "of the utmost value for the security of the Realm."

But for all his intellectual gifts and growing reputation as astronomer, Dee hungered after knowledge that he could not discover—the secret of the philosophers' stone, for instance—and talents he could not acquire, most notably second sight. He had become terribly interested in crystallomancy and spent hour after hour gazing into a convex mirror—his "magic glass"—that he believed had been bestowed upon him by the angel Uriel. But only once did he catch a fleeting glimpse of something, barely discernible, in the depths of the glass; he became convinced that if he was ever to make any headway in the unseen world, he would need an assistant—someone with the powers he lacked, whose visions, and conversations with the angels, he could record, analyze, and interpret.

Enter Edward Kelley. Dee had already gone through a couple of assistants, of insufficient ability, before Kelley got wind of the opening and introduced himself. Up until that time, Kelley, a swarthy young Irishman, had not had the most illustrious ca-

reer; at one time an apothecary's apprentice, he had turned his hand instead to forging and counterfeiting. Convicted for those crimes, he'd had his ears cut off. When he presented himself to Dee in 1582, it was as a scryer, someone who could see and hear the denizens of the otherworld. Dee, wanting to make sure this new applicant understood exactly what kind of service he was entering into, explained that he did not consider himself a magician—the term carried some evil connotations and, depending on how the civil authorities were disposed at any particular time, grim penalties—and that before he made any attempts at crystal gazing, or whatever, he always asked for divine assistance. Kelley put Dee's mind to rest on that score, dropping to his knees and praying for the next full hour, before looking into the magic glass and describing what he saw.

Dee couldn't have been more excited.

What Kelley claimed to see there was a childlike angel, imprisoned in the glass, struggling but unable to make its voice heard. From the description Kelley gave, Dee identified the figure as Uriel. Dee, who was fifty-five years old at the time and beginning to despair of ever making his big breakthrough, welcomed Kelley not only into his employment but into his home, too. Dee's much younger wife (whom he had married after his first wife died of the plague) was none too happy about the new domestic arrangement, but for the sake of her husband's career, she was prepared to go along. Later, she'd come to regret it.

Kelley, who wore a black cap to conceal his missing ears, spent the next several years communicating with angels and spirit guides for Dee and the many notable patrons they were able to acquire. Among the spirits Kelley spoke for was "a Spiritual Creature," as Dee described her, "like a pretty girl of seven or nine years of age," by the name of Madimi. (Dee named one of his eight children after her.) While Kelley relayed Dee's questions and related Madimi's answers, Dee made careful transcripts of the conversations. But despite her great willingness to chat, Madimi's pronouncements weren't all that revealing.

On one such occasion, Dee welcomed the spirit by saying, "Mistress Madimi, you are welcome in God for good, as I hope;

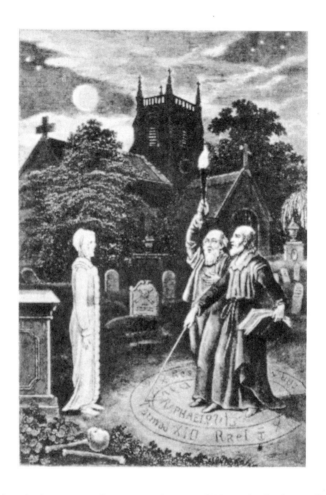

what is the cause of your coming now?" To which she replied, "To see how you do." Dee went on: "I know you can see me often, and I see you only by faith and imagination." The spirit pointed at Kelley: "That sight is perfecter than his. . . ."

After a few more questions designed to uncover the future for one of their clients, Count Albert Laski, a pretender to the Polish crown, and a few more cryptic replies, Kelley seemed to lose patience and went straight to the heart of what mattered to him most: "Will you, Madimi, lend me a hundred pounds for a fortnight?" And, like anyone else unexpectedly hit up for a

loan, Madimi gave him the brush-off. "I have swept all my money out of doors," she said. Dee quickly jumped in to smooth things over: "As for money we shall have that which is necessary when God seeth time."

Madimi, in one of the responses so typical of otherworldly entities, concluded the conversation by instructing them to "Hear what I say. God is the unity of all things. Love is the unity of every Congregation (I mean true and perfect love). The world was made in the love of the Father." And so on and so forth.

Kelley then decided to try necromancy. In the graveyard of Walton Le Dale in Lancashire, he went with his assistant, a fellow named Waring, to elicit information from a freshly buried corpse. But his luck wasn't much better. There, he drew a magic circle and inscribed its border with the names of several helpful angels—Raphael, Rael, Miraton, Tarmiel, and Rex. Standing inside the sacred space and reading by torchlight from a book of incantations, Kelley was purportedly successful in coaxing the corpse, still in its burial cloth, to rise from the grave and speak to him, though no record exists of what they talked about.

Interestingly, there was one subject on which the spirit Madimi's instructions were quite clear and explicit. According to Kelley, he was consulting her one day when she advised him that he and the good doctor should "share all things in common, including their wives." Jane Dee had seen this one coming and flew into a rage. Mrs. Kelley's reaction has gone unrecorded, but it's safe to say she wasn't too pleased about it either.

Encountering such strong opposition, Kelley quit his post. And even though Dee himself had been no less appalled by the immoral instruction, he soon found himself missing the best scryer he'd ever had. Later, when Kelley came back, once again consulted the magic glass, and this time said that Uriel, too, was advocating the wife-swapping scheme, Dee gave in: "There is no other remedy," Dee wrote, "but as hath been said of our cross-matching, so it must needs be done." According to Dee's diary entry on Sunday, May 3, 1587, the two husbands and their wives "covenanted with God, and subscribed the same for in-

dissoluble and inviolable unities, charity, and friendship keeping, between us four, and all things between us to be common, as God by sundry means willed us to do.''

The new peace didn't last long. The wives fought bitterly, the husbands ran short of cash, and Dee decided the partnership wasn't working, after all. Kelley packed up his old kit bag, filled with magic powders and trinkets, and traveled through Bohemia and Germany, telling fortunes and selling his wares. He was arrested twice as a heretic; the second time, afraid that he might actually wind up with a sentence of death, he tried to climb over the dungeon wall, lost his grip, and fell. He broke both legs and two of his ribs, and in February 1593, he died of his injuries.

As for Dee, he set up shop in his ancestral home in Mortlake, where gradually he slipped into penury. A couple of new scryers he employed proved to be incompetent, and his pursuit of the philosophers' stone was fruitless. He wrote voluminously, but with little effect or public acclaim. The queen came to his rescue with a small appointment, but when she died and was replaced by James I, no friend to men with a reputation for sorcery, Dee knew that he'd run out of luck. A lonely and impoverished old sorcerer (his second wife, too, had died), he passed away at his home in 1608, surrounded by arcane texts and the strange instruments of his trade.

THE LODGE OF THE MYSTERIES

*O*n October 29, 1768, Johann Georg Schropfer opened a small café in the town of Leipzig. But Schropfer's café offered something not seen on the menu in most such establishments—initiation into the mysteries of magic and the occult. Schropfer, who joined Cagliostro as one of the most renowned sorcerers of his day, served up a magic punch made from his own secret recipe, along with lessons in the summoning of the dead, for anyone brave enough to undertake them.

Unlike many other necromancers, however, Schropfer disdained the use of corpses. He was something of a purist in that

regard. When Schropfer went about conjuring the dead, he began by fasting and praying for three days. Then, when he was ready, he took off his shoes, dropped to his knees (while ordering anyone else present to do the same), and placed two fingers on the Gospel of Matthew. The room, which he had specifically outfitted for these rituals, had a black carpet and a black altar, on top of which he placed two candles and a skull.

After lighting the incense, he drew a magic circle around the altar, warned everyone to stay inside its boundaries, and began the invocations. The first spirits he conjured were always good and benevolent ones; Schropfer said he needed them for their help and for the protection they could provide against the evil spirits to follow. If all went as planned, the evil ones did indeed come next, their entry marked by the dousing of all the lights, a rumbling in the floor and walls of the room, and noises of violence and rage. The spirits appeared, in the smoke from the incense, and grudgingly snarled out answers to the questions the necromancer put to them, before vanishing again into the mist and shadow. One more fitful rattling of the walls, and peace would return to the house.

But for all his success and generally polite demeanor, one day Schropfer apparently said something unflattering about Prince Charles of Saxony, and word of it got back to him. The prince dispatched one of his officers to teach the upstart magician a lesson. The officer was doing just that, whipping and pummeling him, when Schropfer broke loose for a moment, threw himself on his knees in the corner, and called up his infernal allies. They came to his aid so quickly that the officer had to run for his life.

But then so did Schropfer. Fearing the prince would send soldiers after him again, he fled to Dresden, where he passed himself off as a French army colonel. But the masquerade didn't last long—soon his new hometown knew that they had the celebrated magician, who had done such wonders in Leipzig, living among them. And Prince Charles began to hear stories of the magician's latest, and most miraculous, feats.

Finally, the prince couldn't stand it anymore; he had to see

these marvels for himself. He issued a public apology to Schropfer and invited him to return—which Schropfer did. But no matter how many tricks and conjurations the magician performed for him, Charles was really interested in seeing only one thing—an evocation of the dead.

He even had a perfect candidate in mind—his late uncle, the chevalier of Saxony. For one thing, the chevalier had died only recently—which, in theory, made raising his spirit somewhat easier—and for another, he'd bequeathed to his nephew the palace in Dresden where he'd died. Somewhere in this palace, rumor had it, vast treasures were hidden away. Charles hoped that his uncle's ghost might show him where they were.

Schropfer agreed to do it, but the plan had to proceed in secrecy; the elector of Saxony, under whose jurisdiction the Dresden palace fell, was an ardent opponent of magic. On the appointed night, the prince and seventeen of his most trusted friends stole into the gallery of the palace, locked all the doors and windows, and prepared to witness the invocation of the spirit. Schropfer urged them all to drink a glass of his punch first, to fortify themselves against the horrors to come, and most of them did. But one, who later provided the eyewitness account of what happened that night, wanted to be absolutely sure his senses were unclouded: "I am come here to be present at raising an apparition. Either I will see all or nothing. My resolution is taken, and no inducement can make me allow anything to pass my lips."

Schropfer, unperturbed by this refusal, retired to a corner of the room, where he began the ceremony. First, he recited a lengthy prayer, calling upon the Holy Trinity and petitioning the Lord to protect him against the demons he would soon be raising. His shoulders heaved with emotion, his body twisted as if in agony. All of a sudden, there was a loud clattering noise outside the window, and the gallery shook as if struck by an earthquake. Then there came a squeaking sound, like wet fingers sliding on glass. Though the onlookers quailed, Schropfer seemed pleased, claiming that these were the signs that the guardian spirits had entered the room.

But as expected, the good spirits were quickly followed by their evil brethren, and the noise they made was an infernal howling. While the prince and his friends flattened themselves against the walls in terror, Schropfer held up a crucifix and demanded the spirits' obedience. The doors to the gallery flew open, and according to the account left by the spectator who'd refused the punch (and which was later recorded in N. W. Wraxall's *Memoirs of the Courts of Berlin, Dresden, Warsaw, and Vienna in the Years 1777, 1778, and 1779*): "something that resembled a black ball or globe rolled into the room. It was invested with smoke or cloud, in the midst of which appeared to be a human face, like the Countenance of the Chevalier de Saxe. . . . From this form issued a loud and angry voice, which exclaimed in German, 'Charles, what wouldst thou with me? Why dost thou disturb me?' "

Charles, who'd been waiting for this moment, desperate to ask his dear departed uncle if there was indeed a treasure hidden in his palace, now found himself speechless with terror. So were all his friends. While the black globe gasped and groaned and rolled back and forth the length of the gallery, the prince and his friends cringed and cowered. They begged the Lord's forgiveness and pleaded with Schropfer to dismiss the spirit forthwith.

Schropfer, apparently, was only too willing. But even his best incantations were proving futile; he prayed, he exorcised, he waved his crucifix and called upon the power of Christ. It was only after a full hour had passed (or so the witnesses claimed) that the smoky black phantom rolled back out the door.

The necromancer, the prince, his cohorts, all nearly fainted with relief—when suddenly the door burst open again, and the phantom appeared once more! Schropfer rallied, and barely managed to exorcise it again—this time, it seemed, for good. When all had gathered their wits, they silently disbanded, afraid to speak of it even among themselves. According to Wraxall's account, the witnesses long continued to "dread and deprecate a renewal of the images . . . and a lady earnestly besought of

me, not to press her husband on a subject, of which he could never think or converse without passing a sleepless night."

Even the magician himself may have been haunted by the awful events of that night. Schropfer, afraid that the elector of Saxony would punish him for practicing necromancy, returned to Leipzig, where he continued to perform his magical feats. But he became increasingly depressed and troubled, burdened by his own reputation and by the hellish sights he had conjured up in the course of his career.

In the summer of 1774, while promising to show them something more marvelous than they had ever seen, Schropfer led three gentlemen beyond the city gates of Leipzig and into the wood of Rosendaal. It was a warm night, about three or four in the morning. He stopped in a quiet grove and told his companions to wait on one side of the clearing while he made the necessary invocations on the other. They did so, until they heard a pistol shot a few minutes later. They ran to the other side of the grove and found Schropfer lying there, fatally wounded by his own hand. Though none could ever say for sure, it was generally acknowledged that the demons, with whom he'd had so many encounters, had finally driven him to madness and, ultimately, suicide.

THE MONKS OF MEDMENHAM

*T*hough they liked to call themselves monks, they were anything but. They were, in fact, a dozen dissolute English gentlemen who formed one of the most notorious "Hell-Fire Clubs" of the eighteenth century.

These clubs, devoted to debauchery and sometimes Satanism, had sprung up in such profusion that by 1721 an official proclamation was made, banning "certain scandalous Clubs or Societies of young persons who meet together, and in the most impious and blasphemous manner insult the most sacred principles of our Holy Religion, and morals of one another." Gathering in backstreet taverns or other out-of-the-way spots, these

Hell-Fire Clubs indulged in everything from orgies to Satanic rites and commonly drew their members from the gentry and aristocracy of the country.

Indeed, the founder of the Monks of Medmenham was Sir Francis Dashwood, who, at the age of sixteen, inherited vast estates and great wealth. On his obligatory grand tour of the European continent, he was reputedly trained by a master Cabbalist in Venice, and on his return to England he brought back with him a collection of magical and pornographic texts and engravings. He squandered even more money—huge sums of it—turning his ancestral manse into a palace unrivaled in its luxury and extravagance.

But by 1752, when all of that had palled, he turned his eye on the abandoned Medmenham Abbey, situated nearby on a neighbor's property.

After getting to know the landlord of the abbey, a young man named Francis Duffield, Dashwood negotiated a long-term lease and immediately began an expensive but secret process of renovation. His aim was to convert the holy ruins into a private retreat for the most depraved and sacrilegious activities, and to that end he had the chapel walls painted with indecent murals, the upstairs "cells" outfitted as boudoirs, the cellars filled with fine wines and the library with forbidden, lubricious books. And then he went about enlisting his fellow members.

In emulation of Christ's twelve disciples, he chose twelve men to join him as members of the Superior Order, and each one was rebaptized with the name of a disciple. (Conveniently, this number, plus Dashwood himself, also made up a witch's coven.) Among the original "monks," or "friars" as they also sometimes called themselves, were several powerful and influential men of their time, including the earl of Sandwich, the marquis of Bute, Charles Churchill, John Wilkes, George Bubb Dodington, and Thomas Potter, son of the archbishop of Canterbury.

For his initiation into the order, the novice was dressed in a white linen robe, and at the tolling of the bell, he was led to the chapel and made to knock on the closed wooden door.

When it opened, to the sound of low, solemn music, the initiate walked to the communion rail. There, while the other members knelt around the altar, he was asked to declare his most profoundly held principles (or, to be more accurate, his lack of them) and to abjure the faith by mocking its language and intent. If he did this with sufficient gusto and wit, he was admitted into the order by participating in further sacrilegious rites, followed by a banquet in his honor.

At this feast, as described by Charles Johnstone in his contemporary account *Chrysal,* "nothing that the most refined luxury, the most lascivious imagination could suggest to kindle loose desire, and provoke and gratify appetite, was wanting, both the superiors and the inferiours [of whom there were also twelve] vying with each other in loose songs and dissertations of such gross lewdness, and daring impiety, as despair may be supposed to dictate to the damn'd."

But by some accounts, this wanton conduct was nothing compared to the more unholy aims of the group; its motto, inscribed above a doorway, was *Fay ce que voudras* ("Do what you will"). In an aspidal sanctuary of the chapel, the eucharist of Hell was celebrated, and the chapel itself was formally dedicated one night to Satan. What exactly went on in this inner sanctum of the abbey was never known for sure; no one but members of the order were ever allowed inside, and they were all bound to secrecy, and for good reason: if their vile rituals had become common knowledge, their lives and careers would have been ruined.

As it is, their professional lives were what brought the order down in the end. Though the members were united in their decadence, many of them rose to prominence in the government—Bute became prime minister, Bubb Dodington joined the cabinet, Dashwood himself became chancellor of the exchequer—and they often came to sit on opposite sides of the fence: in the House of Lords, Lord Sandwich at one point impeached John Wilkes for blasphemy.

At their last meeting, in the early summer of 1762, only half a dozen of the members convened. With rumors circulating

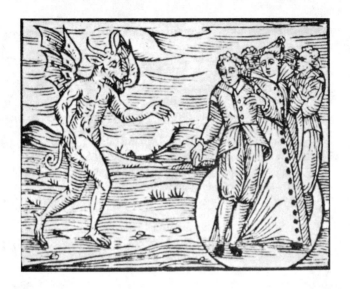

about the evil practices of the Monks of Medmenham, and so much now at stake, it was decided to end the order. The diabolical and pornographic accoutrements of the abbey were spirited away, and the abbey was shuttered once more. By the time Horace Walpole came to see it in 1763, he found it to be "very ruinous and bad." Sold by Francis Duffield in 1777, its later caretakers charged a small admission price to picnickers and sightseers who came to see the cloisters and chapel where the monks had run riot and Satan had been invoked.

ELIPHAS LÉVI

*A*lthough he was better known as a theoretician than an actual maker of magic, Eliphas Lévi did indeed conjure up one important soul and left a full record of the experience in one of his many books, *Transcendental Magic, Its Doctrine and Ritual.*

In 1854, Lévi, a large man with a great forked beard, and much noted for his mastery of magic, was approached in London by a young woman, an adept who was dressed all in black. Claiming to be a friend of Sir Bulwer Lytton (the English author

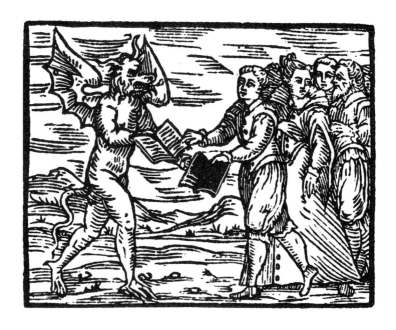

who was himself a student of the occult), she asked Lévi if he could summon the spirit of Apollonius of Tyana, a pagan philosopher, and ask of it two questions. Lévi, a man who could no more resist a young woman than he could a lavish dinner, decided to abandon his books and take on the assignment; though there's no record of it, the impoverished French magician might also have been tempted by a tidy commission.

In any event, to prepare for the big night, Lévi put aside his usual appetites and practiced fasting and abstinence for twenty-one days. (He had arrived at twenty-one by multiplying 3 and 7, two numbers with powerful occult reputations.) What food he ate was strictly vegetarian, and for the last seven days before the ceremony he claims to have eaten nothing at all. All the while, he meditated deeply upon the life and writings of the ancient philosopher Apollonius, even going so far as to hold imaginary chats with him, in order to create a strong mental bond between the two of them.

Then, on July 24, Lévi outfitted himself in a white robe (to

signify the purity of his aims) and put a vervain wreath, entwined with gold, around his brow (vervain purportedly kept demons at bay); with a brand-new sword in one hand and a manuscript of the ritual in the other, he was ready at last to enter, alone, the magical "cabinet" which the mysterious woman had obligingly prepared for the ceremony.

This cabinet consisted of a single room, high in a turret; four concave mirrors were on the walls, a new white lambskin on the floor. The altar was made of white marble, and carved in its top was a pentagram; a copper chafing dish, filled with charred alder and laurel wood, was placed atop the altar, and another chafing dish was placed on a tripod to one side. Around it all was a magic circle, formed from a chain of magnetized iron, to ward off any hostile spirits.

With some trepidation, Lévi lit the two chafing dishes, in order to get a pall of smoke going, which the spirit of Apollonius could use to give itself some definition. For hours he recited, in low, sonorous tones, the necessary invocations to the dead: "In unity the demons chant the praises of God," he intoned, "they lose their malice and fury . . . Cerberus opens his triple jaw, and fire chants the praises of God with the three tongues of the lightning . . . the soul revisits the tombs, the magical lamps are lighted."

Gradually, as the smoke swirled in the air around him, Lévi thought he could discern a shape. He tossed more twigs into the chafing dishes and recited his prayers more loudly. In the mirror opposite, he saw a vague figure, approaching him as if from a great distance. He closed his eyes and summoned the spirit, three times, to appear before him. When he opened his eyes again, "there was a man in front of me, wrapped from head to foot in a species of shroud, which seemed more gray than white; he was lean, melancholy and beardless."

Terrified at his own success, Lévi found himself almost unable to speak; he felt chilled to the bone and slapped one hand down on the pentagram to reassure himself. Then, making his first mistake, he tried to order the ghost to obey him by pointing the sword at it. The ghost, not pleased, promptly disappeared.

Lévi ordered it to come back, but instead he felt something touch the arm holding the sword; instantly, the arm went numb, from the elbow to the hand, and the point of the sword drifted downward. The figure then reappeared, and though it never spoke, answers to the two questions Lévi had planned to ask came to his mind. One answer was "death," the other was "dead." Weakened with fear, no doubt intensified by his weeks of fasting, Lévi apparently fell to the floor in a faint.

For days afterward, the arm remained sore. "Something of another world had passed into me," Lévi wrote, "I was no longer either sad or cheerful, but I felt a singular attraction towards death, unaccompanied, however, by any suicidal tendency." On two subsequent occasions, he claimed to have raised the spirit again, each time learning a great secret of the Cabbala. But he could never be certain exactly how, or why, the operation worked: "I do not explain the physical laws by which I saw and touched; I affirm solely that I did see and that I did touch, that I saw clearly and distinctly, apart from dreaming, and this is sufficient to establish the real efficacy of magical ceremonies." He did add one caveat: "I commend the greatest caution to those who propose devoting themselves to similar experiences; their result is intense exhaustion, and frequently a shock sufficient to occasion illness."

LA VOISIN

*A*lthough her married name was actually Catherine Monvoisin, to the nobles of the French court of Louis XIV, who flocked to her for poisons, love philters, and necromantic rites, she was simply known as La Voisin—the purveyor of magic and skilled practitioner of the Black Mass.

Her husband was an unsuccessful jeweler, and La Voisin first turned her hand to magic as a means of making ends meet. She began with the usual parlor tricks, reading palms and faces, telling fortunes with coffee grounds, and gazing into crystal balls. When that went well, she broadened her horizons, moving on

to such feats as the raising of specters and invocation of demons. In her Paris home, she kept a small, secret chapel, its walls hung with black drapes; the altar was covered with black cloth and a mattress, on top of which rested thick black candles. These candles were made from human fat, which La Voisin procured with the help of two hangmen. They brought her the bodies of the executed felons, and whatever she didn't need of them was burned in the chapel furnace.

But her true calling became the manufacture of love potions and, even more pointedly, poisons. Men and women of rank, caught up in the eternal intrigues of the French court, came to her for elixirs, powders, and spells; what they wanted, in nearly every case, was to better their position or social standing, and if that meant getting someone to fall in love with them, fine; if it meant killing someone who stood in their way, that was fine, too. If they needed a baby to be born in secret, La Voisin would act as midwife; if they wanted an abortion, she could perform the operation. She was sorcerer and physician, apothecary and poisoner, and she grew quite rich as a result.

But her most loyal customer was the marquise de Montespan, a beautiful young woman who had come to the court as a lady-in-waiting to the queen. It wasn't long before the marquise had caught the roving eye of the king, and not long after that, in 1667, she showed up on La Voisin's doorstep, looking for a way to replace both the queen and the duchesse de La Vallière, the king's current mistress, in the royal affections.

To get the job done, La Voisin brought in a priest, Father Mariette, who said a special Mass designed to get the marquise what she wanted; he prayed not only that the queen would be barren but that the king would lose all interest in the duchesse and fall madly in love with the marquise instead—to the point of asking her, in the end, to become his new queen. The ritual was repeated twice, the last time in a church where the hearts of two doves (a bird of amatory reputation, sacred to Venus and to Christ) were consecrated on the altar in the names of the king and the marquise. Whether it was due to the ceremony or not, things did begin to go her way, for by July of that year the

marquise de Montespan had become the king's most prized mistress.

But hanging on to the title was never easy—whenever she became unsure of her hold on the king, de Montespan returned to La Voisin for a sort of refresher spell. On one such occasion, La Voisin whipped up an aphrodisiac for her, concocted from dried moles, the blood of bats, and cantharides (which was more commonly known as Spanish fly, the powdered remains of blister beetles). On another occasion, when things were looking especially dire, de Montespan implored La Voisin for something even more powerful.

The answer was Abbé Guibourg, a corrupt old prelate known for his sensual nature. He was a tall, bulky creature whose fleshy face was disfigured by a permanent squint. Using de Montespan's naked body as his altar, he performed a secret Mass to ensure the king's devotion.

According to accounts left by La Voisin's daughter, Marguerite (who witnessed several such Masses), the marquise was laid out on her back with her arms outstretched; black candles were balanced on each palm. A napkin embroidered with a cross was laid on her chest, and the chalice was placed upright on her belly. It was then the true horror occurred: a child was sacrificed, its throat cut, and the blood was poured into the chalice, where it was mixed with flour to make the unholy host. In de Montespan's name, Guibourg then recited the incantation: "Astaroth, Asmodeus, princes of amity, I conjure you to accept the sacrifice of this child, which I offer in return for what I ask: that the King and the Dauphin will continue their friendship towards me, that I may be honored by the Princes and Princesses of the Court, and that the King will refuse nothing I ask of him, both for my relatives and my retainers." When she was done serving as the altarpiece, de Montespan took some of the foul wafer and dried blood and slipped them into the king's next meal.

In March 1669, the marquise bore a child by the king, baptized Louis-Auguste, who was promptly handed off to another woman to be raised. Over the following years, she had six more children by the king. But his interest, inevitably, began to wane.

While he stopped by her apartments in the palace for regular chats—she was, by all accounts, a clever and cultivated woman, whose conversation was admired by the likes of Saint-Simon and Marie de Sévigné—the king's romantic inclinations were now directed at a younger newcomer by the name of Angélique de Fontanges. The marquise was not about to stand for this and consulted, as usual, La Voisin about the course she should take.

A short time later, Angélique died of mysterious causes. Poison was suspected but never proved.

Poison, as it turns out, was being suspected more and more at the court of Louis XIV. Henrietta, the duchesse d'Orléans, was thought to have been murdered with a poison. The duchesse de Bouillon was accused of trying to do away with her husband in order to make a better marriage with the duc de Vendôme and was banished by the king. Indeed, the nobility were so busy practicing sorcery and witchcraft against each other that in 1680 the king decided to do something about it by convening the Chambre Ardente ("burning chamber"). A court that met in secret, in a room where the only illumination was provided by lighted torches, the Chambre Ardente tried only the most serious crimes of heresy and witchcraft, and its sentences, from which there was no appeal, were notoriously harsh. Most of the accused who stood before it were later burned alive at the stake.

La Voisin and her confederates, not suprisingly, were some of the first to be tried. La Voisin herself was briefly tortured, then burned alive on February 20, 1680. Abbé Guibourg was thrown into the dungeons of the castle of Besançon, where he was chained to a wall for three years before he died. Thirty-five others, also condemned for crimes of magic, were burned; five more were sent to the galleys. Some unfortunates, who were found innocent of actual crimes but were held to be in possession of knowledge the king and judges did not wish to become generally known, were simply imprisoned for life; their jailers were given orders to flog them into silence if they ever tried to impart anything of what they knew.

Many others, however, who were too well established in the court hierarchy, or too closely tied to the king himself, went

unpunished altogether or were merely banished (the duchesse de Bouillon for one). The marquise de Montespan, who had clearly been a steady customer of La Voisin, was allowed to retire to the Convent of St. Joseph with a pension of half a million francs; there she devoted the remaining years of her life to good works—donating funds to charities and hospitals—and doing penance for her earlier transgressions. When she died on May 27, 1707, the king forbade the illegitimate children he'd had by her to wear any sign of mourning.

MYSTICAL
ORDERS

The mind is the great
Slayer of the Real.

Madame Blavatsky

THE SEEKER AND THE SORCERER

*A*lthough mysticism and its professed aims—the penetration of the mysteries of the cosmos, the unification with the godhead—were good, and even laudable, over the centuries this valiant search for meaning often pushed into darker territory. Its practitioners sought not only knowledge but power—power that was sometimes subverted to evil purposes. The line between seeker and sorcerer was often forgotten, and easily crossed.

And though both might balk at being so linked, the mystic, with his avowedly holy aims, and the magician, with his frankly secular schemes, have always had more in common than they'd like to admit.

For one thing, both of them seek to attain a higher state, a knowledge of things unknowable by traditional means. For another, they both believe that the ability to achieve such a state resides within themselves, in a power that lies latent within the normally uncultivated regions of their mind and soul. Before the mystic and the magus separate to seek their respective goals, they are heading in much the same direction, and for much of the way they might even be said to keep company.

But where the magus stops short, the mystic presses on.

In broad terms, the aim of the magician is to find a way to conquer and control the forces of the universe, to find out how to use his will and the powers of his imagination to acquire the worldly things he desires. Love, riches, glory—the magician believes that all of these things can be had if only he is wise enough, and skilled enough, to decipher and then speak the secret language of the occult.

The mystic, too, must penetrate this unseen world, must travel beyond the knowable, the visible, the tangible. He must elevate himself from this plane to the next, must believe so fervently in the existence of some higher state that doubt and fear do not tether him inextricably to the mundane world. He must share with the magician a strange amalgam of humility, ac-

knowledging that there is so much of which he is ignorant, and hubris, believing that he can, and will, ultimately attain to this higher wisdom.

But where the magician seeks to manipulate the things of this world, the mystic seeks to detach himself from them. Where the magus hopes to absorb all things within himself, and within the scope of his powers, the mystic desires to merge himself into the godhead, the ineffable source of everything.

"Then God enlightened me with his spirit, that I might understand his will and get rid of my sorrow," wrote the German mystic Jakob Boehme in his *Aurora* (1612), "then the spirit penetrated me, and now, since my spirit, after hard struggles, has broken through the gates of hell to the innermost origins of godhead, and been there received with love, it has seen everything, and recognized God in all creatures, even in plant and grass; and thus immediately with strong impulse my will was formed to describe the nature of God."

One of the impediments to this spiritual breakthrough—and this held true for many magicians as well as mystics—was the strong hold that the things of this world could exert. Even the alchemist, who bent his every effort to transmuting base metals to gold and silver, was advised to live an everyday life of austerity. His home was usually a hovel, in a back alley of the town, where he could perform his experiments in obscurity; his poverty was seen as a sign of his seriousness of purpose. Magicians, too, often led meager and barren lives, presumably because they were bound up in the pursuit of higher things, oblivious to the baser needs of human nature.

The mystic, however, often took this asceticism to new heights, purposefully ignoring the ordinary human needs and even performing grisly mortifications of the flesh (Origen, on whose writings much of later mysticism drew, castrated himself in order to get rid of the distractions of lust and sensuality). Other Christian mystics, such as Catherine of Siena and Padre Pio, displayed the stigmata—the wounds of the crucified Christ. Though differing in degree, and even in their espoused aim, the

mystic and the magus shared a rejection of conventional wisdom while embracing an otherworldly outlook.

Over the centuries, many different mystic sects were formed—the Waldenses, the Cathari, the Beguines, to name a few—and many influential mystic teachers emerged, including Emanuel Swedenborg, Meister Eckhart, and Jan van Ruysbroeck. In the Middle Ages, there was a strong reaction to the seeming coldness and formality of the Catholic Church; people were suffering greatly from war, poverty, and, in the fourteenth century, the absolute devastation of the Black Death. They needed comfort, they needed answers, they needed a sense that they were not so far removed from God. They also needed to know that there was no immense bulwark (as the church must have sometimes seemed to be) standing implacably between them and the Divine.

Mysticism, in its many strains, provided that reassurance and gave them, as St. Bernard observed in his *De Diligendo Deo* (c. 1126), a feeling of being included, forever and always, in some greater providential plan:

> As the little water-drop poured into a large measure of wine seems to lose its own nature entirely and to take on both the taste and the colour of the wine; or as iron heated red-hot loses its own appearance and glows like fire; or as air filled with sunlight is transformed into the same brightness so that it does not so much appear to be illuminated as to be itself light—so must all human feeling towards the Holy One be self-dissolved in unspeakable wise, and wholly transfused into the will of God. For how shall God be all in all if anything of man remains in man? The substance will indeed remain, but in another form, another glory, another power.

This was welcome news—the universe was in us, and we were, forever, a part of the universe—that many at the time felt

an overwhelming need to believe. And, if we are to judge from the popularity of many New Age beliefs that are so similar to earlier mystic teachings, there is a great and growing number of people who feel that same need today.

THE GNOSTICS

*A*lthough the Gnostics by no means created Satan, many of their beliefs, most notably the idea that there are opposing gods of good and evil, and two worlds, one of light and one of darkness, certainly offered him room to grow and take hold in the imagination of mankind.

The Gnostic sects, which proliferated in the early centuries A.D., in and around the Middle East, offered rival views to the Judaic and early Christian theologies. The very word "Gnostic" meant "one who knows," and what the Gnostics knew, the secret knowledge that they possessed, wasn't something easily demonstrated or proved. What the Gnostics knew was that the world, as they saw it, was unmitigatedly evil and that no supreme deity could possibly have made it that way. Consequently, they argued, the supreme deity must be far, far away, pretty much existing on his own in a heaven of his own making. What we were left with here was something created by proxy, a world fashioned by lesser deities, known as archons (rulers), who had made a hash of the job.

It was the archons, for instance, who had created man. They'd seen a brilliant vision of a man flash above them, but they'd been unable to hold the image fast. What exactly was it that they'd seen? Working from memory, they tried to re-create the image, but the man they made was so badly built, according to some of the Gnostic teachings, that he couldn't even stand up on his own; he squirmed around like a giant earthworm until God caught a glimpse of him and flicked the divine spark his way. This, at least, got man onto his own two feet.

In the view of some of the Gnostic teachers, these archons were in fact rebel angels; in the second century A.D., Saturninus

of Antioch taught his followers that the world had been created by seven of these fallen angels, whose leader was the God of the Jews. These seven had deliberately misled Moses and the Old Testament prophets so that they in turn would lead mankind down the garden path. In the opinion of many Gnostic followers, the God of the Old Testament was a brutal, evil deity; some of them even equated Jehovah with the Devil. They praised his enemies, condemned the prophets and patriarchs, and made some other, equally incendiary arguments. In some Gnostic sects, the serpent was worshiped, and the serpent in the Garden of Eden was proclaimed a friend to Adam and Eve. Why? Because, by Gnostic lights, the serpent was just doing its level best to open Adam and Eve's eyes to the difference between good and evil. And when it came to Cain and Abel, the Gnostics, predictably, sided with Cain; only an evil deity would prefer Abel's blood sacrifice to Cain's nonviolent fruits and berries.

All in all, the Gnostics could be counted on to turn upside down nearly every traditional Judeo-Christian value. In a world created and governed by evil, you might just as well throw caution to the wind and do as you pleased; after all, you didn't get to Heaven by following the rules laid down by archons. You got there by possessing within yourself the gnosis, or true knowledge, of the way things were. Some of the Gnostics interpreted this as a virtual license to steal, embarking on wild lives of sexual profligacy and forbidden magical practices. But normal heterosexual sex was frowned on, because there was such a good chance it would wind up creating another human being who would only add one more slave to the archons' battalions.

Other Gnostics, however, went in the opposite direction, freeing themselves of the worldly snares by leading the lives of hermits and ascetics, focusing themselves on the purification they would need to undergo if they ever hoped to transport themselves above this muck and mire. (In this particular view, it's easy to hear an echo of the Greek Platonists, who believed that the wise soul must work its way back toward the higher world of light, arriving at last at its heavenly home.) For the Gnostic, home was a long way off, and the soul had to undergo

lots of trials before getting there. It had to lead a life on earth that was almost wholly unconnected to the earth, free of the worldly appetites, and it also had to rise up through the spheres of Heaven ruled by the seven angels. That was the only way to get to the Heaven of the supreme deity.

To get past these seven angels, however, the soul had to know their respective names and powers; it also had to know how to address them and what symbols had to be shown to them in order to move on to the next level. There were hostile spirits to contend with, too, who might try to waylay the rising soul. All in all, the road to individual salvation, which the Gnostic movement, like so many other mystical religions, was finally all about, was long and difficult, and anyone setting out on it had to pack his bag full of holy secrets, sacraments, and signs.

SIMON MAGUS

*N*o one had a kit bag more packed with miracles and revelations than the magician who came to be known as Simon Magus. In the first century A.D., Simon built up such a following of believers, from his native Samaria all the way to Rome, that he gave the fledgling Christianity a run for its money.

But it was a race that Simon lost, quite overwhelmingly, in the end.

Sometimes credited with having been the founder of Gnosticism, Simon was in fact only one of many who promulgated Gnostic principles and, from the Christian perspective, unforgivable heresies. He claimed to be, at various times and various places, the Son of God, the Redeemer, the transcendent God of the Gnostic universe. He was said to have been born, like Jesus, from a virgin mother. Among the miracles he purportedly performed were the raising of the dead, the healing of the sick, and the magical creation of pure spirits. He could marshal and control legions of demons, make himself invisible, or take on any shape he wished. He could walk unscathed through walls of fire, bore his way through mountains, or animate statues so that they

laughed and danced. The list of his credits went on and on, but when his magic ran up against the greater powers of Christ's disciples, Simon Magus came up short time and again.

He'd received his early training in Egypt, from a man named Dositheus, who claimed to be the living incarnation of something called the Standing One, or supreme principle. One day, in front of Dositheus's own disciples, Simon challenged him to a battle of the wizards. When Simon won, Dositheus took a swipe at him with his staff, but the staff passed right through Simon's body. That's when Dositheus knew the jig was up— Simon must in fact be the true Standing One. Dositheus handed over the leadership to Simon and a short time later died.

Wherever Simon went, he performed miraculous feats, and according to the biblical account left in Acts, it wasn't long before he was being venerated as a god—which he strongly encouraged the public to do. There was only one thorn in his side. These Christian evangelists were also traveling around the region performing miracles, and their miracles were getting even better notices than his. The one called Philip had cured palsies, made the lame to walk, plucked unclean spirits out of many who were possessed. Two of the apostles, Peter and John, had come from Jerusalem and laid hands on people, infusing them with the Holy Spirit.

Simon was impressed not only with their works but with the relative ease they displayed doing them; he confessed that his own effects took lots of preparations, incantations, and such. In fact, he was so anxious to learn the magic words the apostles were using that he offered Peter some money (from which we derive the word "simony") if he'd only share the secret of such powers. Peter refused him in no uncertain terms: "Thy money perish with thee, because thou hast thought that the gift of God may be purchased with money. Thou hast neither part nor lot in this matter: for thy heart is not right in the sight of God" (Acts of the Apostles 8:20–21).

From that time forward, Peter became his archenemy, repeatedly foiling his attempts to win over converts and make a dishonest living. Afraid that Peter might even accuse him of sor-

cery, Simon took his books of magic and threw them into the sea, then set off for Rome, where he was sure the emperor Nero and his citizens would still give him a warm welcome.

He was right; in Rome, his stock still high. And it grew higher when Simon faked his own resurrection. After somehow bewitching a ram into taking on his appearance, the ram was beheaded—and three days later, Simon reappeared, with his head back on his shoulders, seemingly unaffected by the recent decapitation. This made a great impression.

But, like a bad penny, Peter turned up again, this time accompanied by Paul. The emperor saw the opportunity for a marvelous face-off between Simon, who claimed to be a deity, and Peter, who was merely, as it were, representing one. Peter readily agreed, and proposed a simple test. He said he'd whisper something in Nero's ear, and Simon, reading their thoughts, should tell them what it was. Simon, who was always rattled the moment he came up against Peter, started hurling imprecations and instead summoned up savage dogs to attack and devour Peter. The dogs dutifully appeared and raced full bore at the apostle, who suddenly stretched out his hands in prayer; in his hands, he held a loaf which he had blessed. At the sight of it, the snarling dogs vanished.

Nero had to admit, Peter looked like the winner.

But Simon had another, and much bigger, trick up his sleeve. He asked the emperor to give him one day to prepare, and in front of the multitudes he would fly off toward Heaven. Nero ordered his servants to build a high tower in the Campus Martius so that everyone would be able to witness the feat, and the next day, as promised, Simon ascended to its peak. Then he stepped off and sailed unharmed through the air. Nero asked Peter what he thought of that, and Peter simply prayed; he prayed in the name of the God who had created all things, in the name of Jesus, who had truly risen from the dead, that the invisible angels of Satan, who were keeping Simon aloft, should loose their hold and let the great deceiver fall to earth.

The powerful prayer worked. The chastened demons dropped Simon like a hot coal. He plummeted to the earth, land-

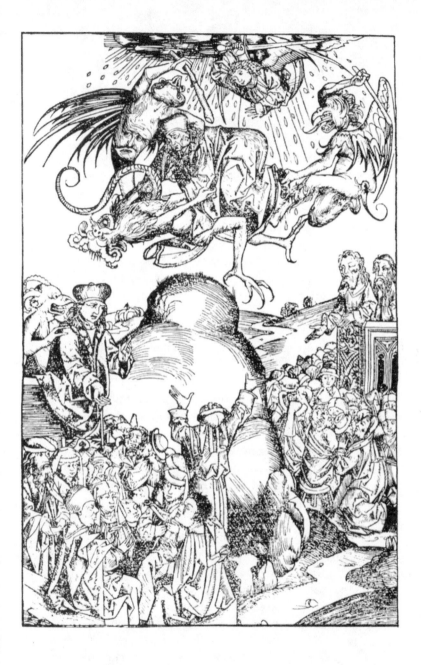

ing in the Via Sacra (Holy Way) so hard that he broke into four pieces.

Which pretty much settled the contest once and for all.

THE CABBALA

*A*lthough many Christian mystics in the Middle Ages and Renaissance ardently embraced it, the Cabbala was of ancient Jewish origin. A body of mysticism and theosophy ("knowledge of God"), handed down to the patriarchs and prophets since the creation of Adam himself, the Cabbala was presumed to hold in cryptic form the secrets of the universe. The very word meant "the doctrines received by tradition." Mystics, alchemists, sorcerers, and the like were drawn to the Cabbala for obvious reasons: mastering it might yield them the answers they needed to uncover the philosophers' stone, or the elixir of life. Agrippa, Paracelsus, Robert Fludd, and many others all combed over these obscure Hebrew scriptures searching for clues and guidance.

Although the Cabbala was extraordinarily difficult to explicate and comprehend (which made it all the more enticing to the magical fraternity), it was in essence a vast cosmogony, dealing with everything from the nature of God to the creation of man, angels, and demons. In one section, called "The Mansions and Abodes," it laid out the structure of Heaven and Hell; in another, entitled "The Book of Secrets," it offered an investigation of demonology.

Overall, the Cabbala argued that God—denoted as En Soph—was a boundless and incomprehensible space in the universe, infinite and above all thinking and being as we know it. No matter how hard you tried to envision or imagine the En Soph, no matter how many times you hit your head against the wall, you wouldn't even be able to come close.

But the En Soph did have a problem (if, that is, it were capable of having problems). To make itself known in any way, the En Soph had to *act,* it had to *create* something. To do that,

however, required such things as intentions and desires, not to mention some rolling-up-the-sleeves, old-fashioned work, and nothing so limitless and inscrutable as the En Soph was about to gets its hands dirty (again, if it had had hands, as we know them).

So, instead, it employed ten intelligences, or *Sephiroth,* which emanated from it like beams from the sun, each one emanating in turn from the one before it. In order, starting with the first, these Sephiroth were denominated the Crown, Wisdom, Intelligence, Love, Justice, Beauty, Firmness, Splendor, Foundation, and Kingdom. And while they did good work, the universe they created was by no means perfect or uncircumscribable. Which just proved En Soph wasn't handling everything directly, for how could boundless perfection create a limited imperfection?

If all of this is beginning to sound a little strange, you're starting to get the hang of the Cabbala.

But this newly created universe could not be called complete until the very acme of creation, mankind, had been added to it. As expressed in the *Zohar,* one of the Cabbala's most important texts, "Man is both the import and the highest degree of creation, for which reason he was formed on the sixth day. As soon as man was created everything was complete, including the upper and nether worlds, for everything is comprised in man. He unites in himself all forms."

The very shape of a human being was thought to be a physical representation of the four letters that make up the Tetragrammaton, the Hebrew word for God, and each part of the human body was thought to correspond to some part of the known and seeable universe. "Just as we see in the firmament above, covering all things, different signs which are formed of the stars and the planets, and which contain secret things and profound mysteries studied by those who are wise and expert in these things; so there are in the skin, which is the cover of the body of the son of man, and which is like the sky that covers all things above, signs and features which are the stars and planets of the skin, indicating secret things and profound mysteries

whereby the wise are attracted who understand the reading of the mysteries in the human face" (*Zohar*).

As for the human soul, it was thought to preexist, long before it went to inhabit a human body, in the World of Emanations. And in that original state it was thought to unite both male and female in one; it was only after it descended to this world that the soul was split up into two parts and made to animate two separate bodies. (Now you know why we're said to be looking for our "soulmate.") A marriage was the reuniting of the two parts of the original soul—but that's only if things went according to plan. As the *Zohar* makes plain, "This union, however, is influenced by the deeds of the man and by the ways in which he walks. If the man is pure and his conduct is pleasing in the sight of God, he is united with that female part of the soul which was his component part prior to his birth."

And if he hasn't been pure and pleasing in the sight of God? Then he enters a kind of spiritual reform program, where his soul is allowed to work toward its own inborn perfection three more times, inhabiting a new human body each time around. If even that doesn't work, if the soul is still too weak to resist sin and worldly corruption, then more drastic measures are taken: the soul is joined to another soul altogether, on the theory that working in unison they'll be able to return, finally purified, to the World of Emanations.

But why all this trouble? Because, according to the Cabbala, the soul of the Messiah is not about to budge until all these other souls have gone down to earth, then come back up again, reentering the bosom of the Infinite. When all souls are present and accounted for, then the soul of the Messiah will descend itself, and the great Jubilee will begin. At that point, all sin, temptation, and suffering will have been eradicated; life will become an unending Sabbath, a great feast, with all souls incorporated into the one and only Highest Soul. Even Satan will be returned to the angelic nature he once possessed. With an end result like this, all the trouble and delay seem more than worthwhile.

DEFENDERS OF THE FAITH

*A*lthough most mystical and religious orders were content to teach and to dwell upon questions of faith, there was one, known as the Order of Knights Templar, that took upon itself a militaristic role.

The order was founded in 1119, and its mission was to protect from Arab attack the legions of Christians who made pilgrimages to the Holy Land. The Templars' first headquarters was a part of the palace belonging to Baldwin I, king of Jerusalem, and was situated next to the former mosque of al-Aksa, thought by some to be the original site of the Temple of Solomon; it was from this that the knights took the name Templars.

The first recruits were an interesting assortment; some were men with a sense of divine mission, devoted to the promulgation of the faith and defending its adherents, but many others seemed to come to the order after lives of war and rapine. In fact, the order actively sought out and embraced any knight or soldier who had been excommunicated from the church; this was their chance to use their fighting skills, the one area in which they were truly proficient, to hack their way back to Heaven.

The order also proved to be fantastically successful builders, merchants, and bankers: from the mighty fortresses they built, most notably their headquarters on Cyprus, they gradually amassed great wealth and extraordinary power—this despite the fact that members of the order were required to take vows of poverty and lead lives of abstemiousness and celibacy. If a member happened to have already been married, and was bound by that lifelong vow, he wore a brown or black robe with the order's insignia, a red cross, on it; unmarried members wore white robes emblazoned in the same way.

For generations, the order grew and prospered, until its very size and might began to nettle the pope and other more temporal rulers. Rumors had begun to circulate that the order had

turned away from its Christian purposes and that it had in fact embraced the dark side. Initiates, it was said, were made to spit and trample upon the cross while crying out three times that they renounced Jesus; they were stripped naked by the other knights and forced to submit to unnatural acts. And in the secrecy of their fortified castles and temples, the knights were said to worship a pagan god known as Baphomet, a creature with the head and the hooves of a goat, a pentagram on its forehead, and a green belly covered with fishlike scales.

In the early years of the fourteenth century, Philippe IV, king of France, saw in these terrible stories a great opportunity. In dire financial straits and running out of options—he had already expelled the Jews and the Lombard bankers from his kingdom after stealing all their property; he had debased the national coinage—he decided it was time to make a raid on the Templars' treasury. First, he relayed to Pope Clement V all the reports he'd heard of the knights' blasphemies, and then, after receiving papal permission to take steps against the order, he organized his plot.

In Paris, the knights inhabited a massive castle, which was governed, as were all the order's castles and manors, by the grand master, Jacques de Molay. The king, on October 13, 1307, arranged for an extravagant evening of entertainment, and he invited de Molay and all of his knights to attend. When they arrived, they were summarily arrested, and then, over the following years, interrogated and tortured until they confessed to the most heinous crimes. Those who did so were burned at the stake; fifty-four who tried to take back their confessions were taken to a windmill in St.-Antoine and burned, all the same. Condemned as heretics, their bones could not be buried in consecrated ground.

Even Jacques de Molay, while he indignantly denied all charges of immoral conduct with the other Templars, finally confessed to having renounced Christ and spitting on the cross; he was sentenced to life imprisonment. But on March 14, 1314, when it came time for him to publicly admit to his crimes from a scaffold erected in front of Notre Dame Cathedral, de Molay

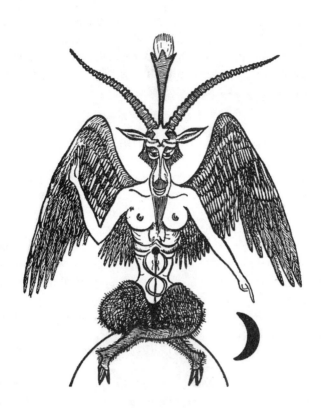

flew into a sudden rage, recanted his entire confession, and declared that he was innocent of all the charges brought against him. That got him a new sentence, on the spot; he was tied to a stake on a little island in the Seine, and from the flames rising around him he challenged the king and pope to appear with him before the heavenly bar. (When both of them died within the next couple of years, many people assumed that they had been called to account.)

The persecution of the Templars, directed by papal decree, continued, spreading throughout Christendom; the knights were rounded up in city after city, tortured, and executed. And their vast riches were appropriated by the kings and clergy. But according to some legends, the order never completely disap-

peared; its members merely went underground, as it were, forming an ultrasecret society whose goal it was to destroy the papacy and the ruling houses of Europe. Later societies, such as the Illuminati (a German order founded in 1776) and the Freemasons, were said to be its descendants.

THE BROTHERHOOD OF THE ROSY CROSS

*A*lthough the earliest documentation dates from 1614, this mysterious brotherhood, which claimed to be in possession of the elixir of life (among other great secrets of the universe), traced its own origins to the fourteenth century and a wandering magus (almost certainly fictitious) named Christian Rosencreutz.

Rosencreutz—whose last name translated as "rosy cross"—followed in the footsteps of many great seekers and magicians before him, from Apollonius of Tyana to Cyprian, who traveled from the West to the East, in the hope of uncovering occult wisdom and teachings. According to the lore, Rosencreutz began his studies at the age of five, in a convent school in Germany, where he learned the traditional humanities. But at fifteen, his education took a decided turn when he embarked, under the wing of a monk, on a trip to the Holy Land.

No sooner had they arrived in Cyprus than the monk took ill and died. But the young Rosencreutz, thirsty for knowledge he could not find in his own homeland, set out alone for Arabia, where he was told some great adepts lived. When he finally found them, they welcomed him with open arms, saying his coming had been foretold. They taught him all that they knew of the occult sciences (he picked up the Arabic language on his own), and three years later they sent him on to Egypt, where the master magicians of Fez showed him how to invoke the elemental spirits.

But that was where his good fortune ended. Rosencreutz's next stop was Spain, where the adepts offered him no respect, or help, whatever. In fact, the Spanish magicians claimed that they'd learned the secrets of the Black Arts from the master

himself—Satan—who'd taught them the finer points of necromancy in a lecture hall at the University of Salamanca. Rosencreutz moved on to other countries, but getting no better reception there, he returned to his native Germany, where he spent the next five years in solitude, writing down the secrets he had learned on his travels.

When that was done, he slowly and methodically began to gather around him the assistants and pupils who would form the nucleus of what came to be called the Rosicrucian fraternity. They created a magical language which they spoke only among themselves, an equally cryptic written language designed for magical incantations, and a dictionary containing all the occult wisdom they'd accumulated to date. They also started to put their knowledge into practice, using it, or so they claimed, to heal the sick. And they built their House of the Holy Ghost, a headquarters that no one has ever found, to serve as the repository of all their records and wisdom; Robert Fludd, an English Rosicrucian, asserted that this sanctuary was located at the world's end, surrounded by banks of clouds, where the brothers breathed only the purified air of true wisdom.

When Rosencreutz died, he was buried in a secret vault, the walls of which were inscribed with magical figures. When all the other original Rosicrucians had died out, the location of the vault was lost. But 120 years later, when one of the brotherhood's lodges was being rebuilt, the door to the tomb was found, hidden behind a bronze tablet, and reopened. Inside the seven-sided vault, they found not only the perfectly preserved body of their founder but various remarkable things—magical mirrors, small bells, the *Vocabularium* of Paracelsus—buried along with it. After debating among themselves, the brothers decided the time had come to make their order, and its miraculous discoveries, available to other worthy initiates in a more public fashion than ever before.

Thus, we have *The Fama of the Fraternity of the Meritorious Order of the Rosy Cross Addressed to the Learned in General and the Governors of Europe*. It was a kind of open letter, published in 1614 in the town of Cassel, Germany, and it called for a

reformation in science equivalent to that which had already occurred in religion. It was time, the pamphlet insisted, that men of science stopped relying on the authorities handed down from antiquity and looked instead to a new synthesis, based on moral renewal and the mysteries of the Grand Orient, which the children of light, the illuminated ones, the Rosicrucians, had obtained. Their symbol became a rose crucified on a cross.

As might have been expected, the pamphlet created quite a stir: some were anxious to know what this mysterious order had to offer, others (who already considered themselves adepts in magical practice) were offended at the suggestion that their own skills were somehow lacking. By the following year, *The Fama* had gone into three more printings, and two additional editions in Dutch. Capitalizing on their initial success, the brotherhood put out another pamphlet, *Confession of the Rosicrucian Fraternity,* which advertised for new members; selected applicants, it said, would be gradually initiated into the mysteries, and into the ranks, of the secret brotherhood. But there was nowhere to apply. All you could do was publicly state your interest and desire, perhaps by printing an ad or pamphlet of your own, and wait to be tapped for membership. It got to be a very frustrating process.

But the rewards were so tantalizing that scholars, magicians, and philosophers continued to line up. After all, the Rosicrucians professed to know the secret of making gold (for which they professed, however, no great zeal) and for the eternal renewal of life (for which they did). Their members were required to go about their business—in large measure, the healing of the sick—dressed in no special garments, but wearing the clothing of the local population; for their medical skills, they were forbidden to accept any payment. And at all times they were to maintain absolute anonymity, never announcing themselves as members of the secret fraternity. (As a result, it's difficult to know for sure who was ever actually a member, but among others the signs point toward Roger Bacon, Agrippa, Paracelsus, Descartes, Thomas Vaughan, and Francis Bacon.)

In Dr. Cohausen's *Hermippus Redivivus: or The Sage's Tri-*

umph over Old Age and Death, translated from German into English by John Campbell in 1744, the case for keeping this low profile was succinctly made:

> . . . the adepts are obliged to conceal themselves for the sake of safety, and . . . having power not only of prolonging their lives, but also of renovating their bodies, they take care to use it with the utmost discretion, and instead of making a display of this prerogative, they manage it with the highest secrecy . . . the true cause of the world's being so much in doubt about this matter. Hence it comes to pass, that though an adept is possessed of greater wealth than is contained in the mines of Peru, yet he always lives in so moderate a manner, as to avoid all suspicion, and so as never to be discovered, unless by some unforeseen accident.

THE FREEMASONS

A mystical order, which for many years became a sort of haven for astrologers, alchemists, and the like, the Freemasons have had a long and ultimately mysterious history. Though scattered records exist, and legends abound, its origins seem to lie in the Middle Ages, in the freemasons—the itinerant stoneworkers—who raised the great cathedrals and other edifices of western Europe. As each huge project was built, it attracted a cadre of skilled builders, the architects of their day, who spoke the language of stone and structure, who formed close bonds with each other over the many years—and sometimes lifetimes—that it took to complete each building.

But what began as an operative guild, an association of men trained in the arts and science of building, over time became a more speculative order, one that embraced all religious faiths in a quest for universal brotherhood. The instruments of the stoneworker's trade—gauges and tool aprons, compasses and chis-

els—became symbols of more arcane practices and wisdom. A complex mythology evolved, claiming that the Masons had existed for millennia, that members of their order had been instrumental in the erection of everything from the Pyramid of Cheops (an assertion strongly promoted by Count Cagliostro) to the Temple of Solomon in Israel. "If history be no ancient fable," went an English poem published in 1723, "Free Masons came from Tower of Babel."

The Freemasons flourished in the British Isles, in particular, where the Grand Lodge, which was founded in London in 1717, served as the society's powerful, central hub. It was here that the fundamental tenets of the society were drawn together, codified, and promulgated to other lodges far and wide. New applicants underwent an elaborate initiation ceremony, which gained them the status of Apprentice; later, they would move on to Fellow Craft, before eventually graduating to Master Mason. Often, in France and Germany, for instance, these ceremonies took on a decidedly occult cast.

In an eighteenth-century French rite, the initiate was held aloft, then slowly lowered to the floor, by several members; this was to symbolize his being lowered into his grave. Then, while he lay on the floor, a bloody cloth was thrown over his face; the members stood around him, swords pointing at his body. Finally, the grand master of the lodge would clasp the new apprentice by the hand, using the Mason's grip, and raise him up from the floor. The Masonic grip, a handshake with the thumb cocked, was a way for Masons everywhere to recognize each other without having to say a word.

As a Mason progressed through the different levels of the lodge, he was allowed to share more and more of the secret knowledge and powers that the order was reputed to possess. According to "The Muses Threnodie," published in Edinburgh in 1638, "We have the Mason Word and second sight, Things for to come we can fortell aright." The lodges grew and prospered, making great inroads into colonial America, too; Benjamin Franklin, an initiate of the Philadelphia Lodge, printed and published the society's *Book of Constitutions* in 1734, and George

Washington, when he was elected president, was serving as master mason of his lodge in Fredericksburg, Virginia.

But with its claims of extraordinary knowledge, coupled with the great shroud of mystery that the society purposely drew about itself, the Masons drew the suspicion, and later the outright hostility, of many other institutions, ranging from governments (the Russian minister of the interior closed down all the Masonic lodges in 1822) to the Catholic Church (the pope issued an 1884 encyclical condemning the organization). Still, the Masons survived all of the assaults and continued to instruct their apprentices in the hidden mysteries and secret signs that had purportedly been preserved and handed down by the members of their order from time immemorial.

THE GRAND COPT

The secret society of the Freemasons acquired no more enterprising member than the self-styled Count Cagliostro, who found in its elaborate rituals and high-flown philosophy the perfect venue for his talents. Both the society and the count prospered mightily from the alliance.

Born in 1743 to an impoverished but reputedly noble Sicilian family, Giuseppe Balsamo, as he was then known, showed much early promise. He was a quick study, with a knack for chemistry and medicine. But he also showed a rebellious streak, an impatience with authority, which caused him to be thrown out of one school or seminary after another. (Reciting from a sacred text in one such institution, he substituted the names of well-known prostitutes for those of the saints. He was, as he had no doubt intended, tossed out on his ear.) Making his way to Rome at the age of seventeen, he managed to scrape together a living using his skills as a draftsman (and forger) while drifting inexorably toward the region of his real interests—alchemy and the occult. A Greek named Altotas, who professed to be a master of these matters, became Balsamo's first and most influential mentor.

Together, they traveled through Africa and Asia, stopping for protracted stays in Egypt, where Balsamo claimed to have acquired an ancient papyrus explaining the secrets of clairvoyance, and Malta, where Altotas gained them an introduction to the grand master of the Order of the Knights of Malta. Here, as everywhere else Balsamo landed during his peripatetic career, he gleaned all that there was to learn, added to his vast mental inventory of science, astrology, and philosophy, and then moved on to his next stop, where he could market what he'd just found out. The supreme salesman, Balsamo was never without a willing clientele. And by all accounts, his most marketable commodity was himself.

"While not actually handsome, his face was the most remarkable I have ever seen. His eyes above all," wrote the baroness d'Oberkirch, an early supporter. "They were indescribable, with supernatural depths—all fire and yet all ice . . . he at once attracted and repelled you; he frightened you and at the same time inspired you with insurmountable curiosity." In summary, she asserted that he was "possessed of a demonic power; he enthralled the mind, paralyzed the will."

As his career caught fire, he abandoned his own name and took on that of his godmother, the Countess Cagliostro. Married to a beautiful young woman he'd met in Rome, Cagliostro traveled through the capitals of Europe, reading minds, telling fortunes, healing through the laying on of hands. It was reported that he had conjured up the archangel Michael; that he had predicted the winning numbers in a lottery three times in a row; that he dined at night with the shades of deceased statesmen and royalty. Wherever he went—Strasbourg, Paris, Brussels, Madrid, Lisbon—he attracted the notice of the local nobility and, of course, anyone with a hankering for knowledge of otherworldly things.

But it was on his second visit to London in 1776 that Cagliostro claimed to have come across the means by which he was to achieve his greatest fame and fortune. At a bookstall, he found an obscure manuscript by one George Gaston, in which were described the mystical rites of Egyptian Masonry. (No other

record of this book seems to have surfaced, and it's more than possible that Cagliostro made up its existence altogether.) But according to Cagliostro, there was this order of Freemasons even older and more powerful than its modern-day counterpart, an order founded by the prophet Elijah and by Enoch, who was also known as the Grand Copt; before long, Cagliostro was using that title himself. Members of this ancient order never died, but were bodily removed, like Elijah himself, straight from earth to Heaven. It was around this time that Cagliostro started circulating the story that he himself was actually several thousand years old.

Armed with these newfound rites, and under the aegis of the Esperance Lodge of Freemasons to which he'd been admitted on April 12, 1777, in rooms at the King's Head in London, Cagliostro embarked on an ambitious tour of other Freemason lodges, to promote his Egyptian program. In each city—Venice, Berlin, Nuremberg, St. Petersburg—he was welcomed with a sumptuous banquet, after which he lectured and offered demonstrations of his occult abilities. Using his five-year-old son as medium, he conjured up angels who left audible kisses on the child's cheeks; he read minds and foretold the future; and he indefatigably pushed his Egyptian rites, telling an audience in Leipzig that if they refused to accept and practice them, the master of the lodge would suffer dire consequences by the end of the month. When the master took his own life a short time later, this was considered confirmation of Cagliostro's claim, and the lodge immediately signed on to Cagliostro's program.

With monies pouring in from the Egyptian lodges, and his fame increasing hourly, Cagliostro was at the peak of his career. When Johann Lavater, the Swiss theologian and friend of Goethe, requested a meeting, Cagliostro answered, "If your science is greater than mine, you have no need of my acquaintance; if mine is the greater, I have no need of yours." But Lavater was not so easily dissuaded, and after the two men met, he became one of Cagliostro's most ardent proponents.

Not everyone was. Cagliostro had many enemies, including high-ranking clergy of the Catholic Church; in the count's pur-

ported "miracles," they saw a challenge to their own divine authority. And there were many others who simply thought he was a fraud and a trickster. The baron de Gleichen touched on both points of view in his own description of the man: "Cagliostro was small, but he had a very fine head which could have served as the model for the face of an inspired poet. It is true that his tone, his gestures and his manners were those of a charlatan, boastful, pretentious and arrogant, but it must be remembered that he was an Italian, a physician giving consultations, self-styled Masonic grand master, and a professor of occult sciences. Otherwise his ordinary conversation was agreeable and instructive, his actions noble and charitable, and his healing treatments never unsuccessful and sometimes admirable: he never took a penny from his patients." Indeed, in keeping with the higher tenets of the Masonic code, Cagliostro gave away money, in great quantities, to the poor and the needy.

But the seeds of his downfall were sown when he became involved, if unjustly, in the Affair of the Queen's Necklace in France. Marie-Antoinette had long coveted a diamond necklace that was too expensive even for her to purchase. Aware of the queen's desire, however, and knowing that the jeweler who owned the necklace was aware of it, too, the comtesse de La Motte concocted an elaborate scheme to convince the jeweler that the queen was secretly buying it, unbeknownst to the king, Louis XVI; to that end, she forged letters signed by Cardinal de Rohan, a man who had long been seeking preferment from the queen.

The jeweler, figuring he was dealing with the queen's own emissaries, let the necklace go without being paid for it up front. But when the bill continued to go unpaid, he secured an audience with the unsuspecting king to make his complaint. The king, naturally, took a long look at the letter purportedly written by the cardinal—who, as it happened, was also one of Cagliostro's closest confidants and friends. The scheming comtesse de La Motte claimed that it was Cagliostro who had made off with the now missing necklace. Thrown into the Bastille, he languished there for almost a year, before offering his testimony

and being exonerated. Still, for a man whose reputation rested on his ability to see the future, read minds, and outwit anyone, this was a public relations disaster.

And it was one from which he never fully recovered.

In the remaining years of his life, Cagliostro and his wife continued their travels, but under an increasing cloud. He was hounded out of several countries, his erstwhile adherents and confederates turned on him, and when he finally turned up in Rome, with the intention of practicing his Freemasonry in the papal city itself, he made his fatal mistake. Arrested by the Inquisition on charges of heresy in 1789, he was tried, convicted, and sentenced to death. His wife was immured in a convent (where she subsequently died). And though Cagliostro's sentence was later commuted to life imprisonment in the fortress of San Leo, he had made his last escape. Confined in almost total darkness, in a dismal cell carved from solid rock, he survived until 1795, when, rumor had it, he was strangled by his jailer.

THE ORDER OF THE GOLDEN DAWN

*I*t isn't often that a magical society has as brilliant a chronicler, and convert, as William Butler Yeats, but the Order of the Golden Dawn did. A poet with a strong religious sensibility and metaphysical yearnings, Yeats was attracted to the mysticism and ritual of the Golden Dawn—and much impressed by MacGregor Mathers, the Scotsman who'd founded the order in 1887.

"At the British Museum Reading Room," Yeats wrote, "I often saw a man of thirty-six or thirty-seven, in a brown velveteen coat, with a gaunt resolute face, and an athletic body, who seemed, before I heard his name, or knew the nature of his studies, a figure of romance. . . . He had copied many manuscripts on magical ceremonial and doctrine in the British Museum, and was to copy many more in Continental libraries, and it was through him mainly that I began certain studies and experiences, that were to convince me that images well up before the mind's eye from a deeper source than conscious or subcon-

scious memory." For Yeats, this source was the *anima mundi,* a kind of collective memory shared by all the members of the human race. Although colored and detailed by our individual lives and experiences, this common memory bank could be accessed by those who properly pursued the mystical course.

The road map, as it were, was provided in the sacred texts that MacGregor Mathers had personally translated and interpreted. Among these texts were such magical standards as the *Key of Solomon,* the Cabbala, and the elaborate Enochian system devised by the Elizabethan astrologer Dr. John Dee. MacGregor Mathers drew from them all, and from another lesser known source, too—an antique manuscript, written in code, that was first discovered in a London bookstall. Mathers, with the help of a couple of other men who were, like himself, Masons, took on the job of deciphering the London text, which turned out to contain instructions for various occult rituals along with general notes on Cabbalistic wisdom and practice. It was this manuscript that was to provide the springboard to the founding of the Order of the Golden Dawn.

Mathers made a good start, attracting to his new order over a hundred intelligent and influential people; besides Yeats, he recruited the writers Arthur Machen, A. E. Waite, and Algernon Blackwood. Lodges were founded in many cities, including Paris, Bradford, and Edinburgh. But what began as a quasi-religious society (one text declared that the establishment "of closer and more personal relations with the Lord Jesus, the Master of Masters, is and ever must be the ultimate object of all the teachings of our Order") gradually changed, as did its leader. The emphasis on magic increased—black magic, in particular—and Mathers, who had never been exactly shy and retiring, became more autocratic and irritable than ever.

In Paris, he claimed to have had a transforming experience. Out walking one night in the Bois de Boulogne, he was suddenly surrounded by spirits, whom he later characterized as "the Secret Chiefs of the Third Order." To him alone would they now confide the secrets of "the Great Work," to him alone would they entrust such arcane knowledge as the true meaning of the

Tree of the Knowledge of Good and Evil; and only he would serve in perpetuity as head of the order.

On this and subsequent occasions, these Secret Chiefs revealed themselves to him in mortal guise, and Mathers wrote that he believed them "to be human and living upon this earth; but possessing terrible superhuman powers." In private, they wore long robes and magical paraphernalia, while in public they looked and dressed like ordinary people, with but one exception —"the appearance and sensation of transcendent health and physical vigour (whether they seem persons in youth or age)." Mathers attributed this physical luster to the elixir of life.

The order also became more and more hierarchical, with eleven grades or degrees, broken down into three categories. Adepts studied geomancy and alchemy, astrology and astral travel. (It was on the "astral plane" that Mathers claimed to conduct most of his sessions with the Secret Chiefs.) Adepts were also taught how to prepare their own magical equipment, which included a cup, dagger, wand, and consecrated sword. The color of the robe they wore indicated what grade they had achieved in the order.

But with Mathers's increasingly authoritarian attitude, coupled with the admission of some unruly members (Aleister Crowley, most notably), the order gradually lost its strength and its original sense of mission. In Yeats's opinion, it was the feud with Crowley (who once claimed to have unleashed forty-nine demons against Mathers) that brought about the ultimate dissolution. Yeats believed that Crowley had been directing a steady, magical current against Mathers for years, sapping his strength, unhinging his wits, and leading finally to his death in 1918.

THE GREAT BEAST

The Order of the Golden Dawn had no more celebrated convert—or, in the end, destructive renegade—than Aleister Crowley, the man who styled himself the Great Beast, after the

fearsome, horned creature described as arising from the sea in the Bible's book of Revelation.

To make matters even worse, Crowley claimed it was his mother who first gave him the nickname.

It's not hard to see where she came by it.

Raised in a wealthy and pious family (after making a fortune in the ale business, his father had become a preacher for the Plymouth Brethren), Crowley turned against organized religion—and Christianity in particular—at an early age. And he did it with a vengeance. His father died in 1886, when Crowley was eleven, and this seems to have put the nail in the coffin of his faith, as it were. Young Aleister, who'd been subject to daily Bible readings at home, turned toward the dark figures of Christian lore, toward Satan, "the Scarlet Woman," and the beast whose number is 666. And his unholy devotion never again wavered.

After a more traditional education at Trinity College, Cambridge, Crowley turned to the Order of the Golden Dawn for the information he really sought. In 1898, he formally joined up, and dubbed himself Perdurabo, a title that meant "I will endure to the end." Over the course of his life, Crowley would take on many more names and aliases—Count Vladimir Svareff, Prince Chioa Khan, Lord Boleskin—and use each one until he became bored with it or until it no longer proved of use. What all these titles were designed to do was make him sound more impressive, moneyed, and mysterious than he actually was.

At first, his membership in the order went reasonably well. He professed to be bowled over by an ancient text that the leader of the order, MacGregor Mathers, claimed to have translated. Entitled *The Book of the Sacred Magic of Abra-Melin the Mage,* "as delivered by Abraham the Jew unto his son Lamech, A.D. 1458," it impressed Crowley as a manual of magic unlike any of the others he'd already perused and, generally, scorned. Among other things it suggested that a long period of purification must be undergone, in a far-off and secluded place, before the Holy Guardian Angel could be summoned and seen. Crowley scoured the Lake District and Scotland, looking for just the right

place, before alighting on Boleskin House, on the shores of Loch Ness.

There, he went about the elaborate rituals the book prescribed, but no matter how many times he tried to invoke the Guardian Angel, he was unsuccessful. By his own account, however, he did manage to conjure up a horde of demons. The entire house, Crowley complained, began to be haunted by strange, dark shapes, and his workroom, where he would spend hours writing down magical formulas, grew so dark, even in the middle of the sunniest day, that he had to keep the lights on around the clock. The groundskeeper lost his mind and tried to murder his own family. When all of this became too much even for Crowley, he took off for Mexico, where, in the hot, dry air, he concentrated on performing such feats of magic as making his own image disappear from a mirror.

Perhaps it was his failure to conjure the Guardian Angel that started his disenchantment, and later feud, with Mathers, but more than likely the break would have come, anyway. Crowley, a big man with a colossal ego and insatiable appetites for everything from drugs to sex, could never last long in anyone else's organization. He charged Mathers with having lied to the members of the order and mocked him for his story of having met the Secret Chiefs in the Bois de Boulogne. What he met there, Crowley claimed, was nothing but a bunch of evil, mischievous spirits, who'd pulled the wool over his eyes. Crowley packed up his things, and his pretty but unbalanced wife, Rose (daughter of the vicar of Camberwell), and set off on a world tour of mountain climbing and spiritual seeking. (In his spare time, he wrote pornography, including one book for his wife, entitled *Snowdrops from a Curate's Garden*.)

In 1904, he stopped in Cairo, where he adopted a strange getup, including a bejeweled turban and silken robes, and traveled through the crowded streets with "two gorgeous runners to clear the way for my carriage." But it was on a visit to Boulak (now the National) Museum that he claimed something very curious had occurred.

His wife, who knew nothing of Egyptian mythology, was wandering through the museum halls in a daze, muttering the name "Horus." When Crowley asked what she was talking about, she pointed at an ancient stele and said, "There—there he is." It was an image of the falcon-headed Horus, the Egyptian sun god, and when Crowley examined it more closely, he saw to his astonishment that it also bore a number—666. The Number of the Beast. He knew then that he was nearing his mystical revelation.

And it came a short time later. At noon one day, his Holy Guardian Angel, which introduced itself as Aiwass, appeared in his Cairo flat. Ordering Crowley to sit and take down every word it spoke, it held forth in a musical voice for the next hour, dictating what would become the opening chapter of Crowley's *The Book of the Law*. Twice more it appeared to him, explaining that it came as a "messenger from the forces ruling the earth at present," and when it was done dictating, Crowley had in his hands the central text in which his philosophy was expressed. Its single most important tenet, the concept around which Crowley's life was to thereafter revolve, was this: "Do what thou wilt shall be the whole of the law."

In brief, *The Book of the Law* argued that up until that time the history of the world had been divided into two eons—the eon of Isis, in which woman dominated, and the eon of Osiris, in which man held sway. But now, in 1904, Crowley declared that the age of Horus, the child, had begun, and that this would be the age of the will (*thelema*), the age in which man was finally able to express his innermost self, unrestrained by the dictates of the church and secular state. "Be strong, O man!" he rhapsodized, "lust, enjoy all things of sense and rapture; fear not that any god shall deny thee for this." Crowley certainly had no fear.

He embarked upon a notorious career of magic and sexual sadism, first in Europe and then, with the outbreak of World War I, in America. He shaved his large head and filed his two canine teeth to a sharp point; when he met his female disciples, he would bite them on the wrist or neck, bestowing what he

called the serpent's kiss. He also founded what he called the Argenteum Astrum (Silver Star), which he said was the Inner Order of the Great White Brotherhood; the Outer Order was the Golden Dawn he'd left behind.

In 1916, he took upon himself the grade of magus, or master magician. As he was to declare in his autobiography, success in magic "depends upon one's ability to awaken the creative genius which is the inalienable heirloom of every son of man, but which few indeed are able to assimilate to their conscious existence, or even, in ninety nine cases out of a hundred, to detect . . . even the crudest Magick eludes consciousness altogether, so that when one is able to do it, one does it without conscious comprehension, very much as one makes a good stroke at cricket or billiards. One cannot give an intellectual explanation of the rough working involved. . . . Magick in this sense is an art rather than a science." And it was an art, in short, that required its practitioners to suspend rational thought and replace it with a kind of unfettered will.

After the war, he wound up in a rented villa in Cefalu, Sicily, where he founded what he hoped would be a magnet for occultists from all over the world. He painted DO WHAT THOU WILT on the front door, drew demons all over the walls of his studio, and even consecrated a temple to the new religion inside. But few came to worship there. Instead, Crowley spent his days addicted to heroin, abusing his several mistresses, and writing, on commission from a British publisher, *The Diary of a Drug Fiend*. The sensation caused by publication of the book led to his being thrown out of the villa altogether. Later in his life, somewhat recovered, he finally composed his veritable last testament, *Magick in Theory and Practice*. Crowley, the Great Beast of the Apocalypse, died of natural causes at the age of seventy-two, on December 5, 1947. His "Hymn to Pan," a flagrantly sexual poem, was read aloud at the funeral service, and the Brighton Council was so scandalized by the incident that it immediately put measures in place to make sure no such thing ever happened again.

DION FORTUNE

\mathcal{A}lthough she was to found her own order later in life—a group known as the Fraternity of the Inner Light—Dion Fortune first embraced the unseen world through the teachings of the Golden Dawn.

She joined because she believed herself to be the victim of a sustained psychic attack.

Born Violet Mary Firth in 1891, she was raised in a Christian Science family, where her marked propensity for daydreaming and deep thought was a subject of some concern; even then, she seemed to show less interest in the material world than the immaterial. So it was perhaps no great surprise that her life should take its most important turn when at the age of twenty she first perceived herself to be the target of a kind of mental curse.

At the time, she was working in an educational institution, where she unintentionally antagonized the principal, a cold and arrogant woman who was known for her highly developed skills in yoga. That woman, Fortune would later come to believe, had twisted the yogic energies into something malign and aimed their destructive force at her. The power of the assault left Fortune physically devastated and mentally drained, but it also pointed her toward her true vocation.

"It was this experience which led me to take up the study of analytical psychology, and subsequently of occultism," she wrote. Trained as a psychologist, an area in which she wrote several other books, she soon decided there was more to the mind than the accepted theories of the time could account for, and she went looking for the rest of the equation in more controversial places—most notably, in the occult practices of the Order of the Golden Dawn. It was only after her initiation into the group that she felt that the damage done to her by that malevolent principal was finally repaired. And she was determined to help others who found themselves under the same kind of attack.

In a book she titled *Psychic Self-Defense* (1930), she laid out some of the best methods for fending off the evil influences. "Sunlight is exceedingly valuable," she wrote, "because it strengthens the aura and makes it much more resistant." But trips into the countryside, presumably to get far away from the malign forces, weren't necessarily recommended because "elemental forces are much more potent away from towns, and if he [the target] is threatened by an uprush of atavistic forces, he had better cling to the haunts of men. The sea, too, is an elemental force that is best avoided for water is an element intimately associated with psychism." Where did she recommend going? "The best place is an inland spa. Games, physical training, massage, anything that improves the bodily condition, are invaluable, but long solitary walks should be avoided. . . ."

She became not only a famed practitioner of many occult practices, including scrying, astral travel, and the Cabbala, but a kind of psychic physician to others who got into trouble on the etheric plane. In one case she recounted, a clumsy magician tried to employ a magic square, but did it wrong. Every night thereafter, he suffered nightmares and unexplained anxiety. Finally, one night, he actually caught sight of the creature now tormenting him: "Its eyes were closed and it was bearded," Fortune relates, "with long flowing hair. It seemed a blind force slowly waking to activity." On a subsequent night, he saw a long red snake slinking out from beneath his bed, and in terror he leapt out of the window. When the blind creature next appeared, the hair on its head had turned, Medusa-like, into a nest of writhing serpents.

Fortune contended that the actual forces of evil in the world had created evil intelligences, entities that had "probably originated through the workings of Black Magic, which took the essential evil essence and organized it for purposes of its own." The presence of these creatures could be detected by sinister sounds, pungent odors, and flickering balls of lights; their effects on humans could range from hallucinations to physical decay.

And even she herself could be tempted to employ them for nefarious purposes. Once, she recalls, as she was lying on her bed thinking about a woman who had done her an injury, and feeling increasingly angry and vengeful, "there came to my mind the thought of casting off all restraint and going berserk. The ancient Nordic myths rose before me, and I thought of Fenris, the Wolf-horror of the North. Immediately I felt a curious drawing-out sensation from my solar plexus, and there materialized beside me on the bed a large wolf. . . . I could distinctly feel its back pressing against me as it lay beside me. . . . I knew nothing of the art of making elementals at that time, but had accidentally stumbled upon the right method—the brooding highly charged with emotion, the invocation of the appropriate natural force, and the condition between sleeping and waking in which the etheric double readily extrudes."

The question now was what to do with the unintended wolf. Summoning up all her courage, Fortune ordered it to get off the bed—which it did. Changing into more of a dog shape, it disappeared through the corner of the room. But Fortune knew the creature was still loose in the world, carrying that explosive psychic charge aimed at the woman who had angered her. She quickly asked her mentor—most probably Aleister Crowley—what she should do; after all, she didn't really want to cause the woman serious harm. Her teacher's advice was to reabsorb the creature, which she could do only by forgiving the woman and defusing, as it were, the ticking bomb.

"I had enough sense to see," Fortune wrote, "that I was at the dividing of the ways, and if I were not careful would take the first step on the Left-Hand path. . . ." Using all her powers of concentration, she called the wolf back to her room, where it appeared "in quite a mild and domesticated mood" on the hearth rug. "From it to me stretched a shadowy line of ectoplasm; one end was attached to my solar plexus, and the other disappeared in the shaggy fur of its belly. . . . I began by an effort of the will and imagination to draw the life out of it along this silver cord, as if sucking lemonade up a straw. The wolf-form began to fade, the cord thickened and grew more substan-

tial. A violent emotional upheaval started in myself; I felt the most furious impulses to go berserk and rend and tear anything and anybody that came to hand. . . ." Eventually, the wolf faded away, vanishing in a gray mist. "The tension relaxed, and I found myself bathed in perspiration."

Throughout her career, which included writing *The Mystical Quabbalah,* one of the few significant additions to the occult canon made in the twentieth century, Fortune resisted that Left-Hand path—the path of evildoing—and used her research and beliefs simply to explore and explain the unseen world. She died in 1946.

MME BLAVATSKY

*H*er magical gifts came to her, she claimed, from sources both ancient and invisible, from the mahatmas of Tibet and the Egyptian goddess Isis. She had traveled long in the Himalayan regions, where she had learned the secrets of clairvoyance, prophecy, and materialization (at a picnic, she once made her cup and saucer appear in her hand out of thin air). She had broken through the wall between this world and the next and could offer her followers—of whom there came to be many thousands, spread across several continents—news from the great beyond. In the history of magic and spiritualism, there are few figures as provocative and, to this day, controversial as Madame Blavatsky.

Born on July 31, 1831, in Ekaterinoslav, Russia, she was the daughter of an army colonel, and she showed her rebellious streak early on in life: at seventeen, she married a much older man, a Russian government official named Nicephore Blavatsky, and before the marriage was ever even consummated (or so she always claimed) she took off for parts unknown. Unaccompanied, she traveled through India, Canada, Mexico, and Texas. Twice she tried to enter Tibet, disguised as a man (as a lone woman, she would never have been allowed in), and once she managed to penetrate the interior before becoming lost; she was

escorted back to the border by a troop of horsemen. Still, whenever she told the story of her life, she drew a veil over the ten years between 1848 and 1858, claiming to have spent them in an unspecified Himalayan retreat, where she learned much from the Eastern spiritual masters.

After returning to Russia, where she achieved a certain celebrity as a medium, she again felt the need to broaden her horizons, and she traveled to America, where the spiritualism craze—begun by the Fox sisters in Wayne County, New York, in 1848—was in full swing. When she arrived in New York City in 1873, she was without friends or resources, she was short and stout (weighing well over two hundred pounds), with a quick temper, unguarded tongue, and chain-smoking habit. But within six years, she had managed to become famous all over the country and had founded an organization, the Theosophical Society, which exists to this day. If this weren't enough to prove her extraordinary powers, there are many firsthand accounts from her contemporaries, which describe her remarkable magnetism and charisma, her ability to bring people around to her own point of view, and her success at recruiting them into her burgeoning group.

The fundamental tenets of theosophy, as promulgated by Blavatsky, were drawn from many sources, ranging from the Cabbala to Buddha, from Hinduism to the Western occult traditions. In brief, the society was dedicated to three main objectives: (1) the formation of a universal brotherhood of man, (2) the study and furtherance of ancient religions, sciences, and philosophies, and (3) the investigation of the laws of nature along with the nurturing of the divine powers lying dormant in every man and woman.

Blavatsky believed, and wrote in her book *The Secret Doctrine,* that all the great religions of the world welled up from one supreme source and were merely different expressions of the same universal truth. This truth, she contended, had been held in trust, throughout the ages, by a mysterious group of Tibetan adepts, or mahatmas (great souls), with whom she was in regular psychical touch. Two of these adepts met and communi-

cated with her on the astral plane, sometimes going so far as to drop letters, with written instructions, down from the ether.

They also helped her to perform the "miracles" with which she attracted crowds and converts. Although Blavatsky herself claimed these "phenomena" were an insignificant part of her mission (and skeptics often proved them to be put-up jobs, involving hidden wall panels and secret confederates), they made an undeniable impression on the public. She could make the flame of a lamp rise and fall simply by pointing at it, she could make rose petals shower down on the heads of the assembled company. When two young gentlemen at a dinner party mockingly referred to the cup and saucer she'd magically produced at the picnic, insinuating that she'd somehow hidden the items beforehand, Madame Blavatsky flew into a rage. Turning to the hostess, she asked her to imagine something that she really wanted, and when the hostess mentioned a brooch that she'd lost years before, Blavatsky told her to envisage it as clearly as she could. Then Blavatsky told the guests to go outside to the flowerbed, where she declared her mahatmas had now deposited it. After a bit of digging, the brooch was found there.

In *Isis Unveiled,* the virtual bible of theosophy which Madame Blavatsky published in two volumes in 1877, she claimed that she had served as an amanuensis to her spirit guides, sitting for hour after hour, smoking her hand-rolled cigarettes (which often contained hashish), and recording what the Egyptian deity and the Tibetan masters dictated to her; sometimes, when she looked up, one of the spirits was holding open a sourcebook for her. According to John Symonds, who wrote a book about Blavatsky, she said of this process:

> I am solely occupied, not with writing *Isis,* but with Isis herself. I live in a kind of permanent enchantment, a life of vision and sights, with open eyes, and no chance whatever to deceive my senses! I sit and watch the fair good goddess constantly. And as she displays before me the secret meaning of her long-lost secrets, and the veil, becoming with every hour

thinner and more transparent, gradually falls off be-
fore my eyes, I hold my breath and can hardly trust
to my senses! . . . Night and day the images of the
past are ever marshalled before my inner eyes.
Slowly, and gliding silently like images in an en-
chanted panorama, centuries after centuries appear
before me. . . . I certainly refuse point-blank to attrib-
ute it to my own knowledge or memory. I tell you
seriously I am helped.

What the guides helped her to understand was that the
world we know is destined to be inhabited by seven "root
races," of which human beings are now the fifth. The first root
race, invisible and made of fire mist, inhabited a region near the
North Pole. The second, which was a bit more visible—and in-
vented sexual intercourse—lived in northern Asia. The third
race, who communicated with each other by telepathy, was
made up of huge, apelike creatures who roamed a lost land in
the Pacific called Lemuria. The fourth, and certainly most fa-
mous, was the denizens of Atlantis, destroyed, in Blavatsky's
outline, by powerful currents of black magic. We humans, the
next in line, are already on our way out, and we'll be replaced
by a race that will live, once again, on Lemuria. When that race
peters out in its own good time, the last root race of all will take
up residence here, before life finally says good-bye to earth al-
together and begins again on the planet Mercury. The time
scheme for all this is, as would be expected, quite vast.

Blavatsky's own time ran out at the age of sixty. After years
of deteriorating health due to heart and kidney disease, she
passed over to the astral plane on May 8, 1891, in the theo-
sophical headquarters on Avenue Road in London.

THE SECRET
DOCTRINE

. . . the Sages have been taught of God that this
natural world is only an image and material copy of
a heavenly and spiritual pattern; that the very
existence of this world is based upon the reality of
its celestial archetype; and that God has created it in
imitation of the spiritual and invisible universe, in
order that men might be the better enabled to
comprehend His heavenly teaching, and the
wonders of His absolute and ineffable power and
wisdom. Thus the sage sees heaven reflected in
Nature as in a mirror; and he pursues this Art, not
for the sake of gold or silver, but for the love of the
knowledge which it reveals; he jealously conceals it
from the sinner and the scornful, lest the mysteries
of heaven should be laid bare to the vulgar gaze.

Alexander Seton, *The New Light
of Alchemy* (c. 1640)

THE ALCHEMISTS' ART

*W*hether the alchemist was most concerned with material or spiritual gain is still a subject of debate, but transformation, in one form or another, was always his goal. Plumbing the mysteries of nature—how matter came into being, why it took the shapes it did, how it could be transformed—these were the questions that occupied the mind of the alchemist, and these were the mysteries that comprised what was sometimes called the Secret Doctrine or the Great Work.

In the material sense, the chief aim of alchemy was to change baser metals—lead, tin, iron—into the most noble metals of all, silver and especially gold, using a mysterious substance known as the philosophers' stone. Apart from its obvious value, gold was considered to have miraculous restorative powers and properties.

In the more philosophical sense, alchemy was a system of thought designed to improve and ultimately perfect the human nature of the alchemist himself. "Out of other things thou will never make the One," wrote the sixteenth-century German alchemist Gerhard Dorn, "until thou hast first become One thyself."

But whatever the specific aims and practices of the alchemists' art, they were always cloaked in great mystery and in language almost impossible to comprehend: "Take the serpent and place it on the chariot with four wheels and let it be turned about on the earth until it is immersed in the depths of the sea . . . and when the vapour is precipitated like rain . . . you should bring the chariot from water to dry land, and then you will have placed the four wheels on the chariot, and will obtain the result if you will advance further to the Red Sea, running without running, moving without motion" (*Tractatus Aristotelis ad Alexandrum Magnum*).

Try that in your home laboratory.

There were several reasons for the deliberate obfuscation of

the alchemists' texts. For one thing, these magical arts always ran the risk of being declared heresy in the eyes of the church, and its practitioners could wind up tied to a stake. So the less that could be proved against them, the better.

For another, it was important, as far as the alchemists' fraternity was concerned, to keep their secrets and discoveries to themselves. If the formulas for making gold or for the alchemists' ancillary aims (such as the discovery of the elixir of life, "the universal solvent," or the creation of homunculi) fell into the wrong hands, they might be used for nefarious or unholy purposes. As Thomas Norton of Bristol put it, in his fifteenth-century manual the *Ordinal of Alchemy*:

> This art must ever secret be,
> The cause whereof is this, as ye may see;
> If one evil man had thereof all his will,
> All Christian peace he might easily spill,
> And with his pride he might pull down
> Rightful kings and princes of renown.

Thirdly, skeptics might say the reason for all the obscurity was, quite simply, that there was nothing there. The alchemists were engaged in an elaborate con game, and making sure that no one understood them was the best way of making sure that no one could question the depth and profundity of their "science."

When all is said and done, there's probably some truth in all of these reasons.

As it is, there was a good deal of discrimination and discord among the members of the alchemical brotherhood itself; those who thought they were practicing the true science—the self-proclaimed adepts—looked down their noses at the rank amateurs, the dabblers and dilettantes whom they thought were debasing their calling. In fact, they had a nickname for them—puffers—after the bellows that these struggling alchemists spent so much time plying in their cluttered, makeshift laboratories.

Even so, the adepts, too, had more than their fair share of equipment—retorts, furnaces, flasks, alembics, grinders, copper pots, crosslets, etc. But it was repeatedly written that most of this elaborate paraphernalia was unnecessary to the true work: in the *Guide charitable,* now in the Bibliothèque de l'Arsenal, it was stated that "the whole expense of the Stone will not be very considerable; the first elements of the Great Work cost little; earthenware vessels, the furnace, charcoal, and various utensils suffice." As for the rest, the serious alchemist was advised to look to the book of nature, which was open all around him, and to maintain the proper attitude. After Nicolas Valois completed what he claimed was a successful transmutation, he offered this recommendation: "thou wilt do as I did it," he declared, "if thou wilt take pains to be what thou shouldest be—that is to say, pious, gentle, benign, charitable and fearing God."

THE ORIGINS OF ALCHEMY

*A*lthough its earliest origins will never be known for certain, there's no question that alchemy is one of the oldest and most practiced of the occult arts. According to one legend, of Arabic derivation, it was God himself who handed down the secrets of alchemy to Moses and Aaron.

But according to another legend, this one recounted by Zosimus of Panopolis, it was an order of fallen angels, known as the Watchers, who passed along the vital information. Why? Because these angels had watched over humankind so diligently that they'd fallen in love—or lust, to be more accurate—with their wards: "And it came to pass, when men began to multiply on the face of the earth, and daughters were born unto them, that the sons of God [the angels] saw the daughters of men that they were fair; and they took them wives of all which they chose" (Genesis 6:1–2). Along with the other skills these angels imparted to their human wives—skills such as botany, astrology, and the use of cosmetics to enhance their appearance—was al-

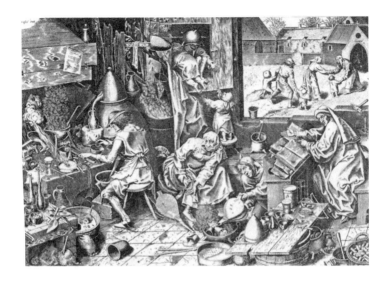

chemy. Needless to say, God took a very dim view of these proceedings.

One of the books of Enoch, which were not included in the Old Testament, tells a similar story, and Tertullian, the early Christian writer, goes on the record to say that it was indeed these wicked angels who introduced mankind to all sorts of magical arts, not least among them the ability to create and harness the powers inherent in gold and silver and lustrous stones. Tertullian went on to say that the master of these alchemists, and of all others who pursued the secrets of nature, was the Egyptian god Thoth, also referred to by Alexandrian Greeks as Hermes Trismegistus (or Thrice-Great Hermes, to distinguish him from the other Hermes of their classical homeland). Hermes was generally credited with being the inventor of the arts and sciences, and as a result, alchemists often described what they did as the hermetic art. (Today, when we say that something is hermetically sealed, we are actually referring to the seal of Hermes that alchemists placed upon their vessels and flasks.)

If anything at all can be agreed upon in respect to the origins of alchemy, it's that the seeds of the science were sown and first flourished in ancient Egypt among those Greeks of Alexandria. In the tenth century, the Arab scholar al-Nadim wrote his *Kitab-al-Fihrist,* in which he declared that the "people who practice alchemy, that is, who fabricate gold and silver from strange metals, state that the first to speak of the science of the work was Hermes the Wise, who was originally of Babylon, but who established himself in Egypt after the dispersion of the peoples from Babel."

Papyri from the third century A.D., found in a tomb in Thebes and partially written in Greek, offer in great detail the methods used by jewelers to manufacture alloys that simulate gold. They're not meant to be occult texts, and the information they present is really nothing more than trade secrets for the making of costume jewelry. But it's more than likely that over time, the practitioners of the art, realizing the fantastic success they were having with marketing fake gold, started to believe their own sales pitches. Later texts increasingly obscure the actual methods of coloring metals and making alloys, and elaborate instead on the arcane theories and claims of transmutation.

As the Arab empire spread itself into Spain and Morocco, this body of knowledge was carried along, where it was commingled with mystical Jewish practices and translated into Latin; the Latin translations brought word of it westward. Most notable of these translations was *The Book of the Composition of Alchemy,* which Robert of Chester completed on February 11, 1144, and in which he announced that he was introducing his readers to a whole new subject of study. From then on, alchemy flourished, and by the thirteenth century it had found in men like Albertus Magnus, Roger Bacon, and Arnold of Villanova its most learned advocates and practitioners. Over a thousand years after it had begun, among the jewelers and early metallurgists of ancient Egypt, alchemy put down its deepest roots in the soil of western Europe.

THE PHILOSOPHERS' STONE

*I*f, by most accounts, the primary aim of alchemy was to discover the method of making lesser metals into gold, the first and most important step toward that goal was to discover the elusive philosophers' stone.

What was the stone? To that, there's no simple answer. According to some authorities, the stone, also known as the powder of projection, was a substance made of fire and water; to others it was an invisible gift from God. In the words of Nicolas Valois, a fifteenth-century French alchemist and author of *Cinq livres,* "It is a Stone of great virtue, and is called a Stone and is not a stone."

A seventeenth-century English alchemist, who wrote under the name of Eirenaeus Philalethes, was a tiny bit more specific. In *A Brief Guide to the Celestial Ruby,* he wrote that the stone was "a certain heavenly, spiritual, penetrative, and fixed substance, which brings all metals to the perfection of gold or silver. . . . It is the noblest of all created things after the rational soul, and has virtue to repair all defects both in animal and metallic bodies, by restoring them to the most exact and perfect temper. . . ."

The recipes for its concoction are some of the most abstruse imaginable. But however you went about getting it, or making it, the philosophers' stone was considered absolutely vital to the transmutation of metals. It was the miraculous powder, elixir, chemical, that could transform one thing into another. A dash of the stone and any man could turn his tin cup into a golden goblet.

Many men spent their whole lives trying.

Alchemy, also known to its adepts (or masters) as the great art, was an all-consuming practice, which required absolute devotion, constant work, and an unwavering attention to detail; if he ever hoped to distill the stone, the alchemist was advised to lead a pure and blameless, contemplative, and abstemious life.

Known for their long beards, long robes, and absentminded, otherworldly demeanor, alchemists spent their days poring over dusty folios, deciphering inscrutable texts, and, most of all, conducting endless experiments in their homegrown laboratories. As astrology was in many ways the precursor of astronomy, so alchemy was the precursor of chemistry. (It was while he was conducting his search for the stone that alchemist Hennig Brand accidentally discovered phosphorus.)

The fundamental idea behind the philosophers' stone was this: metals "grew" in the earth, just as plants grew in the soil, and as all things aspired upward, so, too, did these humble metals aspire to become gold. The alchemist's job was to strip these metals of their baser properties, and through the addition of the stone, help them to achieve their highest state—which just so happened also to be their most valuable state.

There were, of course, countless claims of success. The Swiss alchemist Paracelsus was the most renowned for the feat (even though, strangely enough, he died leaving no great estate). An experimenter named J. B. van Helmont (1577–1644) declared that he'd managed to transmute mercury into gold. And as late as 1782, an Englishman named James Price—a doctor, chemist, and Fellow of the Royal Society—was displaying a couple of mysterious powders, which he claimed would yield gold and silver when mixed properly with other ingredients. To get silver, he took the white powder, mixed it with fifty or sixty times its weight in mercury, tossed in borax and niter, then heated the result in a crucible; to keep things suitably fluid, he stirred the mixture with an iron rod. To get gold, he used a red powder and otherwise followed the same procedure. When the resulting metals were tested at assay, they proved to be quite genuine.

The Royal Society was so impressed with Price's discoveries that they invited him to conduct these experiments in front of some of their own trained observers; news like this, the society declared, was too good to be kept secret. Price agreed, though he must have been having some pretty serious doubts, because he had no sooner arrived for the demonstration than he swal-

lowed a draft of prussic acid, fell writhing to the floor, and died. Later inquiry suggested that the iron rod, which he'd been using to stir the solution, was actually hollow, and that he'd been injecting the gold and silver into the crucible through its stem.

THE ELIXIR OF LIFE

*P*erhaps it should come as no surprise that the second great aim of the alchemists, after the secret of transmuting metals, was the discovery of the elixir of life, the miraculous liquor that would restore the physical body and even bestow immortality. Many an aged alchemist, having toiled in penury and want all of his life, no doubt dreamed of stumbling upon the fountain of youth, the elixir that would make all of his travails worthwhile and grant him a second chance to enjoy life. On their deathbeds, several of them claimed to have discovered this amazing secret.

But, given the fact that they all went ahead and died anyway, this seems highly unlikely. (Right up to the last, the German abbott best known as Trithemius was dictating the recipe for a concoction that he promised would give perfect health and memory to anyone who took it.)

The idea of such an elixir was as old as the gods themselves. The ancient Greeks believed the mighty figures on Mount Olympus sustained themselves, for eternity, by feasting on nectar and ambrosia. And alchemists, who believed all things had to be stripped of their corruption and brought to their highest, purest state, believed no less of the human body: it was all a matter of refining and purging, of ridding the body of one illness or imperfection after another, until it had prevailed over all of its afflictions, and its "humours" (vital essences) had been brought into perfect balance. "For since there is one single and most general beginning of all corruptions," wrote Gerhard Dorn, "and one universal fount of regenerating, restoring, and life-giving virtues—who, save a man bereft of his senses, will call such a medicine in doubt?" Who indeed?

Theory aside, the alchemists believed the elixir existed for

another reason, too: they just couldn't fathom a god who would grant to lowly beasts a gift he withheld from his highest creation, man. "Let us turn rather to Nature," wrote Arnold of Villanova in a tract published in Paris in 1716, "so admirable in her achievements. . . . Is it possible that she will refuse unto man, for whom all was created, what she accords to the stags, the eagles, and the serpents, who do annually cast aside the mournful concomitants of senility, and do assume the most brilliant, the most gracious amenities of the most joyous youth?" Stags were thought to renew themselves by eating snakes and vipers; lions were thought to do the same by devouring the flesh of pepper-eating apes; certain birds, it was said, lived for six hundred years, elephants for three hundred, and horses for one hundred. "From all which considerations," Villanova concluded, "it follows that it is not beyond belief that a like prodigy may be found in the superior order of the same productions whence man himself has been derived, for man is assuredly not in a worse condition than the beasts whom he rules." When all was said and done, the alchemists were arguing that it just wasn't fair for animals to get a better deal than humans.

And they bent every effort to rectifying this strange inequity.

In antique times, Aristaeus declared that he had found it, the miraculous compound that would transmute metals and grant man the gift of immortality. He was thought to have lived already several hundred years, and many of the inhabitants of his native Sicily were so impressed that they built temples where they could worship him as a kind of god.

An early nineteenth-century text on alchemy, written by K. C. Schmieder, points to a fifteenth-century magician named Salomon Trismosin and states that after he'd ingested a half grain of his own compound, "his yellow wrinkled skin became smooth and white, his cheeks red, his grey hair black again, and his bent spine was lifted vertically."

Denis Zachaire, author of the *Opuscule très excellent de la vraye philosophie naturelle des métaux,* even offered the prescription for using a dash of the philosophers' stone as a cure-all: "To use our Great King [the stone] for restoring health, a grain weight

of it must be taken after its production and dissolved in a silver vessel with good white wine. The sick person must be made to drink this, and he will be cured in a day if the illness is of only a month's standing; if it is of a year's standing he will be cured in twelve days. To remain in perpetual good health he would have to take some of it at the beginning of the autumn and spring, made up in the form of a confected electuary." (An electuary was a pasty concoction made up of a powdered medicine and a sweet syrup to help it go down.)

H. Zedler's *Universal Lexicon,* published in the eighteenth century, described a "panacea aqua," which a Parisian practitioner reportedly employed to cure several patients. The panacea appeared to be nothing more than highly distilled water.

And of course there were the stories that every alchemist told of his own miraculous discoveries and successes. Cagliostro's was one of the most famous.

Consulted by an aging noblewoman desperate to recover her lost youth, Cagliostro prescribed two drops of his precious Wine of Egypt, to be taken only when the moon had entered its last quarter. As that event was still a short time off, the old woman locked up the vial in her wardrobe cabinet and, to further ensure its safety, told her maid it was nothing more than a cure for the colic. But as bad luck would have it, the maid suffered a terrible bout of the colic on the very next night, and remembering the vial, opened it and drank its entire contents.

The next morning, feeling very much better, the maid went to her mistress's room and pulled aside the bed curtains. The old lady looked at her with confusion, asking who she was and what she wanted.

"Who am I?" the servant replied. "I'm your maid."

"But that can't be," the noblewoman said. "My maid is a woman fifty years old."

The maid put her hand to her face, then turned to look at herself in the mirror. What she saw there was a fresh-faced twenty-year-old, free of wrinkles, cured of the colic, and probably out of a job.

THE ALKAHEST

*I*f there was a third string to the alchemists' bow, a third secret that the fraternity was bent on discovering, it was the alkahest, or universal solvent.

All things in the universe, according to the alchemists' understanding, could be broken down in the end to what they called the *prima materia,* the first matter, the essence to which everything, both material and immaterial, could be reduced.

But this essence was very tough to pin down and isolate. It was fleeting, fragile, impossible to discern with the naked eye. If this ultimate reduction of all things was captured at all, it would have to be in the form of a mysterious liquid, which would have the power of dissolving all things it came into contact with.

The difficulties become readily apparent.

One of the first to pursue the alkahest was Paracelsus, who claimed, in his book entitled *Members of Man,* that the alkahest acts "very efficiently upon the liver; it sustains, fortifies and preserves from the diseases within its reach. . . ." In another of his books, *On the Nature of Things,* Paracelsus discussed an elixir that can transmute and perfect metals. Though he doesn't say so explicitly (and in alchemy texts, nothing is ever clear or explicit), it sounds again like he's claiming to use the alkahest to conduct his experiments.

In the early seventeenth century, a Dutch alchemist named Jan Baptista van Helmont took the cue from Paracelsus and went after the alkahest in a big way. Claiming to have used divine inspiration in his pursuit of the elusive essence, he said he'd finally found it. It dissolved everything it touched, he proclaimed, just "as warm water dissolves ice." Not only that, it was the most spectacular wonder drug the world had ever known: "It is a salt, most blessed and perfect of all salts; the secret of its preparation is beyond human comprehension and God alone can reveal it to the chosen." Of which he seemed to be about the only one.

But for the next couple of hundred years, the search was on—and heated. Alchemists, chemists, doctors, magicians, herbalists, seers, everyone was after this great prize, and many of them claimed, at one time or another, to have found it. One of the more impressive claims was staked by Johann Rudolf Glauber, a German pharmacist born in Carlstadt in 1603. What Glauber had actually stumbled upon was sodium sulfate, which he called Glauber's salt. Echoing van Helmont, he declared that anyone pursuing this arcane research must understand that "such a work is purely the gift of God, and cannot be learned by the most acute power of human mind, if it be not assisted by the benign help of a Divine Inspiration." Offering some encouragement to those who hoped to follow his lead, he said he was sure "that in the last times, God will raise up some to whom He will open the Cabinet of Nature's Secrets. . . ."

Another alchemist, Johann Kunkel, wasn't so sure. Perhaps frustrated by his own unsuccessful attempts, Kunkel declared that "such a dissolvent does not exist, and I call it by its true name, *Alles Lugen ist,* 'all that is a lie.' " Voicing the obvious and insurmountable problem, Kunkel said, "If the alkahest dissolves all bodies, it will dissolve the vessel which contains it; if it dissolves flint, it will render liquid the glass retort, for glass is made with flint." Although Kunkel's declarations didn't put an absolute stop to the search—one adept asserted that he'd found the universal solvent and that he was able to store it in a vial of wax—much of the enthusiasm was inevitably lost.

PARACELSUS

*H*e was bald and fat, with a violent temper and a caustic tongue. His manners were notoriously coarse, and his clothes shabby and disheveled. His face was known to turn purple with rage. But Paracelsus was also a pioneer of medical science and an occultist of the first stripe. Everywhere he went—and in his life he went virtually everywhere, from Sicily to Sweden to France to Egypt—he stirred up trouble, made headlines, and chal-

lenged the authorities, whether they were secular or scientific, religious or royal. When he died under mysterious circumstances at the age of forty-eight (some say he was poisoned, others that he was thrown from a cliff by his enemies), he left behind him a legacy of obscure texts, fantastic stories, and, perhaps most important, scientific methods that are in essence used to this day.

He also gave us the word "bombast." Born Theophrastus Bombast von Hohenheim in 1493, his own name came to signify a loud and aggressive personality. It was only later in life that he chose to call himself Paracelsus, to signify his superiority to the ancient Roman physician known as Celsus. Modesty was never one of his virtues. His father was a Swiss physician, and his mother had supervised a hospital before getting married, but Paracelsus was bored and restless with the usual course of study. Even at sixteen, when he discontinued his studies at the University of Basel, he was already fed up with the rote learning that passed for education in his day. He took off for the abbey at Sponheim, where he absorbed all that he could from the abbot there, Trithemius, whose own chemical experiments—in search of the philosophers' stone and the universal cure-all, which he called the Grand Catholicon—were considered the most advanced and successful to date.

His next stop, when even that began to pall, was the Tirol, where he studied firsthand the lives of the miners who toiled for the wealthy and powerful Fugger family.

Paracelsus learned a lot there. First, he learned a great deal about minerals, ores, and precious metals, about stones and soil. All of this knowledge would later figure greatly in his chemical and astrological studies.

But he also studied the injuries the miners routinely suffered in the pits and the bronchial diseases they endured. And he rapidly became disenchanted with the standard medical wisdom and practices. Up until that time, doctors relied almost entirely upon the wisdom of the ancients, on the theories and advice handed down by Galen and Avicenna and Aristotle. Paracelsus would have none of it; if he couldn't see something with his own

eyes, he refused to believe it. If he couldn't determine the efficacy of some treatment by testing it on his own patients, he made up his own treatment instead. He was bold, he was uncompromising, and he was, above all, open to knowledge wherever it might come from.

"Everywhere," he writes, "I inquired diligently and gathered experience of the true medical art, not alone from doctors but also from barbers, women, sorcerers, alchemists, in convents, from the low ranks and from those of the nobility, from the intelligent and the simple-minded."

When he returned to Basel in 1526, he was made town physician and given a teaching appointment at the university there. But in no time he had riled his fellow faculty members, first by lecturing in German (when Latin had always been the accustomed tongue) and second by challenging the standard texts. Indeed, he went so far as to take the books of Galen and Avicenna, toss them into a brazen vase, and burn them.

Not that this endeared him to any of the other practicing physicians of his day. (Or the apothecaries, who made their living selling the concoctions that the ancients had formulated and prescribed.) Paracelsus was attacked for his theories and for his lack of professional degrees. But he argued back that he had learned what he knew from the best source of all—life itself, which he had observed and analyzed. "Whence have I all my secrets," he asked, "out of what writers and authors? Ask rather how the beasts have learned their arts. If nature can instruct irrational animals, can it not much more men?" The fact that Paracelsus presented lectures based on his own discoveries and observations was revolutionary.

But it was all, ultimately, too much for Basel to handle. Things came to a head when one of Paracelsus's patients, whom he had successfully cured, refused to pay his bill. Paracelsus brought suit against him, and, though he was indisputably in the right, he lost the case; that's when he decided there was no point in remaining there. He packed up his belongings and left—but not before dropping a few choice words for the "wormy lousy

sophists" who had, he felt, influenced the verdict and made his university tenure so troublesome: "You are nothing but teachers and masters combing lice and scratching," he declared. "You are not worthy that a dog should lift his hind leg against you. Your prince Galen is in hell, from whence he has sent letters to me, and if you knew what he told me, you would make the sign of the cross on yourselves with a fox's tail." Pronouncements like these made Paracelsus fresh enemies wherever he showed up.

But it was his genius, combined with the undeniable force of his personality, that also made him such an influential figure. And though his scientific methods and much of his philosophy were wise and insightful—it was Paracelsus who was one of the first to understand the powerful influence of the mind on the body, to realize that the dread of disease was sometimes worse than even the disease itself—he was also the ardent proponent of mystical ideas and systems that defied not only logic but any empirical attempts to verify them. He was, quite clearly, a man of vast contradictions.

"Resolute imagination," he once said, "is the beginning of all magical operations." And through the practiced use of imagination, Paracelsus believed many things were possible: "It is possible that my spirit, without the help of my body, and through an ardent will alone, and without a sword, can stab and wound others. It is also possible that I can bring the spirit of my adversary into an image and then fold him up or lame him at my pleasure." He believed that imagination could allow a man to predict the future and to see what his friends were doing, even if they were in another country.

He also contended that it was possible to create life in the laboratory and claimed that he'd done it himself—that he'd formulated an artificial human being, a creature known as a *homunculus*. He even offered the recipe in one of his books. First, it was necessary to deposit a sizable specimen of human semen into a flask, then seal the flask tightly and bury it in a pile of horse manure. It was also important to "magnetize" the sample

properly, though it's not entirely clear what that meant. Forty days later, Paracelsus claimed, a tiny, transparent proto-human would appear inside the flask.

The next step was to take the flask back into the lab and start adding to it daily doses of human blood; for forty weeks, the flask was to be kept at the steady temperature of a mare's womb. If everything had been done according to the instructions, at the end of that time you'd have a fully formed, though small, human child, altogether normal in every other way. "It may be raised and educated," Paracelsus wrote, "until it grows older and is able to look after itself."

Paracelsus had devised an elaborate and mysterious system in which all things in the universe were interconnected, and influenced each other for good or ill. And man was simply a microcosm of the whole; to understand how all things operated on each other in the outer world was to understand how they would operate inside the individual human being. For instance, he believed in a strong astral influence upon the body: "A physician who wishes to be rational must know the constitution of the universe as well as the constitution of man. . . . All the influences that come from the sun, the planets and stars act invisibly upon man, and if these influences are evil they will produce evil effects."

Each of the major organs in the body, according to Paracelsus, was developed under the influence of a particular planet or star and worked in some mysterious conjunction with it. The heart, he asserted, was in sympathy with the sun, while the brain related to the moon; the gallbladder was under the sway of Mars, the kidneys Venus, and the spleen Saturn. Thus, he argued, "If a man gets angry, it is not because he has too much bile, but because the Mars combative element in his body is in a state of exaltation. If a man is amorous it is because the Venus element in his body is in a state of exaltation." If those two in particular come together, the result is a fit of jealousy.

Plants and metals, too, had their celestial correspondences. But if the physician was sufficiently skilled and knowledgeable,

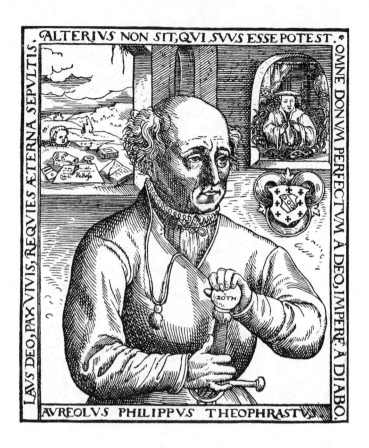

Around the image border: ALTERIVS NON SIT, QVI SVVS ESSE POTEST. · LAVS DEO, PAX VIVIS, REQVIES ÆTERNA SEPVLTIS. · OMNE DONVM PERFECTVM A DEO, IMPERF. A DIABO. · AVREOLVS PHILIPPVS THEOPHRASTVS

he could take all of this into account when tending to his patients. His reasoning may not have always been right, but Paracelsus's prescriptions often were; in an era when bleeding and purging and emetics were the usual methods, he used new plant- and mineral-based pharmaceuticals of his own invention, employing opium, mercury, sulfur. He recommended natural baths, and opening sick rooms to fresh air and sunlight, and taking antiseptic measures when performing surgery. He asserted that epileptics, contrary to popular wisdom, were not lunatics possessed by demons but simply people afflicted with a strange disease.

In the end, it was Paracelsus's contention that, even though

"our astral bodies are in sympathy with the stars," it was "absurd to believe that the stars can make a man. Whatever the stars can do we can do ourselves, because the wisdom which we obtain from God overpowers the heavens and rules over the stars."

ROBERT FLUDD

*A*mong the most prolific and successful of Paracelsus's followers and disciples was the English physician and alchemist Robert Fludd.

The son of Sir Thomas Fludd, the treasurer of war to Queen Elizabeth in France and the Low Countries, Fludd was born in Milgate, Kent, in 1574 and later educated at Oxford. He studied medicine, ultimately becoming a Fellow of the College of Physicians, but it was while traveling in Europe for six years that he first became acquainted with the work and the theories of Paracelsus. In London, he set up his medical practice in a house on Fenchurch Street, where he practiced medicine with great success—in part because of his indisputable skills and in part because he was well known for his amiable and curious disposition. But he was never satisfied with the conventional wisdom or accepted methods. He was always pushing at the boundaries, trying to find new forms of treatment, and even more important, new ways to understand how the innermost workings of the cosmos might be reflected in the constitution of the individual human beings whom he saw in his daily practice. Fludd was convinced that the connection was there.

In an attempt to discover how it worked, he took up alchemy and studied the Cabbala; he read the ancient philosophers and became an active member of the Rosicrucians. (Indeed, when the Rosicrucians came under attack from several German authors, he wrote, in 1616, a vigorous defense.) Fludd was astonishingly eclectic in his tastes and interests, taking at

once both progressive stands, such as a firm belief in actual experimentation, and more "mystical" positions, such as his abiding faith in the as-yet-undiscovered philosophers' stone and elixir of life.

His theory of disease was especially novel. He believed that a wind, under the control of an evil spirit, could agitate other evil spirits (which were at all times hovering in the air unseen) and cause them to enter a person's body, either through his open pores or into his lungs while he was breathing. If there was a vulnerable point in the body, these evil spirits, Fludd felt, would be sure to find it; they would then attack the places where the four bodily humors were out of balance, which would, in turn, cause the disease to erupt. If the imbalance wasn't attended to, it could lead to the total collapse and death of the patient.

To fight the malady, Fludd recommended the application of sympathetic compounds, which would stimulate the angelic forces (something like heavenly antibodies) and counteract the illness. Among these compounds were herbs collected under the correct astrological influences, chemical solutions, and in some cases "magnetic" preparations. In his 1631 book, *Integrum Morborum Mysterium* (The Whole Mystery of Diseases), he laid out his theory in great detail.

Magnetism, too, was one of Fludd's most fondly held beliefs. Each and every person, he contended, shared, with the earth itself, a positive or negative, active or passive, magnetic polarity. Natural attractions and aversions between people could be traced back to something as simple as their respective emanations.

Fludd also explored, with considerable zeal, the notion commonly known as the music of the spheres. The world and the heavens above were like one huge instrument, he argued, the keys of which were attuned to the intervals between such things as the angelic hosts and the fixed stars, the planets and the elements (or material world). In this, he was following the lead of Agrippa von Nettesheim, who had written that "musical har-

mony is a most powerful conceiver. It allures the celestial influences and changes affections, intentions, gestures, notions, actions and dispositions. . . . It lures beasts, serpents, birds, to hear pleasant tunes. . . . Fish in the lake of Alexandria are delighted with harmonious sounds; music has caused friendship between dolphins and men."

For all his strange theories and convictions, Fludd was a pivotal figure in the history of science, medicine, and philosophy, one of the last to try to bridge the gap between the medieval/Renaissance perspective and the coming scientific revolution.

When he died in London on September 8, 1637, he had left careful instructions as to his burial. His undisturbed body was wrapped in fresh linen, as ordered, and transported to the inn at Bearsted in Kent. After night had fallen, the corpse was carried in a torchlight parade to the parish church and interred under the floor there. Afterward, the mourners (for many of whom Fludd had left money to pay for their funeral clothes) went back to the inn to enjoy a healthy repast (also at the good doctor's expense).

ALEXANDER SETON

*F*or a seventeenth-century Scotsman named Alexander Seton, it was a shipwreck that gave his alchemical career just the boost it needed.

In 1601, while residing in relative obscurity in a coastal town not far from Edinburgh, he happened to spot a Dutch merchant ship foundering offshore. Bravely, Seton went about rescuing several of the crew members from the raging sea, then put them up in his own house until they were well enough to return to their homes; as they had lost everything at sea, he even helped to cover their travel expenses. In return, the pilot, James Haussen, invited Seton to visit him in Holland.

Shortly thereafter, Seton took him up on it.

While Seton was in Holland, he mentioned to his host that the line of work he was in was alchemy; to prove it, he conducted a couple of transmutations that absolutely astonished Haussen. Haussen then told a prominent Dutch physician about it, the physican told his grandson, who mentioned it to a friend who was a famous author, who then wrote to an alchemical journal a letter about this remarkable foreigner and his discoveries. Seton's name was suddenly being bandied about everywhere, and everyone wanted to know if his claims were true.

Seton embarked on a lecture and demonstration tour, traveling to Amsterdam and Rotterdam, then Italy, Germany, and Switzerland. In Basel, he gathered together some of the most important people in town and conducted one of his experiments in front of them. Wolfgang Dienheim, an avowed skeptic of alchemy who was also present, has left a description of Seton "as short but stout, and high-coloured, with a pointed beard, but despite his corpulence, his expression was spiritual and exalted." Apparently, Dienheim was convinced by the demonstration and thereafter became one of Seton's supporters.

In Munich, Seton took a little time off from work and used it to woo and win a local maiden. In fact, he was so happy with his newly married state that when he received an invitation from the youthful elector of Saxony, Christian II, to come and demonstrate his skills, he refused to part from her and sent an apprentice, William Hamilton, instead. Using the secret transmuting agent, Hamilton was able to create gold that passed every test with flying colors. Far from satisfying the elector, however, this just made him that much more anxious to see Seton himself. He sent another request—which, coming from him, was tantamount to an order—and this time Seton reluctantly kissed his young bride good-bye and left for the elector's court in Dresden.

He would soon be sorry that he did.

As soon as he got there, it became plain to him that it wasn't just a demonstration that the elector was after, nor was it a small

measure of the magical powder. What Christian II wanted from Seton was nothing less than his secret, the method by which he made the gold, and he wouldn't be satisfied until he'd pried it loose. When Seton refused to give it to him, citing the higher purposes of the great art, Christian had him thrown into a tower prison, where he was guarded round the clock by forty soldiers. Seton was put to the rack, he was roasted over a slow fire, he was whipped and scourged, but he still refused to talk. The elector left him in his cell, presumably to rot.

But no one who could make gold from lead could languish long. A Moravian chemist named Michael Sendivogius had a little influence with some friends at the elector's court, and using it he was able to pay a visit to the imprisoned Seton. That's when they struck a deal. If Sendivogius would help him escape, Seton would tell him the secrets of his art. Sendivogius sold all his property and took up residence near the prison. With the money he'd raised, he bribed several of the guards, and on the night of the planned escape he paid for a huge feast for all the other soldiers; while they were sleeping off the effects of the lavish food and drink, Sendivogius broke into Seton's cell. To his consternation, he found that the master alchemist could barely walk anymore.

Still, Sendivogius was able to carry him out of the tower and into a waiting carriage. They took off together, stopping only long enough to pick up Seton's wife and the remaining quantity of the secret powder, and didn't stop again until they'd reached the safer environs of Cracow. There, they settled down, to rest and recover.

But Sendivogius, having done his part, now demanded the other half of the bargain; he insisted that Seton keep his promise and tell him the secrets of transmutation. But Seton refused, claiming that it was too terrible a burden for him, as an adept, to pass on to his pupil. Within two years, still suffering from the tortures he had undergone at the elector's court, Seton died— leaving only the remaining powder, but no formula, to Sendivogius. Desperate and frustrated, Sendivogius turned to Seton's

widow; he courted and later married her, in the hope that she would hand on to him her dead husband's secret knowledge. But there again, he was in for a disappointment. She hadn't a clue.

The most important thing Sendivogius discovered among Seton's effects was a manuscript called "The New Light of Alchymy," which he seems to have decided to put his own name on. Using some of the instructions in the book, he tried to produce more of the magical powder, but all he wound up doing was squandering the small amount he used in the experiments. Carefully preserving what was left, he took off on a Continental tour of his own, claiming he possessed the secrets of the great art and sparingly using the last of Seton's powder. According to one French witness, a dose of the powder was introduced into a glass of wine; then a crown piece was dipped into the mixture. The part of the coin that had been immersed turned to gold— and showed no signs of having been soldered or fraudulently made.

Sendivogius managed to scrape along on his reputation for many years, bilking potential investors out of substantial sums, even acquiring a country estate from King Sigismund of Poland, until in 1646, aged eighty-four, he died in Parma, no closer to the actual secrets of the great art than ever.

THE SCOURGE OF MILAN

*D*espite their reputations as everything from sorcerers to charlatans, alchemists were seldom accused of committing acts of great and purposeful evil. But in seventeenth-century Milan, one such alchemist was—and a column was erected on the site of his razed home to remind posterity of the terrible deeds he confessed to having done there.

His name was Pietro Mora, and he lived in one of the oldest houses in a remote quarter of the city. Though no one could say exactly where his fortune came from, he was a very wealthy

and mysterious man; rumor had it that he had concocted a red powder which he used to transmute base metals into the gold that every alchemist sought.

Other rumors circulated, too. Mora was said, for instance, to be able to effect miraculous cures—and lethal curses. He could make pomanders—and poisons. Under cover of darkness, many people were thought to have knocked on the door of his forbidding house. Some were ambitious young noblemen who had tired of waiting for the present lords to pass away and bequeath to them the titles they were due; others were jealous husbands who suspected their wives had been unfaithful. Some were merchants who felt they'd been cheated; others were soldiers anxious for promotion. What all of them sought was immediate gain, and in many cases revenge, and they turned to Mora to get what they wanted. By all accounts, he provided it.

Among the many goods and services Mora offered were bouquets of artificial flowers whose scent could bring on apoplexy; bottles of Cyprus wine spiked with lethal ingredients; baskets of apricots impregnated with a slow-acting poison. He was also reputed to be a master of the spirits, someone who was capable of calling up Hell itself to do his bidding. He even went so far as to compile a book of his incantations and magical practices; commonly known as the *Zekerboni,* it was replete with Cabbalistic words and designs, conjurations in Greek and Hebrew, elaborately patterned pentagrams, and explicit instructions on how to summon up a demon so that he appears "in a pleasing form, without any horror of shape or size, without any loud or thunderous noise or alarum, without seeking to harm him who summons thee, and without hurting any who are of his company."

The book was equally explicit in its instructions on how to get rid of the demon once your business was done with him. (Demons were notoriously hard to shake.) The *Zekerboni* advised the conjurer to take a fairly warm and conciliatory tone: "Depart then, gracious and kindly spirit, return in peace unto thy dwell-

ing-place and unto thine own habitation, but yet do thou hold thyself ready to attend and appear before me whensoever I call upon thee and summon thee in the name of the Great Alpha, the Lord. Amen, Amen, Amen."

Mora might have continued to prosper in his backstreet bastion had not the Great Plague swept into Milan in 1630. As the disease spread and the bodies accumulated, the panic-stricken officials of the town began to suspect black magic and witchcraft. In a surprise attack, they burst into Mora's house one night. Inside, they found all the paraphernalia of the alchemist's trade—the vials and retorts, aludels and astrolabes, chemicals and charts. On the bookshelves they discovered planetary tables and manuals of the art, by such officially sanctioned authors as Porta, Cardan, and Bernard Trevisan.

As for Mora, he was vehemently denouncing the raid and declaring his innocence when one of the magistrates happened to knock on a wall, which gave off a hollow sound. Careful inspection revealed a secret door, hidden by trick carpentry; behind the door there were extensive cellars, where the magistrate and his men found what they'd been looking for. Besides the High Altar of Satan, they discovered a padlocked chest containing silver-tipped wands, magic crystals, and amulets engraved with the names and sigils of various devils. In a cupboard they found an array of poisons and other loathsome substances, arranged just as more wholesome ingredients might be in an apothecary's shop. Mora was carted off for further interrogation.

Before long, he had confessed to being the grand master of a secret group of Satanists, whose aim was to decimate the whole city of Milan. To that end, he and his confederates had smeared their deadly potions on door knockers and gates; they had poured poison into the springs that fed the town; they'd mixed ergot with the baker's flour; they'd even polluted the stoups of holy water in the cathedral with oil of vitriol. But none of this was so deadly as the work they'd done under the guise of charity; according to Mora, they'd taken clothing and bed

linens from the dead and dying, then distributed them among the living and so-far-uninfected people in the poorer quarters of the city.

Mora and his confederates were summarily sentenced to death for their crimes. Mora's house was then burned to the ground, and a tall column, inlaid with a bronze tablet detailing the evils he had brought on Milan, was raised above the cinders.

THE MAN WHO COULD NOT DIE

Though everything about him, including his name, often changed, he was known for most of his life as the comte de St.-Germain, and he claimed to have discovered, among other things, the elixir of life. In the royal courts of eighteenth-century Europe, he was sometimes hailed as a hero and genius—Frederick the Great of Prussia called him "the man who cannot die"—and sometimes persecuted as a charlatan and fraud.

What is probably true is that he was born in the town of San Germano, Italy, the son of a tax collector, around the year 1710. But he drew such a veil over his actual past that little more is known of his origins. (He was possibly of Portuguese Jewish extraction.) A lively, dark-haired man who often wore clothes encrusted with valuable jewels, he first made a name for himself some thirty years later, in Vienna, where he became a friend of various Austrian and French aristocrats; in fact, it was one of these French noblemen, Charles de Belle-Isle, marshal of France, who brought him to France and introduced him into the circle of Louis XV and Madame de Pompadour.

There, he endeared himself by bestowing on the king a diamond worth ten thousand livres and by assuring the other members of the court that he had a miraculous, secret method for removing the flaws from any stone. He was by all accounts a magnificent conversationalist (fluent in as many as eleven languages), a talented musician (playing the violin and harpsi-

chord), a historian, scholar, and chemist. Wherever he went—and he seems to have spent his entire life traveling from one patron to another—he set up a laboratory and was reputedly quite skilled in ways of dyeing silk and leather goods.

But his greatest claim was that he had discovered the elixir that granted eternal life. When asked his age, he would merely smile enigmatically and change the subject. But if the conversation turned to historical events, he was known to chime in with anecdotes and purportedly firsthand observations on events from the most distant past and far-off lands. He claimed, for instance, to have had conversations with the queen of Sheba, Christ, and Cleopatra. He also made it known that he had shared his miraculous elixir with his valet; as a result, his valet was once asked if he, too, had been present at these ancient events. "No," the valet replied, "but you forget—I've only been in the count's employ for one century." For court ladies, he provided an emollient, free of charge, that he claimed would make wrinkles disappear.

At table, the count was known not only for his wit but for his abstinence. Even when seated at the most elaborately prepared banquets, he would eat and drink nothing, declaring that he lived, instead, on a magical food of his own preparation.

He was extraordinarily popular and might have remained so had he not become entangled in some political and diplomatic intrigue involving a peace between France and England. Having worn out his welcome with Louis XV, he set out for London, then Holland, where he established himself as Count Surmont. There, he spent a decade or so, making a fortune and building factories for dyeing fabrics and for the "ennobling of metals," before taking off again (under some kind of cloud) for Russia.

Once more, he managed to make friends in high places, and after the Russian army defeated the Turks, he was made a general—General Welldone, he called himself—for the services he had rendered.

Still, he couldn't stay put, but traveled on, to Nuremberg, Paris, Leipzig, before finding his last patron in the landgrave Charles of Hesse, in Schleswig-Holstein. Charles, too, happened to be an ardent alchemist, and together they pursued their occult experiments. But St.-Germain began to suffer from bouts of depression and chronic rheumatism, and after four or five years, he died, cradled in the arms of two chambermaids. Or, at least, that was the official account.

According to other accounts, however, St.-Germain didn't die at all; there were reports that he was seen in Paris many years later and that he had in fact sent a letter to Marie-Antoinette after the fall of the Bastille: "No more maneuvers," he warned her. "Destroy the rebels' pretext by isolating yourself from people whom you do not love any longer. Abandon Polignac and his kind. They are all vowed to death and assigned to the assassins who have just killed the officers of the Bastille." After the queen's execution, some people reported that they had seen the count lingering around the Place de la Grève, where the guillotine was still doing its deadly work.

Another story was perhaps even more outlandish. This one claimed that St.-Germain had journeyed to Tibet, where he had become one of the Hidden Masters who later guided the hand of Madame Blavatsky, the founder of theosophy.

FATE AND THE FUTURE

*F*or the gods perceive what lies in the future, and men what is going on before them, and wise men what is approaching.

Apollonius of Tyana

THE DIVINATORY ARTS

*I*t's not hard at all to see where the arts of divination came from. For as long as man has wondered whether the battle would be won or lost, whether the crops would fail or flourish, whether his love would be requited or spurned, he has looked for ways to divine—or foresee—the future.

But even if the urge to see into the future is unsurprising, what is surprising—even astonishing—is the number of ways that have been invented to do it. In some respects, the history of man is a long catalog of ingenious methods devised to ascertain just what was around the corner, starting with the ancient study of sacrificial animal bones and continuing today with psychic hot lines on late night TV. The methods have differed, but the purpose has always been the same: to know today what's going to happen tomorrow.

In general, these divinatory arts have fallen into several broad categories. First, there were omens and auguries, signs of what was to come that were drawn from the observation of natural phenomena. In the ancient world, the shape of a cloud, the scuttling of an insect, the cry of a bird, were all considered predictors of or clues to future events. (Plutarch even had faith in fishes, arguing that because they were mute and so far removed from the heavens, they must have developed some extraordinary skills of reason and intelligence.)

A second category might be called invited guidance—throwing dice or knucklebones, reading playing cards or tea leaves, drawing lots. The ancient Chaldeans, and later Greeks and Arabians, used arrows as divinatory tools, throwing a quiverful into the air, then remarking on the direction and manner in which they fell. (The practice was known as belomancy.)

The third form of divination, one in vogue even today, is the most personal and intuitive of them all. It relies upon self-induced visions, dream analysis, crystal gazing, and/or, with the help of a psychic or reader of some kind, clairvoyance. In an

antique version, the Pythian priestess of Delphi, whose oracles were thought to be divinely inspired, first chewed on a hallucinatory herb, then, while sitting on a tripod above a fuming crevice in the rock, made her cryptic pronouncements; her words were taken down by male priests, who later pored over them to extract the true meaning. (Interpretation, truly, was all: When Croesus, king of Lydia from 564 to 546 B.C., asked what would happen if he declared war on the Persians, the oracle said that he would destroy a great empire. Croesus took her words as encouragement, went to war, and succeeded in destroying a great empire, after all—his own.)

Today no one travels to consult with the Delphic oracle anymore, but many people do rely upon the advice and counsel of their astrologer or psychic to guide them in everything from their romantic liaisons to their investment decisions. Even the occupants of the White House have turned to the divinatory trade from time to time; Nancy Reagan reportedly consulted a San Francisco astrologer named Joan Quigley for advice on everything from the scheduling of the president's diplomatic meetings to the takeoff times for *Air Force One*. Nor have the advances of science and reason—the proliferation of computers and the many forms of instant information retrieval—put a stop to the reliance upon these age-old methods of prediction.

Why haven't they?

Because for all of our purported enlightenment and technological advancement, one thing—human nature—has remained essentially unchanged. The things we want to know—how will things turn out? does she really love me? should I take the job or not?—are as perplexing as they ever were, and all of the computer programs in the world can't predict with certainty the outcome or tell us what to do. Indeed, in a world where so many decisions have to be made every day, where the pace of life has increased and the time to ponder has declined, perhaps it's not surprising that people turn to less rational, more mysterious methods.

What the divinatory arts also promise us, in a way, is a measure of control—if we can foresee events or their outcome,

we can make our plans accordingly. And in an age plagued with dreaded specters ranging from nuclear warfare to AIDS, the search for answers, for an understanding of the greater forces affecting our lives, becomes even more urgent. With so much spinning out of control, it's important, even vital, to feel that there is still some power we can exert—even if it is only predictive—over our affairs and fortunes.

In that quest, a whole host of divinatory arts has been created over the centuries; in addition to the better-known variations, such as chiromancy (palm reading), cartomancy (tarot and other cards), and astrology, scores of even more baffling methods have emerged over the ages and found, at one time or another, widespread acceptance and use. Some of the more interesting and commonly employed include the following.

Gyromancy used a sacred circle to receive messages and portents from the unseen world.

To begin with, a circle was made on the ground, and its border was marked with letters of the alphabet or other, more mystical symbols. The practitioner then entered the circle and began to march around and around inside the circle, making himself progressively dizzier. Each time he stumbled, the letter or symbol that he landed on was duly noted; once he couldn't get up and go around anymore, the message was considered complete.

There were two reasons why the dizziness was thought absolutely essential. For one, it was thought to rule out any premeditated or intentional selection of the letters. He was falling down at random. And for another, the very act of turning around, of spinning in place until all balance was lost, was a staple of spells and enchantment since time immemorial. Many sacred dances used the same method to induce a kind of prophetic trance. In fact, it was long thought that fanatics and lunatics, whose movements involved wild spinning and turning with arms extended, were themselves possessed by invisible elements of the spirit world. They weren't spinning so much as they were being spun.

This belief gained widespread acceptance in the 1400s, when an epidemic of a disease that came to be known as St. Vitus' dance swept across western Europe. A hysterical form of the neurological disease chorea, it not only caused its victims to run and leap and spasmodically jerk their limbs but also induced hallucinations; when these fantasies were uttered aloud, the auditors considered them prophetic. Sufferers were taken to the chapels of St. Vitus, a little-known Christian saint of the fourth century, who was the guardian of those afflicted with convulsive diseases.

Alectromancy, a variant of the gyromancy described above, required a barnyard cock. And it could only be performed when the sun or moon was in Aries or Leo.

Once again, a circle was drawn on the ground, and its border was marked with the twenty-six letters of the alphabet; a kernel of wheat was placed on each letter. A young white cock, which had been declawed, was then forced to swallow a tiny parchment scroll on which magical words had been written. Holding the cock aloft, the magician recited an incantation before depositing the bird inside the circle. From that point on, it was important to keep track of which grains the bird pecked, and in what order. As soon as the bird ate a grain, it was replaced (just in case the word being spelled out used that letter more than once).

According to one ancient account, Iamblichus, a Syrian philosopher who also dabbled in magic, decided to see if this method would help him find out who should succeed Valens Caesar as ruler of the empire. But the bird only pecked at four letters—THEO—and there were four contenders whose names began with those letters: Theodosius, Theodotus, Theodorus, and Theodectes. The magician was left wondering who the successor would be. But the emperor Caesar himself, hearing about the prophecy, decided to take matters into his own hands and had several of the possible choices executed. Iamblichus, figuring his own number was up, too, swallowed poison.

* * *

Birds were one of the earliest and most popular elements of augury. As early as the first millennium B.C., the Etruscans had studied the behavior of birds as well as their entrails and then organized what they had learned into an elaborate code of religious ceremonies known as the *disciplina Etrusca*.

The Romans were no slouches at it, either. In fact, they had a state-sanctioned college of augurs (soothsayers), drawn from men of highest merit and awarded their positions for life. Recognizable by their distinctive togas (*trabeas*) with scarlet stripes and purple hems, it was the job of the augurs to categorize and interpret the behavior of birds, along with all other kinds of omens, and pass along that information to the appropriate public officials.

All in all, there were two kinds of omens. First, there were the commonplace and occasional omens, domestic events such as spilled salt, a leak in the roof, wine turned to vinegar, which the augurs eventually stopped bothering with; there were just too many of these omens, they were piling up too fast to record, and in the long run they were proving to be of too little importance.

Instead, the Roman augurs concentrated on larger natural phenomena—thunder, lightning, falling stars—and how these might be interpreted to convey the will of the gods. To get an accurate reading, the augur set up a tent on the eve of taking the omens, slept in it, and then, the next morning, rose early. There was only one opening in the tent, and it had to face south. That put the lucky quarter, the east, on his left; by and large, signs on that side were considered favorable, while signs on the right, or west, side were considered unfavorable. (In Greece, however, the situation was reversed: the seer faced north, and signs on his right side were the good ones.) Sitting on a stone or on a chair so solid it would never creak (creaking chairs could be considered omens in themselves), he uttered a prayer to the gods and then stared out at the space before him.

If, however, he was planning to concentrate his efforts on the flight and behavior of wild birds, he might situate himself on top of a tower or at the crest of a hill and face eastward.

Using his *lituus* (a staff free from knots, with a curved handle), he marked out his *templum* (the consecrated section of the sky he would use for his observations), drew a cowl over his head, and made a propitiary sacrifice to the gods. Then he was ready to go.

The first thing he had to do was know his birds—they weren't all of equal value. Some, such as the eagle, buzzard, and vulture, were significant because of the speed or direction in which they flew; others, such as the owl, crow, and raven, were chiefly noted for their cry—which was generally considered an ominous sign. The woodpecker and the osprey counted on both scores.

Overall, if birds flew toward the east, the direction of the sunrise, the news to come would be good; if they flew westward, where the afterworld was thought to be located, the news would not be so welcome. If they kept low to the ground and skittered about in confusion, then they were agitated and upset—not a happy portent of things to come.

Their songs, too, were full of meaning. Were their voices strong and vibrant? Or weak and quavering? It was a good sign if an augur heard a crow cry to his left or a raven to his right. And it was favorable, too, if a bird was seen flying with food in its beak or eating voraciously. If, for instance, the sacred chickens, which were kept in cages and often consulted by Roman generals, ate so quickly that bits of food dropped from their beaks, this was considered a very good omen. (In his work *On Divination,* however, Cicero claimed it was a put-up job—that the chickens were starved in advance so that their gluttony could always be seen as a sign of Jupiter's goodwill.) Adding up all the data and weighing it was a difficult task, which the augurs tried to make easier for themselves by keeping detailed archives, the *commentarii augurum,* and later distilling that information into a handy manual for regular (but not public) use, called the *libri augurum.*

Birds were not the only animals used for divination in the ancient world and on into the Middle Ages. In a practice some-

times known as *zoomancy*, good and bad omens were drawn from the sight and the sound, the comings and the goings, of everything from butterflies to bunny rabbits.

If a swarm of bumblebees alighted in your garden, that was a portent of prosperity. If their humming was low and steady, that was a good sign. If, however, their buzzing became louder and more agitated, it wasn't. (Not exactly a shock.) The sound of a wasp suggested malicious gossip or an unexpected visit from someone you'd never met. Small spiders brought money to the house; big ones, sacred to Athena, were models of industry and must never be squished. A spider spinning its web in your house, however, could be a sign that someone was plotting against you.

Black cats spelled bad luck, as many people believe even today, especially if they crossed your path or stole in front of a funeral procession. White ones could bring good luck. If the cat was busy rubbing its paw behind its ear, it was time to close the windows—rain was coming.

A dog howling in the dark was a warning that ghosts were lurking about and death was imminent. For the longest time, dogs were thought capable of scenting death for miles around. But in the folklore of the northern European countries, the appearance of a spotted dog was a happy sign; three white dogs was an even happier omen.

Traditionally, the glimpse of a lizard was bad news—signifying that a miscarriage would occur—while a frog was good news; frogs were emblematic of lifelong passion.

Weasels were a sign of trouble at home.

If you happened to spot a piebald pony, it was good luck, and if you thought fast enough, you could make a wish upon it; if, however, you looked at the horse again, the wish would no longer come true. Donkeys rolling around in the dust were a sign of good weather. Cattle who stopped grazing and lay down in the field were harbingers of inclement weather; when they got up and started running around, a storm was soon to ensue.

A hare seen darting about a graveyard was considered a shade of the dead; a snake slithering among the headstones was

a symbol of fertility, until it disappeared into the ground—when it became a bearer of messengers to the afterworld.

If rats were spotted deserting a ship while it was still at anchor in the harbor, that was bad news for the next voyage (and many a sailor would fail to report for duty). When rats deserted a sinking ship, it wasn't so much an omen as it was common sense.

When, according to one ancient story, a Gothic king named Theodotus wanted to know the outcome of an impending battle with the Romans, he asked a Jewish soothsayer what to do. The seer told him to take thirty hogs, give some of them Roman names and some of them the names of Goths, and then divide them into separate pens. When the pens were opened at the appointed time, all of the Roman hogs were alive, but half of them had lost their bristles. The Gothic hogs, however, were all lying dead. The king hardly needed to be told what this meant: his own soldiers would be slain to the very last man, but the Romans would lose only half of their own army.

The use of a wand, staff, or divining rod to discover everything from water sources to buried treasures is one of the oldest and most practiced of the divinatory arts, and is known, in its many variations, as *rhabdomancy*. Moses, who was schooled in all the magical arts of Egypt, invariably used his staff in performing his wonders, whether it was striking the rock with his staff to make water gush forth or, even more notably, parting the vast expanse of the Red Sea so that the Israelites might cross with safety.

In almost every form of magic, a wand or rod is used, in which the magician's powers are both literally invested and symbolically represented. But over time, rhabdomancy came to refer almost exclusively to the use of the divining rod; by the sixteenth century, especially in the Harz mountain region of Germany, the forked stick had become accepted as a mining tool no more unusual than a pick or shovel.

There were several different ways to make and use a divin-

ing rod. In a treatise on the subject published in Paris in 1725, the abbé de Vallemont offered the most common method:

> A forked branch of hazel, or filbert, must be taken, a foot and a half long, as thick as a finger, and not more than a year old, as far as may be [determined]. The two limbs (A and B) of the fork are held in the two hands, without gripping too tight, the back of the hand being toward the ground. The point (C) goes foremost, and the rod lies horizontally. Then the diviner walks gently over the places where it is believed there is water, minerals, or hidden money. He must not tread roughly, or he will disperse the cloud of vapours and exhalations which rise from the spot where these things are and which impregnate the rod and cause it to slant.

The exact physics of all this—how these "vapours" rise up and take control of the end of the rod—are unclear, but the abbé insisted that

> the corpuscles—as well those which transpire from the hands of the man into the rod, as those which rise in vapour above springs of water, in exhalations above minerals, or in columns of corpuscles from the insensible transpiration over the footsteps of fugitive criminals—are the immediate effective cause of the movement and bending of the divining-rod.

In a celebrated case from 1692, a divining rod was used to pursue the murderers of a wine merchant and his wife. Their bodies had been found, throats cut by a billhook, in the cellar of their shop in Lyons. When the local constabulary could come up with no leads, they called in Jacques Aymar, a humble peasant renowned for his skills with the divining rod. Aymar had discovered springs of fresh water, underground mines rich with

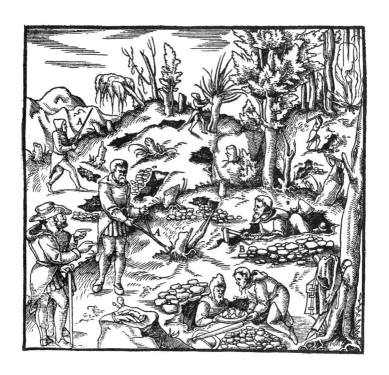

ore, secret caches of buried treasure; now they asked him if he could track down a murderer. Aymar murmured that he would try.

According to Pierre Garnier, a local physician who wrote an account of the case, the moment Aymar arrived at the scene of the crime, "his rod twisted rapidly at the two spots in the cellar where the two corpses had been found." Aymar himself, feeling feverish, left the shop and, armed with his rod, "followed the streets where the murderers had passed, entered the courtyard of the archiepiscopal palace, left the town by the Rhone bridge, and turned to the right along the river. He came into a house where he pointed out a table and three bottles as having been touched by the murderers, and it was certified that this was so by two children who had seen them slink into that house."

From there, the trail led Aymar down to the Rhone again,

where he boarded a boat and followed the murderers down the river. He got off at every port where they had gotten off, found the streets they'd walked, the beds they'd slept in, the tables where they'd eaten. At Beaucaire, he said the murderers had gone their separate ways; he followed in the tracks of the one that the rod seemed most affected by. It led him to a prison, where he looked around at the inmates, then singled out a hunchback who, as it turned out, had just been arrested for a petty theft. At first, the hunchback denied any knowledge of the murders in Lyons, but after repeated questioning, he admitted that he'd been there and witnessed the crime being committed by two other men. Aymar set out again, but after arriving at Toulon and the sea, he stopped short; the murderers, he announced, had already sailed abroad. And though justice remained unserved, Aymar's tracking was often cited as a persuasive example of the power of the divining rod.

Dreams, too, have played an immensely important role in divination. In the Bible, Jacob foresees the lofty future of his people when he dreams of a ladder rising from his breast to the very heights of Heaven, with angels ascending and descending its many rungs; in the Gospel of St. Matthew, an angel visits Joseph in a dream and informs him that Mary will be having a child by the Holy Spirit; in dreams, an angel warns the magi not to tell Herod about the birth of Jesus, advises the Holy Family to flee from the imminent Massacre of the Innocents, and later tells Joseph when it's safe to return to Israel. According to early passages in the Passion, even Pontius Pilate's wife had dreams, troubling dreams which led her to beg her husband to spare the life of Jesus rather than Barabbas.

The study and interpretation of dreams, known as *oneiromancy,* was a regular practice among the ancient peoples of Mesopotamia, Egypt, and Palestine: the Egyptians called dreams mysterious messengers and believed they were words of counsel sent by the goddess Isis; the Greek playwright Aeschylus claimed they were invented by Prometheus, the Titan who had also bestowed fire on mankind; Herodotus tells us that in the temple

of Bel in Babylon, a priestess slept on a bed of ram skin and purposefully dreamed dreams that would foretell events. In the second century A.D., Artemidorus Daldianus, a professional seer, collected every anecdote, story, and scientific observation he could find pertaining to dreams and published them in five books called the *Oneirocritica*: "I have not only made special efforts to obtain every book on the interpretation of dreams," he wrote, "but also have kept company for many years with the much-disdained soothsayers of the marketplace." His aim, he asserted, was "to fight against those who wished to abolish divination," and in that he was surprisingly successful; his books were reprinted, and translated into several languages, for many centuries to come. (Even Freud read them with interest.)

Although the theories of the ancients differed in many respects, there were some broad similarities. By and large, it was believed that in sleep, the soul was set free from the body and communed with the cosmic forces in a way that it couldn't when imprisoned by flesh and wakefulness. It was able to travel unimpeded and see events and scenes and accidents that might figure in the dreamer's future life. But because these visions were so often garbled, unclear, or, according to one popular theory, exactly the *opposite* of what would actually transpire on the earthly plane, they required careful analysis by someone skilled in the task.

In a pseudo-physiological explanation, the Christian philosopher and magician Albertus Magnus argued that there was a special spot in the front of the brain that connected each human being with the universe as a whole and that the five senses transmitted all of their findings, via the bloodstream, to this special spot. There, in what Albertus called the *cellula phantastica,* or *imaginatio,* dreams were constructed.

Later, his disciple Arnold of Villanova divided these dreams into those that came from outside, from a divine source, and those that originated in the body itself. As a doctor, he was particularly interested in the medical meanings of dreams, and he attributed a lot of their imagery to the four bodily humors. If, for instance, you dreamed of rain and damp, Villanova

chalked it up to an excess of phlegm. If you dreamed about shooting stars or thunder, it was yellow bile that was causing it; catastrophe and horror, black bile. If you dreamed about things that were colored red, from fire to apples, it had something to do with the blood. Villanova also believed that when you dreamed about certain parts of the body, those parts signified members of your family and household. The eyes referred to children; the head to father; the arms to brothers. The right hand related to the mother, sons, and friends; the left hand to a wife or daughter. As for the feet, they were reserved for servants.

A later doctor, Paracelsus, threw in his lot with the ancient Greek philosophers Plato and Aristotle, whose teachings were being enthusiastically revived during the Renaissance. Because the individual soul is a part of the greater cosmic soul—a microcosm in touch with the macrocosm—Paracelsus believed that it could, when freed by sleep, apprehend both the past and the future. It could also transport messages back and forth between the living and the dead. There was only one hitch, as far as Paracelsus could see: if the soul failed to get back to the body before the sleeper awakened, then the sleeper, finding himself short of the vital life force, might die.

In the many "dream books" that were written and compiled over the centuries, all sorts of meanings were attached to specific imagery and visions. One of the most influential of these books was written in 1530 by an astrologer in Lyons named Jean Tibault; entitled *La Physionomie des songes et visions fantastiques des personnes,* it included roughly four hundred catchphrases, alphabetically arranged, for the decoding of elements drawn from a dream. "To dream that you are a tree," it said, "means illness." "To see a lighted candle means anger or strife." "To gather grapes means harm." "To grind or purloin pepper means melancholy." "To have a long beard means strength or profit." "To hear bells ring means slander." "To cut bacon means the death of someone." "Old shoes," it also mentioned, "means sadness," while new ones meant consolation.

In another such book, *The Golden Key of the Egyptians,* an

extensive table of days was included, with dates on which various dreams could be considered good, or bad, omens. Dreams you have on March the 2, 9, 12, and 14, for instance, were dreams you should never tell anybody about. Dreams you have on December 10, 20, and 29, on the other hand, would bring great joy. In general, according to this key, dreams you have on Wednesday nights would be the most informative when it came to business matters, while those you have on Fridays would be more pertinent to romantic affairs.

When trying to decide which dreams were truly oracular and which ones were simply, well, dreams, an authority on the subject who went by the name of Rankajou suggested that you should discard any dreams that occurred during the first couple of hours of sleep; they were just the results of the digestive process. You should also discard any dreams of things or people that you had just heard discussed; these were no more than echoes from the day. Also to be discounted, dreams that resulted from an illness, a fright, an uncomfortable sleeping position, or a book you were reading before falling off to sleep. The best dreams, when it came to their predictive power, were the ones you had between three and seven in the morning, when digestion was all done, the mind had been untroubled, and the body, presumably, had found itself a relaxing position of repose. How exactly you remembered these particular dreams and distinguished them from any others that had come to mind (from tainted causes like a draft or a head cold) Rankajou did not say.

THE SIBYLLINE BOOKS

*D*uring the reign of King Tarquin the Proud, who ruled Rome from 534 to 510 B.C., a strange visitor appeared at his palace one cold winter day. Unlike most of the dignitaries and plutocrats who asked for an audience with the king, this visitor was an old woman in a voluminous cloak. Nobody knew who she was or where she'd come from, but there was something in her

demeanor that was so mysterious and compelling that she was allowed to see the king, nonetheless.

When he asked her what business she had with him, she drew from under her robe nine books (or scrolls) which she offered to sell to him. Tarquin asked her how much she wanted for them, and the old woman quoted a price so fantastic that Tarquin laughed. The old woman didn't. With a sober, even sad, expression, she took three of the books and threw them into the fire burning in a brazier near the king's throne. Then she asked him if he wanted to buy the six remaining books.

Again, the king asked the price, and she gave him the same price she'd originally asked. "Why should I pay you for six books as much as you were asking for nine?" Tarquin replied.

The old woman threw three more books into the fire.

Tarquin was amazed. Who was this old woman, and what was in these books?

For the third time, she asked if he would buy the books, and this time the king didn't laugh or scoff at the offer. Fixing his gaze on the resolute old woman, he wondered what he should do. And when, without bending, she moved to throw the last remaining books on the fire, he said, "Stop!" And he paid her, in gold, the full sum she was asking.

Then the old woman turned and slowly walked out of the palace. She was never seen again.

Had Tarquin made a good buy?

When the books were opened, they were discovered to be written in Greek. After they were translated for the Roman king, he learned that they were books of magic and prophecy and that they addressed the future and the welfare of the Roman empire. Now, the king's augurs declared, the old woman must have been the famed Sibyl of Cumae, one of the divinely inspired seers of the ancient world, the same one who had counseled Aeneas before he made his descent through the infernal regions.

The Sibylline Books, as they were then dubbed, were reverently placed in a shrine in the great temple of Jupiter on the Capitol; there, they were overseen by a small group of official

custodians (half patrician, half plebeian) whose duty it was to consult them, at the behest of the Senate, whenever guidance was needed. Most important, the books were used to figure out what religious rituals had to be performed in order to stave off national catastrophes, such as earthquakes, droughts, pestilence, and war. After one such consultation in 226 B.C., the guardians of the books ordered that a Greek and a Gallic couple be buried alive in the Forum, in propitiation of the gods of the underworld.

Though the fate of the original books is unclear (they were probably consumed in a fire in 83 B.C.), reconstituted versions remained among the most precious and revered possessions of the Roman empire for many centuries. When Augustus became pontifex maximus, he ordered all the books of magic and prophecy then extant to be gathered together and burned (in 12 B.C.). But the three Sibylline Books he spared. These he ordered to be taken from the Capitoline Hill and placed in a golden chest, which was then enshrined in the base of a statue of Apollo on the Palatine Hill.

They were preserved there until the reign of the emperor Honorius (from A.D. 395 to 423). At that time, the empire was in great danger, with the barbarians restive at its borders, and the Goth leader, Alaric, moving his army across the Alps. It was then that the Roman general Stilicho decided to put a stop to the pagan beliefs that half the population still stubbornly clung to. He stole the treasures stored in the temples, ripped the gold plates off the doors of the Capitol, and put the Sibylline Books to the torch. When his wife, Serena, took a precious necklace from a statue of the goddess Rhea and had the nerve to wear it herself in public, the wrath of the people became unquenchable. Stilicho, despite his private cadre of barbarian bodyguards, was hunted down, captured, and beheaded. The Senate then sentenced his wife to death by strangulation.

Terrifed by the approaching Gothic horde, the government officials turned to some persuasive Etruscan sorcerers, who claimed that they could call down lightning bolts and blast the Goths to powder. Needless to say, the Etruscans failed to deliver, and after a prolonged siege, the Romans were forced to surren-

der nearly everything they owned to Alaric and his army, in exchange for the privilege of keeping their lives.

THE HAND OF FATE

*O*f all the body parts regularly turned to for divination—and this pretty much includes everything from the head to the toes—none was ever more studied than the hand. The hands are at once one of the most expressive parts of the body and of course one of the most utilitarian. Perhaps because they are so vital in the practical sense, they have also been invested with considerable importance in other ways, too—the hands have been used both to predict the individual destiny of their owner and to diagnose his or her present health and disposition.

The science, or art, of chiromancy (from the Greek words for "hand" and "divination") goes back as far as three thousand years before the birth of Christ, when it was already being practiced in China. Even in the most ancient Greek writings, chiromancy is discussed as if it were an established and widespread belief; Homer refers to it, and later on, so do Aristotle, Hippocrates, and Galen. (Indeed, there's a story, possibly apocryphal, that a chiromancer studied Aristotle's palm, then made some rather unflattering statements about the great philosopher's character. Aristotle's students were so shocked and dismayed that they were ready to string up the palmist by his heels, when Aristotle stopped them and said that the hand reader had done a good job; the very flaws that the reader had seen were in fact the flaws he'd been striving all his life to overcome.) In the patristic literature (the writings of the Fathers of the early Christian church) several references to chiromancy are made, and it's clear from these that most people at that time believed there was mystical significance in any marks that could be found on this "organ of organs," the hand.

When studying the hand for divinatory purposes, everything about it was to be taken into account. How was the hand shaped? Was it small and narrow or wide and thick? Was the

skin rough or smooth? Were the fingers short and blunt, or were they long and tapered? Were there many lines, crisscrossing the palm every which way, or were there just a few, barely discernible? Were the nails hard and clear or brittle and cloudy? Was there hair on the hand, and if so, where and how much? And what about the veins—were they blue and prominent or pink and delicate? Was the skin warm and dry or cold and damp? All of these were factors that a conscientious chiromancer could, and usually did, take into account.

And although their methods and the interpretation of their data varied over the centuries, the chiromancers (or palmists, as they were often called) did gradually build up a kind of catalog of hand shapes and traits and features which they could use for handy reference. The first question that had to be decided upon, however, was which hand to read. Many palmists insisted on using the left hand, as that was the hand (most people being right-handed) that had suffered less wear and tear; the lines and signs in it, they felt, would be more visible and undisturbed. (Of course, in a left-handed person, the right would be used, for the same reasons.) Some readers looked at both hands, and many distinguished between the two by saying that, in a right-handed person, the left hand displayed the inherited characteristics, while the right showed what had, and would be, accomplished in the person's life. (Again, this distinction was reversed for lefties.)

As for the shape of the hand, there were several broad categories into which it could fall. First of all, there was the question of length; palmists measured the length of the hand from the top of the extended middle finger to the bulge of the wristbone (known to the medical profession as the ulnar styloid) on the outside of the forearm. If this distance seemed unusually long, the person was thought to be of a pensive and brooding nature, inclined to spend more time working toward perfection than toward getting the job over and done with. If the length was unusually short, the person was thought to be imaginative and creative but a tad impractical. If the hand and fingers were thin,

it implied a nervous disposition and possibly a timid one; if they were thick, it suggested a more carnal and earthy nature.

The influential French chiromancer Henri Rem declared that hands could be divided up into four major types, with a host of emotional attributes corresponding to each one. The first type he called the pointed hand, with sharp, tapered fingers. "Pointed fingers," he wrote, "offer a conduit free and without obstacle, and in this resemble the magnetised points of lightning conductors; they easily draw in and emit fluid, consequently absorb spontaneously surrounding ideas and emit them in the same manner. Hence the inspirations, the illuminations, the inventions which flow from pointed fingers and make dreamers, poets and inventors." Among the notables with pointed fingers, Rem included Shakespeare, Milton, Goethe, George Sand, and the painters Raphael and Correggio. He also observed that the pointed hand belonged to those with a taste for luxury and sensual pursuit. What it wasn't well suited for was "the battle of life, for reasoning, for materiality, for effort."

The second type of hand Rem identified was the square hand, whose fingers ended in a clear, squarely cut nail. This, Rem declared, was "the hand of reason, of duty and of command." It belonged to those with a cool and methodical nature, who could consider a problem dispassionately and come up with a logical, precise solution to it. Square-handed people of note were Voltaire, Rodin, Holbein, and the great stage actress Sarah Bernhardt. There were, however, a couple of worrisome things to look out for: If the middle finger was too square at the end, then it implied an uncompromising, and even intolerant, disposition. Even worse, "if by an excess of malformation, the square finger attains the shape of a ball, a tendency to murder may be feared."

The third type of hand, the conical, was "the philosophical hand, *par excellence*." Why? Because, with its gently rounded fingertips, it was partly square and partly pointed—an ideal mix of attributes. "It is the hand of him who can understand everything and love everything, who can acknowledge his errors, be

benevolent, friendly, indulgent, the friend of peace and harmony, of order and comfort." Rousseau had the conical hand, as did Molière, La Fontaine, and the legendary Italian actress Eleonora Duse.

Finally, there was what Rem called the spatulate hand, with "spatula shaped fingers, with the nail joint almost flat (exception must be made in the case of deformation owing to the use of tools)." Spatulate fingers could be found on people who looked before leaping, who were sometimes overly confident and overbearing. Such people had an inborn aversion to bureaucrats and hated any form of confinement, whether it was as extreme as a prison or as ordinary as a workplace. "It is the hand of instinct," Rem wrote, "of feelings but little restrained, of the material mind, of revolt (most revolutionaries have these finger signs)." Among the spatulates were Rembrandt, Rubens, and Napoleon III, the emperor of France from 1852 to 1870.

Even Rem conceded, however, that few hands were purely one type or the other; most displayed certain features of different types, and so they required a practiced eye to assess their true meaning—all, perhaps, but the "elementary hand," which Rem said he often came across in the country. "The fingers are thick, massive, it is the hand of the peasant, instinctive, of the rudimentary being. . . . It is the helpless hand of the born slave."

But even more telling than the size or shape of the hand were the signs to be read in its palm—the lines (or creases), the mounts (or hills), and the valleys (or plains). In nearly every form of palmistry, this information is correlated to astrological and mythological lore. To get a rough idea of where these various features lie and what they are supposed to reveal of the future, imagine a left hand, with its palm facing you. We'll start by laying out the mounts, or fleshy elevations, of the palm. Their size, their position in respect to the adjacent mounts, the ways in which they are transected by the lines of the palm, all of these factors are thought to influence their power and significance, but overall the mounts and their respective meanings go pretty much as follows.

The first mount is the raised area of the palm that sits at

the base of the thumb. This is called the Mount of Venus, after the goddess of love and beauty. It represents warmth, affection, and sexual allure. On the negative side, however, it can betoken an indiscreet and tasteless nature, given to promiscuity and irresponsible behavior.

Moving just above that, to the crux of the thumb and index finger, is the mount called Inner (or Lower) Mars, named after the god of war and power. Not surprisingly, it suggests energy and daring, adventure and bravery. But it also suggests wanton destruction and malice.

Next, at the base of the index finger, is the Mount of Jupiter, after the king of the Greek gods, and it symbolizes justice, pride, and ambition. On the downside, it can convey pomposity, arrogance, and tyranny.

At the base of the middle and longest finger is Saturn— authoritarian, rigorous, controlling, and sometimes a bit dull. But good at amassing and maintaining a fortune.

The Mount of Apollo lies below the fourth finger. Like the sun god after which it is named, it suggests creativity, beauty, and charm. But it can also signal fickleness, conceit, and an unwise proclivity to gamble.

Just below the little finger is the Mount of Mercury, standing, like the messenger of the gods, for quick-wittedness and adroit maneuvering. But at the same time, it can suggest dishonesty, greed, and compulsive chattiness.

Moving just below Mercury, and running along the outside of the hand, is the mount called Outer (or Upper) Mars, representing such laudable qualities as courage and consideration, and such negative traits as irrationality and stubbornness.

Finally, there's the Mount of Luna, which sits at the base of the palm, on the side opposite the thumb. Luna signifies imagination and introspection, vitality, and a love of travel. Less favorably, it can suggest a selfish, secretive, and overly sensitive nature.

The central area of the palm that is bordered on all sides by one or more of the various mounts is called the Plain of Mars. If it's full and fleshy, it indicates an energetic and hopeful spirit.

If it's visibly depressed, or hollowed out, it conveys ineffectuality and pessimism. If it falls somewhere between these two extremes, if it's got a gentle curve to it, then that suggests a well-balanced, good-natured temperament.

But the feature that has always drawn the most attention from palmists and their clients is the lines that furrow the palm. Are these lines deep and long or short and shallow? Are they complete, or do they instead stop and start? Are they many in number, or are they few? According to one theory, people with more sensitive and complicated souls have an abundance of lines, while those of a simpler, less intelligent nature have not nearly as many. Again, the interpretation of the lines is largely up to the individual palmist. But even so, some general observations can be made.

Five lines are considered by most palm readers to be the most significant. The first of these is the Line of Life, which runs around the base of the ball of the thumb. If this line is deep, it signifies great energy and drive; if it's not, it suggests lassitude. If there are parallel lines running beside it, this indicates a strong need for affection and the company of other people. If it makes a wide curve toward the center of the palm, it suggests an active nature; if it curves close to the thumb, it shows an activity of the mind, instead.

The Head Line begins above the Life Line, in the Upper Mars area, then curves outward, across the Plain of Mars, and toward the opposite edge of the palm. If this line is deep, then the person's thoughts will be equally deep; if it's shallow, it indicates a more pragmatic than inspired nature. If it's not there at all, there will be death by accident. If it is wavy, the person's thoughts will go in many different directions; if it's straight, it suggests practicality.

The Heart Line starts at the outer edge of the palm (known as the percussion) and travels across toward the Mount of Jupiter, below the index finger. As would be expected, it represents the more tender emotions, and for that reason was traditionally supposed to be more evident and significant in the palms of women than in those of men. A Heart Line that suggests a fa-

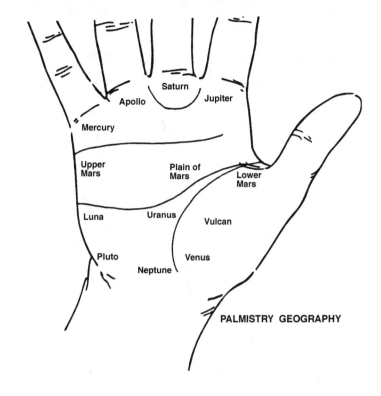

Saturn

Apollo Jupiter

Mercury

Upper
Mars

Plain of
Mars

Lower
Mars

Luna Uranus Vulcan

Pluto Venus

Neptune

PALMISTRY GEOGRAPHY

vorable love life, one filled with affection and conjugal joy, will be straight and unbroken and carry a healthy hue. If it's too reddish, it might signal such passions as jealousy or over-possessiveness, and if it's too pale, it might signal a dearth of amorous activity. (Never a happy sign to see in one's own palm.)

The Line of Fate (also called the Line of Luck or Destiny) runs in a roughly vertical course, starting at the wrist and moving up the palm toward the Mount of Saturn at the base of the middle finger. If it actually lands at Saturn, then that signifies a happy and contented old age. But the line may veer off toward one of the other mounts or lines, and depending on where it goes, many other things may be indicated: if, for instance, it stops short, at the Head Line, it may indicate psychological difficulties or unwise and impulsive behavior; if it ends at the Heart

MAJOR LINES

1. Life Line
2. Heart Line
3. Head Line
4. Fate Line

Line, it may signal heart trouble or a change in position as a result of a romantic liaison; if it forks, the golden years may not be so golden, after all. If it's very red in color, then watch out for sudden disasters.

Finally, of the five major lines, there's the Line of Apollo (or, simply, the Sun). This one can start at several different places in the hand, though most commonly it begins at the ring around the wrist and heads toward the root of the ring finger (the Mount

of Apollo). Sometimes it will even bifurcate this mount with a fairly deep groove. When it does, it's an indication of the person's enthusiastic and outgoing nature, and it reveals a lot of luck and even, possibly, great fame to come. In the view of many palmists, if the line is altogether missing, then you might as well hang it up—success just isn't in the cards (or palm) for you.

Besides the lines and mounts, however, there are a host of other signs that can be read in the palm, and these either add to or subtly ameliorate the more pronounced features. There's the Ring of Solomon, for example, which makes a short loop from the base of the index finger around to the other side of the middle finger. Named after King Solomon, renowned for his skill in magic, this line shows a talent for the occult and a strong ability to sway other people to do your own will.

At the wrist itself there are several lines, which are called the bracelets. These lines can be consulted to predict your life span—each one, according to some chiromancers, is worth thirty years of life. Most people have two or three. When there are three lines, all of them well formed and uninterrupted, this is called the Royal Bracelet, and it's a strong vote of confidence in your future.

To the practiced eye, there is also a plethora of crosses and triangles and dots, squares and circles and stars, which are formed by the crisscrossing of the lines and creases in the hand; where these show up, and how strongly, contributes a lot of additional information. Stars, in general, are signs of good fortune, and if one appears, for instance, on or near the Mount of Venus, then it suggests good luck in love; if it appears in the proximity of Saturn, it's an indication of scholarly achievement. A triangle signifies skill; a square suggests moderation and the careful protection of resources; the so-called Mystic Cross, a sign that can show up in the middle of the palm between the Head and Heart Lines, reveals a proclivity to metaphysics and mystical pursuits and, in some cases, an overly superstitious turn of mind.

READING THE STARS

The ancient Babylonians had two methods of divining the future. One was to extract and dissect the liver of a sacrificial animal; the other was to consult the movements of the celestial bodies.

All things considered, it's not hard to see why liver divination has pretty much gone out of style, while astrology has remained the most popular occult science of them all. Who wouldn't rather look up at the stars?

Which is, undoubtedly, how astrology truly got started. Primitive man studied the heavens, saw their ever-changing aspect, and began to wonder how the movements of these stars and planets, the course of the sun, the waxing and waning of the moon, might affect his own fortunes. There had to be some divine plan at play up there, some orderly progression, and if he could only fathom its secrets, he might be able to see how the celestial arrangements applied to life down below.

And even plan accordingly.

Legend has it that Adam himself was the first astrologer, that God had revealed to him how to read the heavens; it was because he was armed with this knowledge that Adam was able to foresee the destruction of the earth, first by fire and then by water. As a service to his descendants, he had two pillars erected, one of stone and one of brick, and on them he wrote a warning of what was to come. The brick pillar was washed away by the torrent of the flood, but the stone pillar, according to Josephus, a Jewish historian of the first century A.D., was still standing at that time in Syria.

The great Jewish philosopher Maimonides, lending his own imprimatur to the heavenly science, conjectured that "for as much as God hath created these stars and spheres to govern the world, and hath set them on high and hath imparted honor unto them, and they are ministers that minister before him, it is mete that men should laud and glorify and give them honor."

Still, the credit for the invention of astrology, as a systematized body of knowledge, must go to the Babylonian priests, who, as much as five thousand years go, had begun to build correlations between the celestial bodies and the gods of their pantheon—the planet Venus with Ishtar, for instance, and Jupiter with Marduk, Mars with Nergal, Saturn with Ninib, Mercury with Nebo, the moon with Sin, the sun with Shamash. Over time, the priests also embraced the fixed and most recognizable stars, and such variable phenomena as eclipses, shooting stars, and the halo that is frequently seen around the new moon. Recording all this and interpreting it, they gradually assembled an enormous "database," as it were, which they used in making their prognostications.

But they were still a far cry from producing what we know today as the individual daily horoscope. For the Babylonians, the heavens produced information pertaining to the general welfare of the state, to great public and political issues of the day. The only individual whose fortunes the astrological phenomena could directly predict was the king, and that was because his well-being was considered inextricably bound to that of his kingdom. If the heavenly bodies were aligned against the king in some way, then the gods might be planning to wallop the kingdom with a plague or a drought or a war. In that regard, at least, astrology did indeed affect even the lowliest farmer in his field.

Around the middle of the fourth century B.C., the Babylonian science began its drift westward, toward Greece and Rome and Egypt, where it took a powerful hold and was mixed quite freely with the other young science of astronomy; the Greek astronomer Hipparchus, for instance, discovered the precession of the equinoxes around 130 B.C., but this—a purely scientific discovery—in no way dissuaded the Greeks from continuing to believe that the heavens held the secrets of an individual's fate. This "judicial astrology," the belief in personalized horoscopes and such, happily coexisted with "natural astrology," which limited itself to the more scientific and empirically based science of the celestial bodies.

Over time, astrology not only entwined itself with astronomy but also subsumed various aspects of chemistry, botany,

zoology, mineralogy, and medicine. Everything from gemstones to flowers, plants to animals, was brought into connection with astrological lore. The sun, for example, was associated with gold, the moon with silver, Saturn with lead, Venus with copper. The human body, too, was staked out into various principalities, each one under the influence of a particular planet. The genital organs and belly, not suprisingly, were considered the province of Venus, the planet named after the goddess of love. Blood and bile were under the tutelage of Mars, the red planet assigned to the god of war. Jupiter, king of the gods, ruled the head and brain. With each portion of the human anatomy connected to a star or planet, astrology became a powerful adjunct of medicine; doctors attributed organic diseases to planetary movements or the changing of the constellations and made such considerations a vital part of their treatment.

There were even textbooks the doctors could consult, offering tips on the proper astrologically prescribed medicines to administer. *The Sickman's Glass,* a well-regarded sixteenth-century text, provided a thorough list of "Herbs which cure the usual infirmities and diseases inherent to man, being discovered by the Sun and Moon afflicted in any of the twelve signs or a figure of twelve houses." For coughs or colds, for instance, it advised "angelica, coltsfoot, horehound, comfrey, elecampane, liquorice, rue, thyme, valerian." For fevers, "marigold, roses, hyssop, dandelion, purslain." And for illnesses of the heart and fainting, the book suggested ingesting a number of herbs and spices, in addition to "the hearts of all creatures which are good to eat."

Indeed, a person's future health and fortune in life were considered to be so predetermined by his horoscope and "nativity" (the map of the heavens at the precise moment of his birth) that it became common for great men and women to conceal that exact information until they were sure the astrologer they were consulting would make whatever adjustments were necessary to predict nothing but glory and success. The Roman emperors Tiberius and Caligula ordered senators who had a bad or threatening horoscope to be executed. Jerome Cardan, the Italian astrologer, had such a loathing of Martin Luther

that he altered the date of the religious reformer's birth just to give him an unfavorable horoscope. And the birth of the French king Louis XIV was actually delayed until the court physician and astrologer, Morin de Villefranche, could determine that the moment was propitious in the heavenly sense. The doctors and nurses attending the queen waited for almost an hour until Morin signaled them, by waving a cloth from his observatory, that they should go ahead and deliver the future ruler. His mother was, no doubt, much relieved.

THE LITTLE ANIMAL IN THE SKY

\mathcal{E}ven the most skeptical and down-to-earth people, who would never think twice about walking under a ladder or boarding a plane on Friday the thirteenth, have a discreet and abiding interest in the occult, and the proof of that is the widespread interest, even today, in horoscopes and individual birth signs. Everyone knows what his or her sign is, and few of us pass by the horoscope column in a newspaper or magazine without at least glancing at what the stars have predicted for us. Anything—even if it's only astrology—that purports to tell us something about ourselves exerts an undeniable pull.

The horoscope, which is seldom drawn up today with the seriousness it was once accorded, denotes both a celestial diagram and the personal forecast that is fashioned from it. At the precise moment of your birth, in the view of astrologers, the heavens have already dictated much of your fate. The relative positions of the planets and stars, plus any unusual circumstances that may have obtained (were there sunspots? a veil over the moon?), have created a kind of map of your future, which only the skilled astrologer, armed with his almanacs and guides, can interpret. Included in all this data, and comprising the best-known part, is the sign of the zodiac under which you were born.

The origins of the zodiac go back as much as four thousand years, and the twelve signs we know today are a kind of amalgam, which emerged over time from different cultures and my-

thologies. But it was the ancient Greeks who gave us the word "zodiac"—which means "the little animal"—and it was they who systematized the astrological lore in the form we use it now. They were also responsible for populating the sky with the constellations drawn from their own mythology, such as Perseus, Andromeda, and Orion.

The twelve signs of the zodiac are essentially geometric divisions, each one thirty degrees in extent; they're counted from the spring equinox and proceed in the direction that the sun moves through them. In other words, the sequence of the signs starts with Aries on March 21, which is the day when the sun crosses the equator toward the north, and then, some thirty days later, goes on to Taurus and so forth. Over the millennia, the signs have accumulated a whole range of associations and supposed effects, and their influence has been thought to bear on everything from medical diagnoses to the fortunes of war. People born under each sign are thought to have an essentially uniform nature (subject to some degrees of difference, based on other astrological phenomena). In brief, the traits and talents associated with each of the twelve signs of the zodiac are these:

Those born under Aries, the sign of the Ram (March 21– April 20), are considered to be as headstrong as that animal— they're full of vim and vigor, enthusiasm and imagination. But at the same time, if they feel crossed or underappreciated, they can react with unseemly rage. Good occupational choices for people born under this sign are acting, architecture, freelance writing—anything where they can pretty much dictate the direction of their own careers. Arians are fairly high-strung, and can suffer from various aches and pains, like headache, neuralgia, and arthritis. In terms of physique, they are by and large lean and hard, with broad heads and pointed chins.

It was under Taurus, the Bull, the next sign of the zodiac (April 21–May 20), that the human race was supposed to have begun. The sun at one time was imagined as a bull, plowing a furrow through the starry skies. And those born under this sign were thought to have a bullish physique, short and strong, with

heavy jaws and big, dark eyes. On the bright side, they were capable of great feats of engineering, able to see projects through to completion with stubborn determination; on the dark side, if for instance they found themselves out of a job, they could quickly descend into laziness and overeating. Taureans make great singers, great cooks, and very trustworthy friends.

Gemini, or the Twins (May 21–June 20), was the sign that presided over the building of the first city and was sometimes symbolized by the fratricidal brothers of Roman legend, Romulus and Remus. Gemini aren't considered the hardiest physical specimens; put them under a little stress, and they can quickly succumb to anything from a head cold to pneumonia. They're tall, thin, and prone to sudden movements. But they're intellectually gifted, very curious about everything going on around them, and make excellent after-dinner speakers—they really know how to put a story across. On the downside, they can be fickle, rash, and superficial; if they have to tell a lie to get what they want, that's not a big problem.

Cancer, the Crab (June 21–July 21), was the sign of the summer solstice. Those born under its sign were considered something of a puzzle—a little aloof on the outside but quite emotional, even romantic, at their core. They're also mightily devoted to family and home, especially when that home is comfortably appointed; Cancerians have a taste for the finer things in life—gleaming antiques, rare objets d'art—and as a result they often make good interior decorators and art dealers. Physically, they're a little on the short side, with a fleshy body and an uneven gait. Because they often internalize their feelings, they find themselves prone to stomach trouble, ulcers, and such.

Those born under Leo, the Lion (July 22–August 21), are about as difficult to read as a billboard—they are loud, proud, and demonstrative. They like to take center stage, and they like to run the show. They're friendly, outgoing, and occasionally obstinate; after everybody else has agreed that the world is round, the Leo might still be arguing the earth is flat. They can also be a bit of a braggart and a show-off, though they generally

have achievements to back up the boasts. They make good leaders but lousy followers, good white-collar types but incompetent laborers; if it requires a hammer, the Leo is hopeless. Taller than average, with a tendency to put on weight later in life, they often suffer from heart problems and back trouble.

Virgo, the Virgin (August 22–September 21), rules over those with more technically oriented dispositions—Virgoans are terrific when it comes to things like analytical chemistry (and are drawn, sometimes more than they should be, to assorted pharmaceuticals). They're conscientious, methodical, and unlike Leos, if they're given a tool, they know just how to use it—especially if it happens to be a rake or hedge clipper. Virgoans like to garden and find themselves at ease in a rural setting. What they lack is self-confidence—they listen to all points of view, but sometimes this creates critical overload, and they no longer know how to make a decision. Of above-average stature and well-filled-out body, they have to keep a close eye on what they eat, as they are prone to gastric disturbances and bowel problems.

Those born under the sign of Libra, the Balance (September 22–October 22), are, as might be expected, liable to spend a lot of their time weighing alternatives. By and large, Librans are easygoing and nonconfrontational—they hate to see things in disharmony and conflict, and they will use their considerable charm and taste to set things straight again. Very sensitive and endowed with an artistic nature, Librans make great fashion designers, painters, directors, musicians. They do, however, have such enormous faith in their gifts that they can quarrel unduly with anyone who doesn't see things their way; that may be why many Librans, despite their intuitive and intelligent natures, wind up in one disastrous marriage after another. Physically, they're quite attractive (blond hair and blue eyes are not uncommon), but they have to watch it when it comes to eating and drinking; they have a tendency to binge.

Scorpio, the Scorpion (October 23–November 21), is perhaps the most powerful sign for students of the occult; it is the sign of secrecy, of mystery and dark passion. Scorpios have powerful, jealous, and determined natures; they can be good or

evil, but either way they excel. Don't cross a Scorpio if you know what's good for you; a spurned Scorpio can turn violent. They're always in control and aware of what's going on—even when they pretend not to be. Their will is so strong that they can even exert a kind of hypnotic power over those around them. Professionally speaking, they make great detectives, first-rate scientists, and skillful physicians (unraveling complicated problems is their forte). As far as their own health is concerned, Scorpios are generally of a hardy constitution, though they can encounter problems in their genitals and nether regions.

Those born under Sagittarius, the Archer (November 22–December 20), are as open as Scorpios are closed. They're cheerful, optimistic, and absolutely dependable; if you're going out of town, you can leave your house key with a Sagittarian. The only danger is, he might throw a party there; Sagittarians are so friendly and outgoing, they can occasionally err on the side of boisterousness and even vulgarity. Best to keep them from getting too loaded. Sober, they evince a strong and compelling intellect and a fondness for the great outdoors. They're always up for a touch football game. Good-looking and of above average height, with a wiry physique and expressive eyes, Sagittarians sometimes suffer from such ailments as sciatica, rheumatism, and anxiety attacks.

Anyone whose sign is Capricorn, the Goat (December 21–January 19), is probably not going to be playing touch football with the Sagittarian crowd. Capricorns are slow-moving and methodical, practical and pragmatic, orderly and trustworthy. If you're looking for someone to do your taxes or make out your last will and testament, a Capricorn is a good choice. Successful Capricorns show up as judges, bankers, arbitrage experts; unsuccessful ones display a whining and disgruntled nature. A lot of them go through life with a scowl on their face. Constitutionally, they're hard and lean and dry as a bone, though they do fall prey to depression and a general malaise of the spirit.

Aquarius, the Water Carrier (January 20–February 18), governs those of a refined and intellectual bent. Aquarians make fine philosophers and poets as well as astronomers and philan-

thropists. On most occasions serious and quiet, they can, among congenial company, break out of their shell, do lively impersonations, and become a spark plug for everyone around them. On the downside, they can be emotionally undemonstrative and expect a little too much from their friends; naïveté is among their failings. Physically, they're a bit stocky, with good complexions, but they run into trouble with their ankles, their legs, and sometimes their vision.

Those born under Pisces, the Fishes (February 19–March 20), make good, if sometimes moody, friends. They're good at listening to other people's problems and show tact and sensitivity in their replies; as might be expected, they make nifty psychotherapists and also do well in things like art and archaeology. What they don't do well is forging a path through life; they tend to be reactive rather than assertive, and they dream about things happening instead of going out and doing whatever's necessary to make them come to pass. A little under the average height and pale-complected, they often suffer from foot problems and assorted skin difficulties.

Finally, the twelve signs of the zodiac are often divided into four categories based on the elements of which the universe was once thought to be composed—fire, earth, air, water. Each of these four ruled three of the signs.

Fire, which signified force and volatility, ruled over Aries, Leo, and Sagittarius.

Earth, representing dependability and pragmatism, governed Taurus, Virgo, and Capricorn.

Air, which stood for liveliness and unpredictability, ruled Gemini, Libra, and Aquarius.

Water, signifying sensitivity and emotion, presided over Cancer, Scorpio, and Pisces.

For anyone seeking a mate, the common wisdom had it that fire and air signs (the "positive" signs) went well together, as did earth and water (the "negative" signs).

TYCHO BRAHE

\mathcal{A}lthough he is justly celebrated for the genuine astronomical advancements he made, Tycho Brahe has also come down to us as perhaps the leading astrologer of his day—and without a doubt the only one who wore an artificial nose.

Born into a noble Danish family in 1546, he received a thorough education, in philosophy and rhetoric, at the University of Copenhagen. But what made an even greater impression on him was the solar eclipse of August 21, 1560, which he regarded as "something divine." Brahe quickly bought and pored over the *Ephemerides* of Johann Stadius and the works of Ptolemy in Latin. And though he went on to the University of Leipzig to pursue a law degree, he secretly devoted every spare minute to the study of the celestial bodies, using a pair of compasses, a globe, and several primitive instruments of his own construction.

Over time, his interests in the stars supplanted all other pursuits, and by the time he'd moved on to the town of Rostock, he was openly posting his astrological predictions. When a lunar eclipse occurred on October 28, 1566, he proclaimed that this celestial event predicted the death of the great Turkish sultan, who was much in the news at that time. When, a short time later, news of the sultan's death reached Rostock, Brahe's reputation soared. But only for a while. When further news was received, establishing that the sultan had actually died before the eclipse had occurred, Brahe's stock quickly fell.

And then Brahe ran into other trouble. After getting into an argument with a Danish nobleman, he was forced to fight a duel, in which his opponent managed to lop off a piece of Brahe's nose. Ever resourceful, however, Brahe made a prosthetic replacement, out of a copper alloy, and wore it the rest of his life.

In 1572, he made his first great discovery—a new star in the constellation of Cassiopeia. Using a large quadrant he had designed himself, he was able to prove that the star was mo-

tionless and so far away that the distance couldn't even be measured. He recorded his findings in a tract entitled *De Nova Stella,* which was printed in Copenhagen in 1573. At about the same time, he also began to explore the mysteries of medicine and alchemy and the possible influence that the planets exerted over various metals.

Word of his achievements reached the ears of King Frederick II of Denmark, who summoned him for a private audience. Brahe, never bashful, told the king all about the work he still wanted to do, the discoveries he planned to make, the treatises he hoped to write. But what he needed, he explained, was a place where he could work unmolested and an income he could depend upon. The king, moved by his candor and his enthusiasm, solved both problems for him.

By royal decree, Brahe was given the island of Hveen in the sound near Elsinore, a pension of five hundred thalers, and additional funds to build a house and a state-of-the-art observatory, equipped with the very best instruments money could buy, at Uraniborg. The observatory itself was of a radical design, being built underground, so that only its roofline showed, and it had soon attracted students from all over Europe. Brahe also had hidden buttons installed, which he could use to ring other rooms in the house, where some of the students lived. Guests who toured the observatory were always amazed when Brahe was able to summon these students as if by telepathy.

The house was also inhabited by Brahe's wife, his nine children, and an adopted family member, a dwarf named Jeppe, who followed Brahe everywhere he went and sat at his feet during meals; Brahe would feed him morsels of food with his own hand. Jeppe, who nattered on constantly, was thought to have psychic powers, so he was listened to quite carefully; if someone fell ill, Jeppe was consulted about the course the disease would take and whether or not it would prove fatal. His diagnostic abilities were purportedly first-rate.

Brahe himself kept up his medical sideline, manufacturing elixirs which he claimed could ward off all forms of contagious diseases. For Rudolf II, Habsburg ruler of the Holy Roman

Empire, he made up a special prescription, composed of treacle of Andromachus, spirit of wine, sulfur, aloes, myrrh, and saffron. If the emperor wished to enhance its efficacy, Brahe advised him to add "a single scruple of either tincture of coral or of sapphire, of garnet, of dissolved pearls or of liquid gold."

Nor had Brahe abandoned his astrological beliefs. In a lecture delivered at the University of Copenhagen on September 23, 1574, he had taken issue with those who were willing to admit that the stars had an influence on nature, but not on man. Man, he argued, "is made from the elements and absorbs them as much as food and drink, from which it follows that man must also like the elements be subject to the influence of the planets, and there is besides a great analogy between the parts of the human being and the seven planets. The heart being the seat of life corresponds to the Sun and the brain to the Moon. In the same way the liver corresponds to Jupiter, the kidneys to Venus, the milt [spleen] to Saturn, the gall to Mars and the lungs to Mercury."

He also took up the cudgels against those who denigrated astrology as a science: "Many philosophers have considered, that astrology was not to be counted among the sciences because the moment of birth was difficult to fix. Many are born at the same moment whose fates differ vastly, because twins often meet with different fortunes, while many die simultaneously in war or pestilence whose horoscopes by no means foretold such a fate. To these contentions I say, even if there was an error of an hour in the assumed time of birth, it would be possible from subsequent events to calculate it accurately.

"With regard to war and pestilence," he added, "prudent astrologers always make a reservation as to public calamities which proceed from universal causes." He even went so far as to argue that a person's astrological forecast could be altered, either by the hand of God or by a spirit that the Creator had instilled in everyone, by which it was possible to change the course of a preordained fate.

But after twenty-one years under the bliss of royal patronage, Brahe found himself out of favor again when Frederick II

died and his son, Christian IV, succeeded him. His pension and fief were rescinded, and Brahe decided to leave the private island he had inhabited so happily and for so long. Eventually, he made his way to Prague, where he landed another pension, and a castle in Benatsky, from Emperor Rudolf II. But less than two years later he fell gravely ill, and on October 24, 1601, Brahe died; his body was buried in the Teynkirche, Prague.

THE DEVIL'S PICTURE BOOK

"*A*n imprisoned person," wrote Eliphas Lévi, "with no other book than the Tarot, if he knew how to use it, could in a few years acquire universal knowledge, and would be able to speak on all subjects with unequalled learning and inexhaustible eloquence." While most people today are vaguely familiar with the tarot—a deck of cards decorated with colorful, antique figures—and treat it as an amusing parlor game, for centuries it was looked upon with awe, and some fear, as a reliable means of divining the future. Part of its mystery hinged on the fact that no one could say with certainty where the tarot had come from.

Even the origin of the word "tarot" is unknown. Was it derived from the river in northern Italy, the Taro, where early decks of the cards began to emerge in the fourteenth century? Or did it come from the French word *tarotée,* the term for the crosshatch design that decorated the back of some card sets? Or was the correct theory the one advanced by the eighteenth-century occultist Antoine Court de Gébelin, who believed that the cards had been passed down from the ancient Egyptians? De Gébelin believed that the word was a combination of the Egyptian words for road, *tar,* and royal, *ro,* so that the cards might be thought to present a "royal road" to wisdom.

In fact, according to one legend, the earliest pictures of the symbols that appeared on the cards adorned the walls of an inner chamber in an Egyptian pyramid and were used as part of the magical initiation rites; in symbolic form, they convey the wisdom of the Book of Thoth (Thoth being the early Egyptian

moon god who was presumed to know the secret formulas needed for a soul to make a safe passage through the under-world). An Egyptian origin would also account for the fact that the cards were commonly used, and introduced to much of Europe, by the Gypsies; these wandering people, known for their fortune-telling skills, were sometimes said to be the descendants of the priests of ancient Alexandria. When the temple of Serapis was destroyed by fire, some of these priests, or so the story went, had quickly gathered together the sacred texts and become nomads upon the face of the earth, traveling about with their occult wisdom jealously guarded. To those who could read them properly, however, the tarot cards could reveal the secrets of the universe.

For those who tried to read and interpret the cards *without* knowing how, the tarot would create nothing but confusion or mischief. Officials of both the Catholic and Protestant churches condemned the cards, too—if the tarot could be used to predict a predestined future, then what would be the good of trying to earn God's grace by doing good works and leading a virtuous life? You might just as well consult the cards and see what particular fate had already been laid out for you.

Not to mention the fact that time spent mulling over colorful cards could be better spent in religious meditation. In the view of these clerics, the tarot—and other playing cards, too—were nothing but "the devil's picture book," designed to turn the players' thoughts away from more heavenly and worthwhile pursuits.

None of which did anything to alter the growing popularity of the tarot. From the fourteenth century onward, the cards were used for everything from gambling and amusement to, ultimately, divination. Special decks were drawn up for important patrons and used to commemorate great occasions, such as royal weddings and accession to the throne. And over time, the deck and its symbolic representations became standardized into the seventy-eight cards that are still in use today.

The cards are divided into two "arcana" (hidden things). The Lesser Arcana consists of fifty-six cards, which in turn are

divided into four suits. But these aren't the four suits—spades, hearts, clubs, and diamonds—we're accustomed to seeing on regular playing cards. These suits are cups, swords, pentagrams, and wands (or scepters). Many different meanings have been attached to these suits—as indeed, many meanings are attached to every element of the tarot—but by and large, the suits are believed to represent the four main segments of society in the Middle Ages.

The cups (or chalices) are thought to represent the church, the swords the military, the pentagrams (or coins or diamonds, as they are sometimes shown) the tradesmen, and the wands (also seen as staves or cudgels) the peasantry.

The four court cards showed the four indispensable members in the household of a feudal lord—King, Queen, Knight (or Courtier), and Page (or Knave). This deck most probably preceded the Greater Arcana, and while it was used chiefly for gambling, it was sometimes employed all by itself for purposes of divination. (In one famous instance, Napoleon's cavalry commander, Joachim Murat, asked the renowned tarotist Mlle Lenormand for a reading. The first time Murat cut the cards for her, he pulled the King of Diamonds—a card of notoriously bad luck. Demanding another try, he pulled it again. He cut once more—and the King of Diamonds turned up again. When he insisted on yet another attempt, Mlle Lenormand threw the deck in his face and said, "You will wind up on the gallows or standing in front of a firing squad!" Her second guess was right: in 1815, he was executed by a firing squad.)

It was, however, the Greater Arcana, made up of twenty-two cards numbered 1 through 0, that emerged as the dominant force in the art of tarot. Each of these cards, also called trumps, bore an elaborate and highly symbolic picture, larded with obscure meanings; the manner in which the cards were laid out, and the messages that each one carried, were determined and interpreted by the reader. Sometimes the cards of the two arcana were mixed, sometimes they were used separately; they were laid out on the table in any number of complex arrangements, which went by such names as the Royal Spread, the

Gypsy Spread, the Celtic Cross, the Horseshoe, and the Tree of Life Spread. The order in which they appeared, and even the way they were pulled from the deck (if the card was upside down, it was sometimes thought to reverse its normal meaning), would provide the petitioner—that is, the customer who'd asked for the reading—with an answer to whatever question he had posed.

In preparation for the reading, it was generally advised that the reader keep his decks of cards in a safe, out-of-the-way place, possibly wrapped in silk; it was also important that no one else handle them. For some time before sitting down at the table, both reader and petitioner were to abstain from any stimulating food or drink and clear their minds of all other considerations. The table itself was to be covered with a neutral cloth (nothing fussy or distracting), the chairs were to face east and west, and the cards were to be shuffled, stacked, and turned over quite thoroughly—first by the reader, then by the petitioner. By having the petitioner do it, the cards were assumed to have absorbed some of his vibrations and thoughts. Finally, the reader asked the petitioner to voice aloud his question.

Once that was done, the reader, or tarotist, began to lay the cards down according to whichever of the patterns he had chosen. Although subject to the order and influence of all the cards that had been dealt before it, the last card dealt was in almost every instance the card that best indicated the answer to the petitioner's question or the possible outcome of what he had planned. Every card carried its own message, but the interpretation of the twenty-two major trumps, and their place in the tarot arrangement, were of paramount importance. (In many cases, these cards of the Greater Arcana were all that were used.) In ascending order, these cards, and the images they bore, were:

0. The Fool. A young man in a jester's cap, with a pole over his shoulder (and all his belongings hanging from it in a pouch) and a dog nipping at his heels. The card referred to the thoughtlessness and extravagance with which many people led their lives.

Its message? Turn away from temptation and overindulgence, and if you choose to go forward with your plans, do so with the utmost caution. (The fool is often depicted walking along the edge of a cliff, without looking where he's going.)

I. The Juggler (or Magician). A man in a wide-brimmed hat, or above whose head is suspended the sign for infinity; on the table in front of him, a collection of magical paraphernalia, including coins, a knife, a tumbler, and juggling balls. In the opinion of de Gébelin, this card signifies the haphazard and illusory nature of all existence; man is like a little ball, who may disappear from the magician's hand in the batting of an eye. The lesson? Don't delay—put your abilities to constructive use; the attainment of your aims will depend on your own determination and initiative.

II. The High Priestess (or Female Pope). A woman in papal robes and three-tiered headdress, seated on a throne and holding a scroll or book in her hands. The perplexing iconography is based on a thirteenth-century rumor, which suggested that a woman named Joan, disguised as a man, had actually succeeded to the papal throne. Once the ruse was uncovered, she was promptly stoned to death. The card itself suggests that the whole truth is never revealed to anyone but the select and initiated; its message seems to be that you should resist being ruled by a member of the opposite sex and use the full measure of your intellect to seek the truth.

III. The Empress. A regal woman with flowing hair, holding a scepter and shield, which symbolize her dominion over all things of this earth. Sometimes she is pictured with a red rose at the neckline of her long gown, to suggest her warmth and kindness. The Empress stands for such things as fruitfulness, pleasure, and comfort, and her message is that you should show generosity, even munificence, toward those around you.

IV. The Emperor (or King). Think Charlton Heston for this one— a mature man with an imposing demeanor, commanding the

throne with casual assurance. Not surprisingly, the card suggests such things as power, wealth, and patriarchy. The advice it conveys to you is twofold: stick to the higher principles, those that would be handed down by a wise and powerful leader, but at the same time avoid the curse of inflexibility.

V. The Hierophant (or Pope). An elderly man, often depicted with a long beard and full mustache; his right hand is raised, with two upright fingers making the ancient sign that was meant to convey both a blessing and the universality of dualism. This card represents spirituality and tradition, and its message is to embrace the new and forgo the useless relics of the past. It also suggests that you should be generous but careful in bestowing your largesse—make sure you know where it's going.

VI. The Lovers. Sometimes they're shown as Adam and Eve, naked in the Garden of Eden; sometimes there's one man, shown making a choice between two women (one of which is virtue, the other vice); sometimes several couples are seen dancing. The card speaks to the choices that have to be made between body and mind, good and evil, and of course, the choices that have to be made when choosing a mate. If the card could speak, it would say, guard yourself against immoral influences and make your choice wisely; be decisive, but do remember, no choice ever gets you everything you want.

VII. The Chariot. An armored warrior, godlike in his powers, steers a chariot drawn by a team of horses, or, in many decks, by a white sphinx and a black sphinx. The charioteer has conquered the elemental forces, and his card signifies triumph and conflict, success in overcoming adversity. To you, it might warn against acting rashly or rejoicing in a triumph too soon (sometimes defeat can still be snatched from the jaws of victory). Yes, success should be relished, but not so much that you lose sight of how things really stand.

VIII. Justice. A serene and clear-eyed woman, in a long robe, holding a scale or, in some instances, a double-edged sword. In some depictions, her hair is braided around her neck, as if it were a hangman's noose; this may imply that humans are responsible for their own fates and sometimes act unwisely in that regard. The woman represents such virtues as righteousness, balance, and purity, and her card is a warning to resist impure temptations, restore balance to your life, and make your own decisions. (In some tarot decks, this card and card XI, Strength, change places.)

IX. The Hermit. An old man in a hooded robe, carrying a staff and a lantern; the staff represents knowledge, mankind's most enduring support, and the lantern refers to illumination and contemplation. (The hermit is also tied to Diogenes, who carried a lamp in his search for an honest man.) The hermit signifies a life of introspection and secret wisdom, hard-won and all the more valuable for it. His message is to seek out and to share that wisdom and to use it in making future plans.

X. The Wheel of Fortune. An eight-spoked wheel, often seen with the sphinx sitting atop it. Life, the wheel suggests, is a cycle, and things are constantly going around and around, changing as they do. On some cards, a young man is seen ascending, a grown man descending, and an old man crawling on all fours. Be patient, the card suggests, because bad luck now will change to good, and opportunities will present themselves. By the same token, don't gloat when things start going your way; that, too, will pass.

XI. Strength (or Fortitude). A young girl bending down, her hands on the open mouth of a lion. It's not entirely clear, however, whether she's prying the jaws of the lion open or trying to clamp them shut. Still, the picture is generally thought to represent the triumph of love over brute strength, not to mention the power of conviction and courage. Its message? You should

confront dangers and obstacles with a firm sense of purpose and seek reconciliation with a foe.

XII. The Hanged Man. A man hanging upside down, from a gallows or tree, with one leg crossed behind the other. Sometimes he's holding a sack of coins, which are spilling out; sometimes the money is just pouring from his open pockets. In the Middle Ages, debtors were occasionally punished by being hung upside down, so that's what this probably signifies. A connection has also been drawn to Judas Iscariot, who hanged himself from a tree after collecting his thirty pieces of silver. The message of the card is sacrifice and renunciation, and it suggests you should right any wrongs you may have committed, and think about living your life differently (and better) than you have been.

XIII. Death. A skeleton in armor, armed with a scythe, and sometimes riding a white horse. With the blade of his weapon, he has cut down all the life around him, so zealously that on some cards the reaper appears to have cut off his own foot, too; in the background, fields are littered with the bodies and body parts of kings, popes, and peasants—though new plants can also be seen springing forth from the ground. Strangely enough, most tarotists give this card a more upbeat reading than you'd think— the card is thought to suggest regeneration and the transitory nature of the material world. Its advice to you? Break free from the shackles that bind you and set off in a new direction.

XIV. Temperance (or Balance). An angel carrying two urns, with one foot in a stream and the other still on the bank. The water or wine contained in the pair of urns is continually poured from one into the other, signifying the essence of life and its passage from the invisible to the visible, then back again to the invisible. The meaning of the card is moderation and self-restraint, compromise and peaceful accommodation. For you, it might also suggest keeping balance in your life by avoiding taking on too many things at once.

XV. The Devil. A satyrlike and winged demon, with the hind-quarters of a goat, holding a lighted torch. The torch may represent the fire of destruction, though on some cards (where the torch is unlit) it may represent the absence of spiritual enlightenment. Either way, the card overall is jam-packed with negative energies, implying everything from self-indulgence and immoral conduct to violence, mockery, and fits of temper. To you, it might suggest overcoming the primitive forces of the id and exercising some caution and self-restraint. Allowing the Devil to take precedence in your life would be to concede the victory of matter over spirit.

XVI. The Tower. A crown-topped battlement, its roof being split by a bolt of lightning emanating from the sun. Sometimes the Tower is thought to be the Tower of Babel, while at other times it's considered a representation of the divine nature of man; when the top is blown off, man falls into the material world below, as is shown by the two figures of a man and a woman hurtling to the ground. Although being thrown from the top of a tower might seem a bit drastic, it is also used as a way to show the importance of breaking with the past and taking a new direction in life. For you, the card might mean it's time to think things through in a new fashion, or take up a challenge, like a new job in a distant city. It's also a warning not to let pride and conceit blind you, for those qualities eventually lead to a downfall.

XVII. The Stars. A young girl kneels, naked, by a pool of water under eight stars—one large one and seven smaller. In keeping with the ancient astrological view, the central star is earth, with seven others—the planets then known—revolving around it. Sometimes the star is tied to the Star of Bethlehem, which guided the magi to the birthplace of Christ. The pool may represent the waters of life, and the urns which the maiden uses suggest the pouring forth of new ideas and rejuvenating energy. Full of hope and optimism and fulfillment, the card advises you

to feel confidence in your future and be emotionally expressive to others.

XVIII. The Moon. The moon rises between two towers—one dark and one light—and a winding path recedes into the far distance. In the foreground, two dogs bay, and a crawfish clambers onto shore. An eerie scene, it suggests the path of wisdom, which man must follow, by the partial light of the moon (a reference to human, as opposed to divine, reason), after crawling up, like the crawfish, from the pool of illusion. The card calls up envy and deceit, slander and dissimulation. To you, it might be a reminder that all is not as it seems and that aiming at unrealizable goals is futile and fruitless.

XIX. The Sun. The sun shines down upon (and sometimes sheds tears over) a boy and girl, innocent and unclothed within a walled garden. Eliphas Lévi contended that the two children represented Faith and Reason, the two feet upon which every man must stand; that the children were nearly naked was a sign that they had nothing to conceal. The card suggests friendship and affection, riches and health, and to you it might encourage enjoying good fortune to the utmost. It also advises you to share the wealth, to spread goodwill wherever you go.

XX. Judgment. A winged angel, presumably Gabriel, blows the celestial trumpet, and dead men and women rise from their graves. This card represents the freeing of man's nature from the mortal coil and the material world below, and it offers the same to you—forgiveness and renewal, tempered by accountability for your previous life and actions.

XXI. The World (or Universe). A woman whose body is lightly veiled, enclosed by a green wreath, which suggests nature. In the four corners of the card, the four elements and evangelists are symbolically suggested. In the upper left corner, we see air, and an angel representing Matthew. In the upper right, we see water, and an eagle representing John. In the lower left, earth,

along with a bull representing Luke. In the lower right, fire, and a lion symbolizing Mark. As the last of the cards in the Greater Arcana, this one indicates completion and finality, the arrival at your destination after a long trip. To you, it might also indicate that all the wealth in the world is nothing compared to true awareness and mastery over the things around you.

MOTHER SHIPTON AND THE CHESHIRE PROPHET

\mathcal{A}lthough their fame spread less widely than that of Nostradamus—and their very existence has sometimes been called into question—the two English seers known as Mother Shipton and the Cheshire Prophet were known throughout the British Isles. Fifteenth-century contemporaries, they were respectively cast as a witch and a fool, but their prophecies nonetheless have been said to predict everything from the Great Plague to the rise of Oliver Cromwell.

In regard to Mother Shipton's origins, what records exist seem to point toward the town of Dropping Well, in Knaresborough, Yorkshire; there, a reputed witch named Agatha Southill gave birth to a baby daughter, Ursula, in 1486. Some of the townsfolk claimed that the girl's father was a necromancer; others, insisting that it was Satan himself, called her the Devil's Child. Her unfortunate appearance seems to have helped that label stick.

According to Richard Head's *Life and Death of Mother Shipton* (1684), her "body was of indifferent height, her head was long, with sharp fiery eyes, her nose of an incredible and unproportionate length, having many crooks and turnings, adorned with many strange pimples of divers colours, as red, blue, and dirt, which like vapours of brimstone gave such a lustre to her affrighted spectators in the dead time of the night, that one of them confessed several times in my hearing that her nurse needed no other light to assist her in her duties." Given the undoubted hyperbole of this description, and overlooking the

question of how the author managed to interview anyone who had known Mother Shipton (who died in 1561) well over 120 years later, it remains a powerful portrait of a witch whose prophecies were closely studied by kings and commoners for many generations.

Despite her frightening countenance, Ursula seems to have snared a husband, one Tobias Shipton, a carpenter in York, by the time she was twenty-four. Her reputation as a seer gradually began to grow, until word of it had actually reached the court of Henry VIII. Many of her predictions related to prominent figures in the king's court—Cardinal Woolsey, the powerful prelate, for one. Woolsey had openly declared that he planned to move his household to York, and Mother Shipton, by local accounts, had said he would never reach the city. Woolsey sent three noblemen, in disguise, to meet this seer and find out if she truly had the gift of prophecy.

No sooner had they knocked on her door than she welcomed them in, greeting each one by his proper name and offering them cakes and ale. Their cover blown, the noblemen told her why they'd really come. Mother Shipton then reiterated her prophecy about the cardinal and the city of York, but reminded them, "I said he might *see* it, but never come to it." The noblemen, hearing the words from her own lips, warned her that if the cardinal did come, he'd probably have her declared a witch and burn her at the stake.

Mother Shipton was unfazed. Taking a linen handkerchief off her head, she tossed it into the fire, saying, "If this burn, so shall I." Fifteen minutes later, when she retrieved it, the handkerchief was intact and undamaged.

A short time later, on his way to York, the cardinal himself climbed to the top of a castle tower and saw, about eight miles in the distance, the city of York. But before he could even climb down again, a messenger from the king arrived, with the news that he was urgently needed at court. Turning around, the Cardinal set out for London but fell ill in Leicester and died there.

Score one more for Mother Shipton.

But famous as she was in life, she became even more so after her death. Her prophecies were collected and reprinted, and sometimes even added to by later astrologers. William Lilly, who published one such almanac of her predictions, began by stating, "All I can say is, that I fear they will prove true, more true than most men imagine, as Mother Shipton's prophecies were never yet questioned either for their verity or antiquity, so look to them to read the future with a certainty and act accordingly." Many people did just that.

In an account left by the writer and diarist Samuel Pepys, Prince Rupert was sailing up the Thames on October 20, 1666, when he first heard about the great fire ravaging London. "All he said was," according to Pepys, "now Shipton's prophecy was out." The prophetic lines that Prince Rupert must have had in mind read: "Time shall happen. A ship shall sail upon the River Thames till it reach the City of London; the Master shall weep and cry out: 'Ah, What a flourishing city was this when I left it, unequalled in the World!' But now scarce a house is left to entertain us with a flagon." It's easy to see why the prince jumped to the conclusion he did.

Others did the same, time and time again. In one of her prophecies, Mother Shipton seemed to imply that the town of Yeovil, Somerset, would be struck by an earthquake and flood in 1879; the locals were so worried about it that many of them deserted their homes on the eve of the presumed destruction, while others, who were anxious to catch a sight of the cataclysm, traveled from all over England to be on hand for the spectacle. Which, as we now know, did not come to pass. Nor did the end of the world, which another one of the prophecies (almost undoubtedly a later addition, thrown in by the editor) predicted would occur in 1881; still, the fact that it was included in Mother Shipton's predictions was enough to send waves of panic throughout the English countryside. Villagers spent the night in open fields or in fervent prayer in their churches.

Legend has it that Mother Shipton lived to a fantastically old age, then died at Clifton in Yorkshire. A headstone marking her grave there reads:

"Here lyès she who never ly'd,
Whose skill often has been try'd,
Her Prophecies shall still survive,
And ever keep her name alive."

Wise as Mother Shipton was considered to be, her counterpart, known as the Cheshire Prophet, was thought to be a sort of idiot savant—a fool who could occasionally glimpse the future without having any notion of what he'd seen.

His name was Robert Nixon, and by most accounts he was the younger son of a farmer who lived in the Vale Royal, Delamere Forest, Cheshire. Born in or about 1467, Nixon led a life of absolute anonymity, performing various simple chores. But every now and then, he would stop whatever he was doing and suddenly blurt out a cryptic prediction, which would, as his neighbors soon began to notice, come true. Most of what he said had only a local relevance, but one day, while plowing a field, he pulled his team to a sudden stop, then gesturing with his whip, shouted, "Now Richard! Now Harry!" He wiped his brow, then cried, "Now Harry, get over that ditch and you will gain the day!"

When a messenger later arrived in the town to proclaim the great victory Henry VII (aka Harry) had won at the Battle of Bosworth Field, the townspeople quickly told him that Nixon had been shouting about it already. The messenger repeated this story to the new king, who then sent for Nixon himself.

But even before word of this royal edict could get back to the town, Nixon knew about it. To the amusement of his neighbors, he was heard running about the streets, shouting that the king had sent for him, the king had sent for him! Nobody paid much attention until the messenger rode into town and asked where he could find Robert Nixon. Then they directed him to the family's farm, where the messenger found him hard at work.

Brought to court, Nixon was introduced to the king, who'd already set up a little test for him. He told Nixon that he'd lost a priceless diamond ring, and nobody could find it. Could he?

Nixon simply replied, "He who hideth can find." And the king was satisfied.

When he wasn't making runic predictions, which were dutifully taken down, Nixon was fretting about being starved to death while he was at court. One minute he was declaring, "The weary eagle shall to an island in the sea retire, Where leaves and herbs grow fresh and green" (a prediction that was later thought to refer to Napoleon's exile to Elba), and the next minute he was hoarding food and quaking with fear. The king, to calm him down, gave Nixon the full run of the palace—including the kitchens—and for a time Nixon seemed to relax.

But one day, when the king was setting out on a hunting trip, Nixon came running up to him in a panic and begged to come along. The king said that would be impossible and instructed an officer of the household to watch over him. Nixon insisted that if the king didn't let him come along, he would surely starve to death before the king could return. The king scoffed and rode away, leaving Nixon shouting that His Majesty would never see him alive again!

Nixon quickly returned to the kitchen and larder, but the servants teased him so much, and he made such a racket, that the officer decided to lock him in a closet until he quieted down. Unfortunately, the officer was sent for shortly thereafter and left the castle without remembering to set Nixon free. When he got back, several days later, he opened the closet and found him—just as Nixon had predicted—dead.

NOSTRADAMUS

According to his contemporaries, Nostradamus predicted the precise time of his own death—and even composed one of his famous quatrains to commemorate the unhappy event. Translated from the original French, it read, "On his return from his embassy, the king's gift put in place, he will do no more, having gone to God. By close relations, friends, blood brothers, he will be found near the bed and bench."

Having just returned from a mission to Arles, the sixty-two-year-old seer was found dead, lying on a bench that he regularly employed to help himself get in and out of bed. Following detailed instructions he had left behind, his body was buried standing upright in a wall, just to the left of the door in the church of the Franciscan friars, in the town of Salon.

Arguably the most renowned astrologer and prophet of all time, Nostradamus, in predicting the conditions of his own demise, had only done for himself what he'd been doing for others—from commoners to kings—all his life: he had consulted the stars and cast his own fortune. His psychic gift, which has come down to us today in the form of one thousand rhymed prophecies, is one of the most celebrated, and debated, in history.

Born in St.-Rémy, France, in 1503, he was christened (though he came from Jewish ancestry) Michel de Nostradame. His father was a notary, but his grandfathers on both sides were physicians, and they undertook to make a doctor out of young Michel, too. In preparation, he was taught Greek, Latin, Hebrew, and astrology, then sent to continue his studies at the University of Montpellier. There, he excelled in the classroom and proved his mettle as a practicing physician when the plague broke out in Provence. Described as a short, florid, and energetic man, he made the rounds of the town unafraid and unaffected by the contagion.

After earning his medical degree, he spent eight years traveling in western Europe, and it was during this time that he began to exhibit his gift of prophecy. Legend has it that when he was in Italy, he passed a young swineherd named Felix Peretti, who had become a monk. Nostradamus fell to his knees and called him "His Holiness." Peretti was as baffled as everyone else, though years later, long after Nostradamus was dead, he was indeed made Pope Sixtus V.

On another, and later, occasion, Nostradamus was walking through the courtyard of a castle in Lorraine when two pigs—one black and one white—ran across his path. To test his guest's much-vaunted skills, the lord of the castle asked Nostradamus what the fate of the two pigs would be.

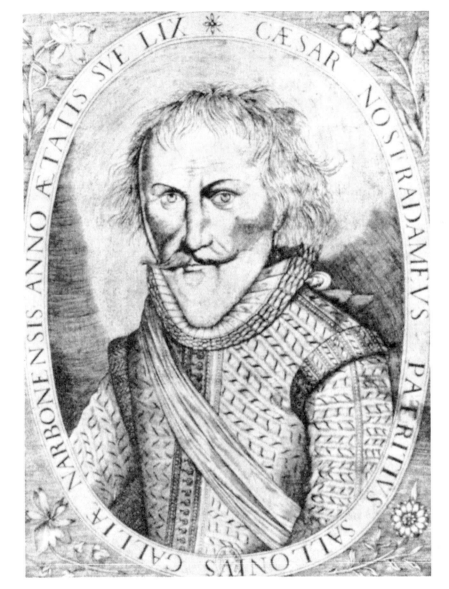

CÆSAR NOSTRADAMÆUS PATRITIUS SALLONIUS GALLIÆ NARBONENSIS ANNO ÆTATIS SUÆ LIX * CÆSAR

"The black one we shall eat," the seer replied, "and a wolf shall eat the white."

That same day, in an effort to foil the great prophet, the lord privately instructed his cook to kill and cook the white pig and serve it for dinner.

The cook did as he was told, but left the roasted white pig in the kitchen unattended—where a wolf managed to sneak in through the door and gobble it up. The cook quickly killed the black pig and served that one for dinner instead—without advising his master of what he'd done.

The lord, laughing, said to Nostradamus, "Well, you must have been wrong about that wolf eating the white pig because the white pig is what we're eating now."

Nostradamus, however, stuck to his guns and said that that was impossible. This was the black pig they were eating.

To settle the question, the lord had the cook brought into the dining room, asked him which pig they were eating, and nearly fell out of his chair when the cook, flustered and fearful, explained what had happened in the kitchen.

But it was his medical skill that eventually brought Nostradamus back to France, where he fought outbreaks of the plague in Marseilles, Aix-en-Provence, and Lyons. (He had already lost his first wife and two children to a previous outbreak.) For his remarkable and brave services, he was awarded a pension and settled in the town of Salon with his second wife. Their house, on a dark and narrow street, had a winding staircase that led to a top-floor study; there, with the rooftops of the town spread out below him, Nostradamus composed his almanacs of astrology and, more important, the prophetic verses that remain his legacy. In two such verses, he described how his visions came, in the still of those midnight hours:

> Gathered in night in study deep I sate
> Alone, upon the tripod stool of brass,
> Exiguous flame came out of solitude,
> Promise of magic that may be believed.

The rod in hand set in the midst of the Branches,
He moistens with water, both the fringe and foot;
Fear and a voice make me quake in my sleeves;
Splendour divine! the God is seated near.

Judging from this account, Nostradamus held in his hand a forked wand, much like a divining rod, while surrendering to his divinely inspired visions: "The things that are to happen can be foretold," he wrote in the preface to his prophecies, "by nocturnal and celestial lights, which are natural, coupled to a spirit of prophecy." He penned his predictions in four-line verses, which were gathered into groups of one hundred and later published as *Centuries*. The obscurity of their meaning can be attributed in part to the mystery of their origin—the Divine Being is not about to spell things out in the most literal fashion—and partly, as Nostradamus himself confesses, to avoid political and religious repercussions for the seer and his family. Predicting the rise and fall of kings and queens could, for obvious reasons, land one in a dungeon overnight. (As late as 1781, the prophecies were condemned by a papal court, for cryptically predicting the fall of the papacy.)

Nostradamus himself said that his predictions would be borne out over a period of hundreds of years, so that it would take many generations before their truth could in every instance be revealed. Consequently, each generation has pondered their runic utterances and tried to decipher the secret meaning. The quatrains have been thought to predict everything from World War II to the end of the world. And some have indeed been interestingly on target, particularly those that seem to describe the period of the French Revolution, which was still over two hundred years in the future. There is, for instance, one verse (century IX, quatrain 20) that goes:

By night shall come through the forest of Reines,
Two married persons, by a tortuous valley, the Queen a
 white stone,

The black monk in gray into Varennes,
Elected king, causes tempest, fire, blood, cutting.

Varennes shows up only once in the greater scheme of European history, and that is when the French king Louis XVI ("elected" because he was the only king to hold his title by will of the Constituent Assembly rather than divine right) and his queen, Marie Antoinette, were captured there after their flight. Louis was disguised in gray, the queen was dressed in white, and after they were returned to the maelstrom of blood and destruction they had unleashed, they were themselves (as the last word of the prophecy indicates) cut—beheaded by the guillotine.

And then there are the lines (century III, quatrain 35) that appear to predict the rise of Napoleon:

In the southern extremity of Western Europe
A child shall be born of poor parents,
Who by his tongue shall seduce the French army;
His power shall extend to the Kingdom of the East.

Napoleon Bonaparte was born in Corsica, into an impoverished family. His bold commands won the hearts of the French troops and enabled him to lead them successfully into Egypt (a campaign that even the Directory, which had dispatched them, thought was likely to end in disaster). Whether by luck or something more, Nostradamus had once again managed to hit the nail on the head.

But while it would take centuries for some of his prophecies to be fulfilled, he was renowned in his own day for his ability to cast astrological charts and offer advice of a more immediate and practical nature. Henry II, the king of France, summoned him to Paris and rewarded him for his labors with a hundred gold crowns in a velvet purse; Catherine de Medici, the queen of France and an ardent believer in the occult, provided him with the same amount, and even sent him on to Bloise, to give the royal children a health checkup. When Charles IX succeeded

to the throne, Nostradamus was named physician-in-ordinary to the king himself.

On his death in 1566, a marble tablet was erected to his memory in Salon. The inscription chiseled in the stone read, in part:

"Here lie the bones of the most famous
NOSTRADAMUS
One who among men hath deserved the opinion of all,
to set down in writing with a quill almost Divine,
the future events of all the Universe caused by
the Coelestial influences."

Glossary

A guide to terms, titles, and proper names used in the text. A missing date of birth or death means none has been recorded with any certainty.

adept—one highly skilled in the occult arts

Agrippa—(1486–1535) Heinrich Cornelius Agrippa, Agrippa von Nettesheim, German magus, author of *The Occult Philosophy*

Albertus Magnus—(1193–1280) German alchemist, reputedly the inventor of the pistol and cannon

alchemy—the mystical art of transmuting base metals to gold

alectromancy—divination using a barnyard cock inside a magic circle

alkahest—universal solvent searched for by alchemists

Apollonius of Tyana—Pythagorean philosopher of first century A.D., reputedly able to foretell the future

Aquinas, St. Thomas—(c.1227–74) Italian scholastic philosopher and major theologian of Roman Catholic Church

Aristaeus—prophet, healer, and divinity worshiped in ancient Greece

augurs—seers and diviners of the ancient world

Avicenna—(980–1037) Persian physician and philosopher

Bacon, Roger—(1214–92) English friar and magician

Blavatsky, Helena Petrovna—(1831–91) Russian founder of Theosophical Society

Boehme, Jakob—(1575–1624) German mystic and philosopher

Brahe, Tycho—(1546–1601) Danish astronomer and astrologer, author of extensive planetary tables

Cabbala—body of mystical Jewish writings and theosophy

Cagliostro—(1743–95) a celebrated mystic, healer, and magician

Cardan, Jerome—(1501–76) a.k.a. Girolamo Cardano, Italian physician, astrologer, and mathematician

Cellini, Benvenuto—(1500–71) Italian goldsmith and artisan

Chaldeans—ancient Semitic people who lived in what was then Babylonia (a region of lower Tigris and Euphrates valley)

Chambre Ardente—the Burning Court of Louis XIV, to prosecute poisoners and others

Chiancungi—an Egyptian fortune-teller who became famous in eighteenth-century England

chiromancy—divination by studying the hand (palm reading)

Crowley, Aleister—(1875–1947) British occultist and mage

Cyprian, St.—(c.200–58) early church father and martyr

Dashwood, Sir Francis—(1708–81) English aristocrat who founded a diabolical order in Buckinghamshire

Dee, Dr. John—(1527–1608) English alchemist and necromancer

del Rio, Martin Antoine—(1551–1608) Jesuit scholar, renowned prosecutor of sorcerers and witches

deasil—going to the right, the direction of good

Eckhart, Johannes—(c.1260–?1327) Meister Eckhart, Dominican preacher, father of German mysticism

elementals—minor spirits of earth, air, fire, and water

ephod—white linen vestment worn by a necromancer

Fludd, Robert—(1574–1637) English alchemist and Cabbalist, author of *The History of the Microcosm and Macrocosm*

Fortune, Dion—(1891–1946) English occultist and author of *Psychic Self-Defense*

Fox sisters—Kate, Margaret, and Leah, who founded American spiritualism in Arcadia, New York, in 1848

Freemasons—ancient and powerful secret society, practicing mystical rites

Galen—(c.130–c. 200) Greek physician and writer on medicine

Gaufridi, Father Louis—French priest executed for witchcraft in 1611

Girardius—inventor in 1730 of the necromantic bell

Glauber, Johann Rudolf—(b. 1603) German author of many texts on medicine and alchemy, including *Miraculum Mundi*

Gnosticism—mystical religion that flourished in the first and second centuries A.D.

Gowdie, Isabel—Scottish witch of the sixteenth century

Grand Copt—the prophet Enoch, founder with Elijah of the Egyptian rites for Freemasons

Grandier, Urbain—priest accused of bewitching nuns in Loudun, executed in 1634

grimoire—a manual of black magic

Guazzo, Francesco-Maria—Italian friar, expert witness in seventeenth-century witch trials

gyromancy—divination by means of spinning in a circle marked with letters and occult symbols

Hand of Glory—a hanged man's hand, used to cast spells

Helmont, Jan Baptista van—(1577–1644) Dutch alchemist and doctor

hexagram—six-pointed star, also known as Seal of Solomon

homunculus—artificial human, or dwarf, made by alchemy

Iamblichus—(c.250–c.326) Neoplatonist philosopher and theurgist

Kelley, Edward—(1555–93) English alchemist and scryer, accomplice to Dr. John Dee

Knights Templar—military and religious order founded to protect Christian pilgrims

Kunkel, Johann—(1630–1703) German chemist and alchemist

Lévi, Eliphas—(c.1810–75) French occultist and author of *The Doctrine and Ritual of Magic*

liber spirituum—the book of spirits, kept by sorcerers

magus—a master magician (plural, magi)

Maimonides—(1135–1204) Jewish philosopher and theologian

Malleus Maleficarum—manual of witchcraft, aka *The Witches' Hammer,* written by Jakob Sprenger and Heinrich Kramer (1486)

Mathers, MacGregor—(d. 1918) founder of the Order of the Golden Dawn

Mora, Pietro—alchemist and poisoner in seventeenth-century Milan

necromancy—the magical art of summoning the dead

Nostradamus—(1503–66) French astrologer and seer

oneiromancy—divination by dreams

Order of the Golden Dawn—magical society founded in London in 1887

Origen—(c.185–c.254) immensely productive and influential theologian of the early Christian church

Paracelsus—(1493–1541) Swiss physician, alchemist, and astrologer

pentagram—a five-pointed star, used in magical rituals

Perkins, William—author of the *Discourse on the Damned Art of Witchcraft* (1608)

Petit Albert, Le—manual of magic published in Cologne in 1722

Philalethes, Eirenaeus—(fl. 1660) pseudonym of English alchemist, possibly Thomas Vaughan (brother of poet Henry Vaughan)

philosophers' stone—the secret material sought by alchemists to convert base metals to gold

Plutarch—(c.46–c.120) Greek biographer

pontificalibus—the ceremonial attire worn by a necromancer

rhabdomancy—the magical use of a wand or divining rod

Rosencreutz, Christian—thirteenth-century founder (probably mythical) of Rosicrucian society

Rosicrucians—a mystical order of adepts and philosophers announced in Germany in 1614

Ruysbroeck, Jan van—(1294–1381) father of mysticism in the Netherlands

St. Bernard—(1090–1153) abbot of Clairvaux, influential theologian and mystic

St.-Germain, Comte de—(c.1710– c.1780) alchemist prominent at various European courts

St. Vitus' dance—a neurological disorder and form of chorea, causing jerky and involuntary movement. A hysterical epidemic of the disease swept Europe in 1500s; victims sought help at Shrine of St. Vitus.

Schropfer, Johann Georg—(1730–84) necromancer and magician of Leipzig

scrying—divination through looking into a magic glass or crystal

Sendivogius, Michael—(1562–1646) alchemist and apprentice of Alexander Seton

Seton, Alexander—(1562–1646) Scottish alchemist

Shipton, Mother—(c.1486–1561) Yorkshire prophetess and witch

Sibly, Ebenezer—English astrologer and occultist in eighteenth century

Simon Magus—Samaritan magician of first century A.D.

Swedenborg, Emanuel—(1688–1772) Swedish mystic and author of *Heaven and Hell*

tarot—deck of seventy-eight cards used for divination

Tertullian—(c.160–c.230) Carthaginian theologian

Tetragrammaton—the four letters comprising the Hebrew word for God

Trithemius, Johannes—(1462–1516) Benedictine abbot and author of treatise on natural magic, *Steganographia*

Valois, Nicolas—fifteenth-century alchemist and author of *Cinq livres*

Villanova, Arnold of—(1235–1312) skilled alchemist, theologian, and physician to Pope Clement V

widdershins—going to the left, the direction of evil

Zachaire, Denis—(b. c.1510) French alchemist who claimed in 1550 to have converted quicksilver to gold

Zekerboni—seventeenth-century grimoire composed by Pietro Mora or his coven, largely based on the Keys of Solomon

Zohar—commentary on the Pentateuch, included in the Cabbala

zoomancy—divination by studying the behavior of animals

Zosimus of Panopolis—(c. third century A.D.) alchemist and writer

BIBLIOGRAPHY

Anthon, Charles. *A Classical Dictionary*. New York: Harper & Brothers, Publishers, 1860.

Bauer, Paul. *Wizards That Peep and Mutter: Christians and Superstition*. Westwood, N.J.: Fleming H. Revell Company, 1967.

Butler, E. M. *The Myth of the Magus*. Cambridge: Cambridge University Press, 1948.

————. *Ritual Magic*. Newcastle: Newcastle Publishing Company, 1971.

Cavendish, Richard. *The Black Arts*. New York: Capricorn Books, 1967.

————, ed. *Man, Myth and Magic: An Illustrated Encyclopedia of the Supernatural*. New York: Marshall Cavendish Corporation, 1970.

Cellini, Benvenuto. *The Autobiography of Benvenuto Cellini*. Translated by John Addington Symonds. Garden City, N.Y.: Dolphin Books.

Chaplin, J. P. *Dictionary of the Occult and Paranormal*. New York: Laurel/Dell Publishing, 1976.

Crow, W. B. *A History of Magic, Witchcraft and Occultism*. North Hollywood, Calif.: Wilshire Book Company, 1968.

Davidson, Gustav. *A Dictionary of Angels*. New York: Free Press, 1971.

Drury, Nevill, and Gregory Tillett. *The Occult Sourcebook*. London: Routledge & Kegan Paul, 1978.

Encyclopaedia Britannica, 11th ed. New York: Encyclopaedia Britannica, 1910.

Ennemoser, Joseph. *The History of Magic*. Translated by William Howitt. New Hyde Park, N.Y.: University Books, 1970.

Fielding, William J. *Strange Superstitions and Magical Practices*. Philadelphia: Blakiston Company, 1945.

Gettings, Fred. *Dictionary of Astrology*. London: Routledge & Kegan Paul, 1985.

Givrey, Grillot de. *Witchcraft, Magic and Alchemy*. Translated by J. Courtenay Locke. New York: Dover Publications, 1971.

Grant, Michael, and John Hazel. *Who's Who in Classical Mythology*. New York: Oxford University Press, 1993.

Hall, Manly P. *An Encyclopedic Outline of Masonic, Hermetic, Qabbalistic and Rosicrucian Symbolical Philosophy*. Los Angeles: Philosophical Research Society, 1988.

Huffman, William H., ed. *Robert Fludd: Essential Readings*. London: Aquarian Press, 1992.

Kernan, Alvin, ed. *Ben Jonson: The Alchemist*. New Haven and London: Yale University Press, 1974.

Kirschbaum, Leo, ed. *The Plays of Christopher Marlowe*. Cleveland and New York: World Publishing Company, 1962.

Lamb, Geoffrey. *Magic, Witchcraft and the Occult*. New York: Hippocrene Books, 1977.

Lyons, Albert S. *Predicting the Future*. New York: Harry N. Abrams, 1990.

Mares, F. H., ed. *The Alchemist,* by Ben Jonson. Manchester: Manchester University Press, 1967.

Masello, Robert. *Fallen Angels*. New York: Perigee Books, 1994.

Mathers, S. Liddell MacGregor. *The Key of Solomon the King*. York Beach, Maine: Samuel Weiser, 1989.

McIntosh, Christopher. *The Astrologers and Their Creed*. New York: Frederick A. Praeger, 1969.

Michelet, Jules. *Satanism and Witchcraft*. New York: Citadel Press, 1939.

Poinsot, M. C. *The Encyclopedia of Occult Sciences*. New York: Robert M. McBride & Company, 1939.

Redgrove, Stanley. *Bygone Beliefs: Being a Series of Excursions in the Byways of Thought*. London: William Ryder & Son, 1920.

Robbins, Rossell Hope. *The Encyclopedia of Witchcraft and Demonology*. New York: Crown Publishers, 1959.

Schmidt, Philipp, S. J. *Superstition and Magic*. Westminster, Md.: Newman Press, 1963.

Scott, Walter, ed. *Hermetica*. Boston: Shambhala Publications, 1993.

Seligman, Kurt. *History of Magic and the Occult*. New York: Harmony Books, 1948.

Shah, Sayed. *The Secret Lore of Magic*. London: Frederick Muller, 1957.

Smedley, Rev. Edward. *The Occult Sciences*. London and Glasgow: Richard Griffin Company, 1855.

Smith, Charlotte Fell. *John Dee*. London: Constable & Company, 1909.

Spence, Lewis. *An Encyclopedia of Occultism*. New Hyde Park, N.Y.: University Books, 1960.

Summers, Montague. *A Popular History of Witchcraft*. New York: Causeway Books, 1973.

———. *Witchcraft and Black Magic*. New York: Causeway Books, 1974.

Sykes, Egerton. *Who's Who in Non-Classical Mythology*. New York: Oxford University Press, 1993.

Thompson, C. J. S. *The Mysteries and Secrets of Magic*. Philadelphia: J. B. Lippincott Company, 1928.

———. *The Mystery and Romance of Astrology*. New York: Causeway Books, 1973.

Trowbridge, W. R. H. *Cagliostro*. New York: Brentano's, 1926.

Waite, Arthur Edward, ed. and trans. *The Hermetical and Alchemical Writings of Aureolus Philippus Theophrastus Bombast, of Hohenheim, Called Paracelsus the Great*. Boulder, Colo.: Shambhala Publishing, 1976.

Ward, Charles A. *Oracles of Nostradamus*. New York: Barnes & Noble Books, 1993.

Wedeck, Dr. Harry E. *A Treasury of Witchcraft*. New York: Citadel Press, 1966.

Wheatley, Dennis. *The Devil and All His Works*. London: Hutchinson of London, 1971.

Williams, Henry Smith, ed. *The Historians' History of the World.*
New York: Encyclopaedia Britannica, 1926.

Wilson, Colin. *The Occult: A History.* New York: Random House,
1971.

The author also wishes to acknowledge the generous
research assistance received from the William Grant Archives of
the Occult.

ILLUSTRATION CREDITS

French occult manuscript *La Magie Noire* (Black Magic), nineteenth century.*

136: Pandemonium reigns in a Puffer's Laboratory. Print by Breughel the Elder, engraved by Cock, sixteenth century.**

149: Paracelsus. Paracelsus, *Astronomica et astrologica opuscula* (Cologne, 1567). Author's collection.**

160: The Comte de Saint-Germain, an Eighteenth-century Alchemist. Portrait engraved by Thomas.**

174: Exploration of a Mining Area by Means of the Divining-rod in the Sixteenth Century. Georg Agricola, *De Re metallica* (Basel, 1571).**

187: Palmistry Geography. Edward D. Campbell, *The Encyclopedia of Palmistry,* New York: A Perigee Book, 1996. Courtesy of Irving Perkins Associates.

188: Major Lines. Edward D. Campbell, *The Encyclopedia of Palmistry,* New York: A Perigee Book, 1996. Courtesy of Irving Perkins Associates.

218: Portrait of Nostradamus at the Age of Fifty-nine. Sixteenth-century print.**

*Indicates illustrations taken from *Picture Book of Devils, Demons and Witchcraft* by Ernst and Johanna Lehner, Dover Publications, Inc., 1971. Used by permission.

**Indicates illustrations taken from *Witchcraft, Magic & Alchemy* by Grillot de Givry, translated by J. Courtenay Locke, Dover Publications, Inc., 1971. Used by permission.

About the Author

Robert Masello is a writer and story editor on the original Showtime television series *Poltergeist: The Legacy*.

An award-winning journalist and author living in Los Angeles, he has written eleven previous books, which have been translated into six languages. Among these books are three novels of the occult (*The Spirit Wood*, *Black Horizon*, and *Private Demons*) and a nonfiction work entitled *Fallen Angels . . . and Spirits of the Dark*.

WHAT YOUR DREAMS ARE TRYING TO TELL YOU...

__THE ENCYCLOPEDIA OF SYMBOLISM
by Kevin J. Todeschi
0-399-52184-4/$17.00
A comprehensive and original approach to symbols and imagery, with more than 2,000 entries and 10,000 interpretations in an A to Z format.

__THE DREAM DICTIONARY: 1,000 DREAM SYMBOLS FROM A to Z
by Jo Jean Boushahla and Virginia Reidel-Geubtner
0-425-13190-4/$10.00
This easy-to-use, illuminating handbook will help readers to recognize dream types, recall dreams more clearly, and learn what is revealed by dreams.

__DREAMS THAT CAN CHANGE YOUR LIFE
by Alan B. Siegel, Ph.D.
0-425-13483-0/$8.95
By analyzing over 100 "turning point dreams," psychologist Alan Siegel shows how even unpleasant dreams can serve as creative tools for insight, inspiration, and inner peace.

__THE SECRET WORLD OF YOUR DREAMS
by Julia and Derek Parker
0-399-51700-6/$11.00
A timeless compendium of dream symbols that unlock the special meaning of dreams.